D1571606

Picturing Arizona
The Photographic Record of the 1930s

Edited by
Katherine G. Morrissey and Kirsten M. Jensen

The University of Arizona Press
Tucson

The University of Arizona Press

© 2005 The Arizona Board of Regents

∞This book is printed on acid-free, archival-quality paper.

Manufactured in the United States of America

10 09 08 07 06 05 6 5 4 3 2 1

Library of Congress Cataloging-in-Publication Data

Picturing Arizona : the photographic record of the 1930s /
edited by Katherine G. Morrissey and Kirsten Jensen.

p. cm. — (The southwest center series)

Includes bibliographical references and index.
ISBN-13: 978-0-8165-2271-2 (hardcover : alk. paper)
ISBN-10: 0-8165-2271-5 (hardcover : alk. paper)
ISBN-13: 978-0-8165-2272-9 (pbk. : alk. paper)
ISBN-10: 0-8165-2272-3 (pbk. : alk. paper)

1. Documentary photography—Arizona—History—20th
century. 2. Photography—Arizona—History—20th century.
3. Arizona—Pictorial works. I. Morrissey, Katherine G.
II. Jensen, Kirsten, 1969– III. Series.
TR820.5.P53 2005
779'.99791--dc22
2005004941

Publication of this book is made possible in part by a grant from the Arizona
Humanities Council, the Charles Redd Center for Western Studies at Brigham
Young University, and the Southwest Center of the University of Arizona.

Contents

Preface

This book, like many collective projects, is the result of a long process. It began somewhat innocently in the fall of 2000 when we met at the University of Arizona. A box of Russell Lee photographs brought us together. Kirsten Jensen, then working as an archivist in Special Collections at the university library, selected Lee's photographs for presentation when Katherine Morrissey conducted an Arizona history class at the archives. After the class, the two of us began discussing Depression-era photography and the lack of published works on 1930s Arizona photography. That discussion—and many subsequent e-mails, phone calls, and coffee meetings—began the chain of events and research that crystallized in this book. Along the way we held a day-long symposium in January 2002, sponsored in part by the Arizona Humanities Council and convened in the newly renovated Special Collections at the University of Arizona Library.

From the beginning, then, we were captivated by those enduring visions of the Depression that linger in cultural memory: dust storms, Okies on their way to California, bread lines, Hoovervilles, and ramshackle tent cities. Documentary photographs, especially those (like Russell Lee's) taken under the auspices of the Farm Security Administration (FSA), contribute to

the powerful visual legacy of the decade. They may be carefully identified by location, but they intentionally reflect a more universal experience and perspective. The FSA photographs, and the scholarship on them, have shaped our understanding of 1930s documentary photography.

Although inspired by familiar photographs by Lee, Dorothea Lange, and others working for federal agencies, we have also been intrigued by less-familiar photographs, especially those that intentionally reflect a more particular experience and perspective. What we have sought to do here is not just to look at government-sponsored photographs of Arizona subjects but also to examine the variety of Arizona images created by Arizonans or others during the 1930s. This book places the work of local Arizona photographers alongside that of federal photographers to emphasize the influence of various cultural agendas and to illuminate the impact of the Depression on the state's distinctive racial and environmental landscapes. The photographs in this volume represent a variety of purposes and perspectives, and the lenses that distill these images for us are photographic as well as political, personal, public, promotional, and touristic in nature, to mention a few. As cultural documents, as works of art, and as historical records, the photographs of 1930s Arizona tell a remarkable history of the state.

The photographs capture a Depression-era Arizona bustling with activity. Federally funded construction projects and seasonal agricultural work brought migrants and newcomers to the state. Its farmers sought to adapt their farms to new technology—often with government assistance. And despite the hardships experienced in the state and elsewhere, Arizona remained a destination for tourists, anthropologists, and archaeologists. The camera's gaze also captured the questions, conflicts, fears, and silences engendered by the hardships of the time. As the economic strains of the decade reverberated through the state, local photographers actively documented the Depression lives of a diverse range of Arizona residents. And like their federal government-sponsored counterparts, they did so with various objectives in mind, whether commercial, political, scientific, and/or artistic.

The number of photographs taken during the decade is staggering. Indeed it was an immensely challenging task to limit the selection of photographs to only the 118 included here. Our objective of exploring the diverse visual record of Arizona during the Depression and New Deal guided our selections. We quickly learned, however, that we could never depict every Arizona location, include every Arizona photographer, or reflect every Arizona experience. Instead, our aim in these six essays and three photo-essays is simply to begin a conversation about the state and its people through the medium of the photographic lens. Through the combination of images and text, we invite you to join this conversation not only by reading

these particular essays and photographs but also by exploring the numerous collections of photographs and manuscripts described in the appendix.

As editors, we have brought together a group of interdisciplinary scholars who can provide unique and diverse perspectives on this period in Arizona and American history. Coming from American Studies, anthropology, art history, history, journalism, and Mexican American Studies, the scholars included here drew upon their own areas of expertise in selecting topics and photographs. Their individual backgrounds, research, and experiences cover a broad swath of American culture and history; they are as varied as their own viewpoints on Arizona and its visual representations. The creative process of sharing our perspectives with each other through the symposium, conversations, and written drafts worked to illuminate each others' essays and shape the project as a whole.

Collaborative editorial projects like this one are not easy, and the editors have relied heavily on the patience and good graces of each other, the essay authors, and countless archivists, scholars, librarians, and other interested parties who have assisted in a variety of ways in this project. We would like to thank the many individuals who provided their assistance, suggestions, and expertise, including, among others, Karen Anderson, Dolores Rivas Bahti, Michelle Berry, Julia Cowden, Riva Dean, Shelly Dudley, Lisa Felix, Alfred Gonzales, Diana Hadley, Peter Iverson, Joan Jensen, Leesa Lane, Kim Lowry, Jack Marietta, Deborah Marlow, Sarah Moore, John Murphy, Mary Murphy, Elizabeth Raymond, and James Swensen.

Archivists, curators, librarians, and other staff members at local historical societies, tribal museums, repositories, collections, and universities have graciously provided access and assistance. We are indebted to them all, including Kay Benedict of the Casa Grande Valley Historical Society; Tony Marinella of the Colton Research Library, Museum of Northern Arizona; Alan Ferg, Jeannette Garcia, Susan Luebbermann, and Jannelle Weakly of the Arizona State Museum; Callie M. Vincent of the Amon Carter Museum; Eunice Kahn of the Navajo Nation Museum; Jan Davis, Roger Myers, Ken O'Neill, and Bonnie Travers of Special Collections, University of Arizona Library; Jared Jackson of the Arizona Historical Foundation; Scott Anderson and Michael Wurtz of the Sharlot Hall Museum; Leslie Calmes, Cass Fey, and Amy Rule of the Center for Creative Photography; Kathy Farretta of Riordan Mansion State Historical Park; Leslie Broughton, Heather Dominick, Kim Frontz, Joe Meehan, Deborah Shelton, and Dave Tackenberg of the Arizona Historical Society; Elizabeth Bentley and Christine Marin of the Department of Archives and Manuscripts, Arizona State University Libraries; Laurie Devine and Melanie Sturgeon of the Arizona State Library, Archives and Public Records; Karen Underhill, Bee Valvo, and Jesse Vogelsang

of the Cline Library, Northern Arizona University; and Barbara Tuttle of the Fort Huachuca Historical Museum. The Arizona Humanities Council, Joe Wilder and the Center for the Southwest, the Charles Redd Foundation, and the University of Arizona's Provost's Author Support Fund have provided needed financial assistance.

 We would particularly like to thank our authors; Patti Hartmann, Anne Keyl, Mary Rodarte, and Alan Schroder at the University of Arizona Press, who wonderfully and patiently attended to the myriad details involved in production; the incredibly accommodating and helpful staff at Special Collections, University of Arizona Library; Betsy Fahlman, who generously shared her collection of FSA/OWI photographs; and Martha Sandweiss, who helped define the scope of the project. Without your assistance this project would not have been possible.

Editorial Note

 Text in illustration captions that is enclosed in quotation marks is from the photographer or the collection that holds the image.

Katherine G. Morrissey
Kirsten M. Jensen

MARTHA A. SANDWEISS

Introduction

PICTURING ARIZONA

Arizona was slow to attract photographers. Photography was invented in 1839, almost a decade before Arizona became part of the United States, but for more than a decade the new American territory went unrecorded by cameramen. Like many other remote and sparsely settled regions of the nation, Arizona seemed to offer little to prospective photographers; travel was difficult, supplies nonexistent, a commercial market uncertain at best. Indeed, the two earliest documented photographers in present-day Arizona went there to show travelers the safest and most expeditious ways to get through it. In 1863, the French-born Rudolph D'Heureuse photographed the route between San Bernardino, California, and Fort Mohave, most likely for the California State Geological Survey, to show how to move from mining sites to the safety of American military installations. Three years later, in early 1866, Charles Brinley accompanied another California State Geological Survey across west-central Arizona to locate and document the most suitable routes for wagon roads through the country.[1] Like so many of the 1930s photographs discussed in this book, these earliest Arizona images were made by outside photographers working for governmental interests; their pictures were made not for Arizonans

themselves but for those who would use the region's natural and human resources for their own purposes and ends.

Arizona was not, of course, an uninhabited place during its first few decades under American rule. But photography during this period required equipment, supplies, and a kind of technical know-how to which the region's sizeable Indian and Hispanic populations had no easy access. Arizona therefore became a place that was photographically described to outsiders, by outsiders, before Arizonans could pick up cameras to describe their own worlds for themselves. The earliest photographs of the Arizona landscape thus describe a place that outsiders sought to incorporate into their own familiar frames of reference. When Timothy O'Sullivan traveled through Arizona in the early 1870s, as a part of Lt. George M. Wheeler's federal survey of the lands west of the hundredth meridian, he struggled to make photographs that would not seem too strange to the eastern American investors, miners, and settlers the federal government hoped to attract to the Southwest. O'Sullivan published his picture of a saguaro cactus with words that described the exotic plant as an important source of food for local Indians and birds. Likewise trying to make an unfamiliar place seem comfortable and attractive to his largely eastern audience, O'Sullivan offered his photograph of Apache Lake in the White Mountains as proof that "Arizona, in its entirety is not the worthless desert that by many it has been supposed to be."[2] In playing to the imagination of his eastern viewers, and in acknowledging their stereotypes and cultural anxieties, O'Sullivan anticipates the work of the Farm Security Administration (FSA) photographers of the 1930s who, as described in this book, catered to the needs of their government employers rather than to the wants of the Arizona residents they pictured on film. Their pictures were not meant to affirm local knowledge but to create knowledge and affirm ideas for those living far away.

O'Sullivan understood what all of the government-employed photographers featured in this book understood, and what most of the commercial and amateur photographers discussed here grasped as well. Photographs may record what is in front of the camera, but they are not neutral documents. They represent particular points of view, participate in arguments, serve political points of view. One embraces them as cold, neutral facts only with some peril. Most of the photographs in this book were meant not simply to record but to persuade.

By the 1930s photography had become a ubiquitous part of Arizona life. One can categorize the photographs with any number of terms: studio photography, commercial photography, advertising photography; photography for the purposes of tourism, development, or official record keeping; photographs made to record family gatherings, municipal events, or federal

projects. But the pictures fall into two main camps—the private and the public, those made for the subjects of the pictures themselves, and those made for more distant viewers. In old mining towns and burgeoning cities, in Indian communities and Hispanic barrios, on remote ranches and in urban schools, snapshot cameras recorded the events of daily life. Weddings and birthday parties, holiday celebrations and family gatherings—countless photographs of these events remain stashed away in family albums and scattered in homes and local archives across the state. These private pictures served as mementos for the subjects or perhaps for the photographers, and with the passage of time, they become harder and harder to read. Who is that person standing on the left? What was Grandpa doing in Bisbee, anyway? Pictures that reaffirmed experiences still fresh in memory, and whose meanings once seemed so evident, become puzzles and mysteries not easily decoded. We know both more and less than the original viewers of the pictures: with historical hindsight, we know what will unfold next, but we are hard-pressed to recover that sense of multiple possibilities the subject felt as he gazed into the camera. As Lydia Otero suggests here in an essay about the snapshots of her own family, the private dreams and desires embedded in personal photographs can be surprisingly hard to uncover. We tend to imagine that vernacular photography—simply because there is so much of it—must serve as a straightforward record of the past. But the capacity of photographs to project imagined and desired selves—to conceal hardships behind a smile, poverty behind a borrowed dress—makes their value as a historical record deeply problematic.

The public photographs that lie at the core of this book likewise prove problematic as historical documents. They were not made for the subjects themselves or to serve as aide-mémoire for the photographer. They were, instead, made by photographers working for particular commercial firms or government agencies who sought to make pictures that their clients could use. Their pictures would be seen by people who would never visit Arizona for themselves; they would be published in government pamphlets and magazines, issued as commercial prints for sale to tourists or would-be investors, used to enlist the sympathy of viewers and win support for various federal relief programs. If private photographs generally depicted what the subjects sought to project, these public photographs conveyed what the photographers sought to show. And so, as Brian Cannon suggests, the photographs that Dorothea Lange and Russell Lee made at Casa Grande Valley Farms, the government cooperative established for low-income agricultural workers, reflected the photographers' own optimism about collective farming rather than the far more mixed experiences of the laborers themselves. Likewise, as Kirsten Jensen argues, Lange's and Lee's photographs of rural Arizona women not only drew upon familiar myths and ideals to underscore

the effectiveness of the government's various relief programs, they also reflected the photographers' own ideas about women's roles in society and the sort of social world they hoped would emerge from the Great Depression. The idealized Hispanic women represented in Lee's photographic tributes to rural life bear little resemblance to the self-confident young urban women pictured in the snapshots that Lydia Otero analyzes. Which pictures most accurately reflect the lives of the Hispanic women of Arizona during the 1930s? Whose vision are we to trust, the outsider's or the insider's? Public and private images often present different and conflicting versions of the same story.

Only rarely do we get enough evidence to compare the two. As Katherine Morrissey persuasively argues, the commercial photographs of Coolidge Dam that circulated in the 1930s convey complex stories about the beneficence of federal water projects, while a scattering of amateur views of the dam testify to its touristic allure. One wonders whether there exists a photographic record that documents the experience of the dam builders or the disappointments of the farmers who failed to benefit from the project as they had hoped. One wonders, too, how the snapshots made in Indian communities during the 1930s contrast with the pictures made by the professionals that Margaret Regan discusses here, or those published in *Arizona Highways*. I'd hazard to speculate that what seemed of interest and importance to those farmers or those Navajo or Hopi families was not necessarily what seemed of interest to the outside photographers who were making pictures for a more-distant audience. But I'd likewise guess that when it came to tourism, public and private photographs more closely converged. The Kolb brothers that Evelyn Cooper writes about here so dominated the market for Grand Canyon views that they effectively invented the sites and points of view tourists wanted to photograph for themselves.

In recent years, the Farm Security Administration's photographs of 1930s America have become the basis of any number of books purporting to offer a glimpse of particular places during that troubled Depression-burdened decade. This book on Arizona, however, is distinctive in several regards. First, because it looks beyond the photographs produced by the FSA photographers to consider the other sorts of images generated during the decade, and second, because it queries, in a critical manner, the very value of these images as historical documents. This book is not a history of Arizona illustrated with old photographs. It is, instead, a history of Arizona written from these photographs. And the two are quite different things. The assumption behind an illustrated history is that photographs generally offer visual affirmation of a point already made in the text. But in a book such as this, the authors start with the assumption that photographs may not affirm what

we know from the written record; indeed, they may offer a different point of view entirely. To write a history from pictures, one must note and account for the points of dissonance from the written record as well as from memory; one must ask whose point of view the pictures record, how they were used, why they were made. It is a challenging sort of history to write. And as Betsy Fahlman suggests here in her overview of 1930s Arizona imagery, one must also consider the ways in which photographers drew upon stylistic conventions to convey ideas, manipulated strategies developed by other sorts of artists, and responded to the cultural tastes of the moment.

Any photographically based history project like this one raises two large questions. First, does it lead to good history? The breadth and depth of any state history written primarily from photographic sources is dependent, of course, on the body of photographs one has to work with. In this case, the writers have written a wonderful history, but it bears noting that it is a selective one. Some groups, and some kinds of photographs, are simply not well represented in the body of material they had at their disposal. The urban populations of Tucson and Phoenix, for example, are not covered here in proportion to their representation in the state's population, a reflection of their relative underrepresentation in the photographs assembled by various New Deal agencies. Likewise, little attention is here paid to social and economic rhythms of small-town life because the authors drew on only a portion of the commercial and personal pictures that document the dreams and aspirations of local businessmen and residents. The second question raised by a photographically based history such as this one is whether it conveys a story unique to Arizona. That is, do the available 1930s Arizona photographs tell a story that is specific to that particular geographical and political space? Here, I think, the answer is a resounding yes. The focus on water and dams, on the saguaro cacti of the Sonoran Desert, on the dramatic topography of the Grand Canyon, together reveals a collective fascination with the distinctive physical landscape of the space. The photographs of archaeological sites, of the Navajo and Hopi communities, hint at a history of human habitation unique to Arizona. The photographs of rural women and children, and the snapshots of urban dwellers, might in some general ways resemble those made in other parts of the Southwest. But they nonetheless hint at the longstanding presence of Hispanic peoples in the region and a history of Anglo Hispanic relations that is particular to this specific physical, cultural, and economic climate. The photographs of 1930s Arizona might capture a brief moment in the state's history, but they contain whispers and traces of more distant pasts; they are ineluctably rooted in this particular place.

As the authors of this book so persuasively show, photographs can conceal as much as they reveal. They reflect the aesthetic whims of photographers,

the needs of patrons, the desires of subjects. They argue for imagined futures, document regretted pasts. For all they show us, there is so much that remains hidden. I am haunted by the final image that Lydia Otero discusses in her essay here, the image of a young Mexican American girl photographed in front of a backdrop that conceals the outhouse behind her. It is a deeply moving image for all it suggests about the efforts of the girl and her family to conceal the evidence of their own economic circumstances. But it serves as a perfect metaphor, too, for all the images in this book. No single photograph can reveal the true depth of human experience or convey the rich complexities of any particular moment in time. Stories always remain hidden, concealed behind the drop cloth. But when viewers begin to ask about what they cannot see, as all the writers have done in this book, the pictures resonate more loudly than ever before, staking their own turf in a world filled with competing voices and memories.

Picturing Arizona
The Photographic Record of the 1930s

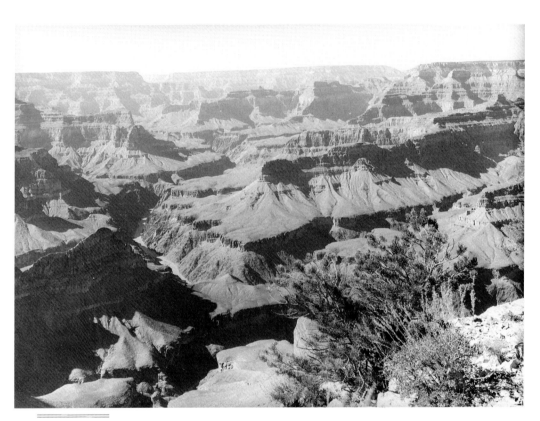

"Grand Canyon
of the Colorado
River." Russell Lee,
October 1940.

BETSY FAHLMAN

Constructing an Image of the Depression

AESTHETIC VISIONS AND NEW DEAL PHOTOGRAPHY IN ARIZONA

Since the nineteenth century, photographers have traveled through Arizona. Those who first came with the government-sponsored surveys were dazzled by the state's geographically impressive landscape, notably the Grand Canyon and Canyon de Chelly. Although they could not equal the rich color and immense scale of landscape artist Thomas Moran's magisterial renditions, grounded in the conventions of Manifest Destiny, the cameramen (women artists did not claim this subject until the twentieth century) shared many aesthetic and thematic concerns with their painterly colleagues. Other photographers favored a focus that was more anthropological and ethnographic, recording Native American communities, especially those of the Hopi and Navajo. The work of Edward S. Curtis exemplifies this impressive, if romantic and culturally biased, record of the state's indigenous peoples. Many of the images produced during this period—a large number the result of team-based, federally connected initiatives—are illustrated in the standard photographic histories and are benchmarks in the development of the medium. They helped define the state's national image to those unable to travel to the far West.[1]

The thematic and aesthetic parameters established by these earlier

photographers remain deeply ingrained in the work of twentieth-century practitioners. Not until the Depression, a decade and a half after statehood, did photographers begin to record a different view of Arizona.[2] Conditions in the Southwest during the thirties were challenging, and Arizona was a place between places people would rather have been. The temperate climate of Los Angeles and the glitter of California's movie glamour were more alluring daydreams for cross-country migrants, though the possibilities for agricultural work in that state's fertile valleys often proved to be false promises in the face of overwhelming economic need. Although both achieved statehood in the same year, New Mexico's intertwined Native American and Spanish Colonial histories were deeply rooted, reinforced by the elitist culture of well-established art and literary colonies in Santa Fe and Taos, which created an entirely different cultural-socioeconomic mix than Arizona.

A harsh and unforgiving desert climate—the state was described by one artist in 1923 as being "all cactus, rattlesnakes, and bad men"[3]—did not encourage lingering. During the Depression, the rickety vehicles of the dusted-out Okies, Arkies, and Texies fleeing the Dust Bowl to what they hoped would be better economic conditions in California, broke down in Arizona, as seen in this 1937 photograph by Dorothea Lange. Their own dislocation paralleled another, as Lange noted in the label she wrote accompanying a

"Family of nine from Fort Smith, Arkansas, trying to repair their car on road between Phoenix and Yuma. On their way to try to find work in the California harvests." Dorothea Lange, May 1937.

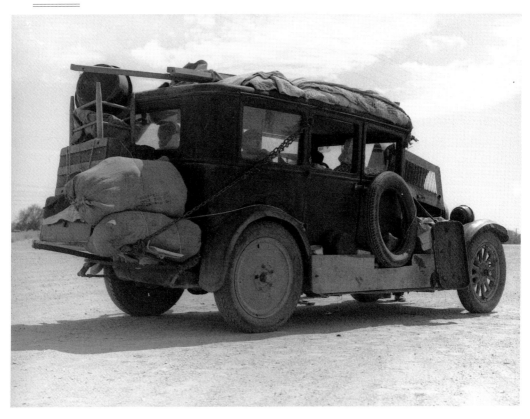

second picture taken that same year, this one in Chandler: "Drought families are now mingling with and supplanting Mexican laborers in the Southwest." Their goal, in a massive westward migration impelled by economic crisis, was succinctly articulated by Tom Joad in John Steinbeck's 1939 novel, *The Grapes of Wrath,* when he responded to a New Mexico border guard's query, "How long do you plan to be in Arizona?" with "No longer'n we can get acrost her."[4] The Joads and their real-life counterparts motored across Route 66 as quickly as they could.

The experiences of these laborers and migrants, and the landscapes through which they passed, formed the centerpiece of the most familiar 1930s government-sponsored photographic work in Arizona. The view of Arizona created by Dorothea Lange, Russell Lee, and Ansel Adams, although shaped in part by that sponsorship, reflected other influences as well—their artistic visions, the nineteenth-century aesthetic tradition, the photographic media, and the cultural contexts of their work. To highlight these other influences, this essay examines their photography in dialogue with the artistic work of other government-sponsored artists in 1930s Arizona—muralists, painters, and sculptors.

Lange, Lee, and Adams came to Arizona employed by four agencies— the Farm Security Administration (1937–42), the Office of War Information (1942–43), the Bureau of Agricultural Economics, and the Department of the Interior. Between 1936 and 1943, assignments enabled these photographers to travel throughout the state (where there were roads), and their trips resulted in several thousand images. Each had substantial art training before entering government service and pursued notable post–New Deal careers as artists.[5] Although their official mandate was to provide documentation of federally sponsored programs, rather than to create works of fine art, the fact that these photographers were skilled artists makes their images resonant beyond mere snapshots of record.

Though the photographers could scarcely avoid the occasional scenic vista as they traveled throughout the state, agency agendas meant that the government-sponsored images constituted a document deeply grounded in the concerns and daily lives of those they recorded, most of whom lived outside urban areas. These artists explored a rich range of the state's residents (migrant and permanent, White, Mormon, Hispanic, Black, and Native American), their professions (mining, agriculture, railroads), and the landscape in which they lived, during a period of considerable economic, political, and social upheaval and transition. Historically, this era of Arizona's history has received comparatively little scholarly attention, in part because it falls between the more "romantic" pre-statehood period of the pioneer and the cowboy and the explosive expansion that followed World War II, through the efforts of developers like Del Webb.[6]

The images that survive from this era have considerable contemporary resonance for many of the issues raised by the subjects recorded by New Deal photographers—irrigation and water usage in a dry state, migrant and immigrant labor, the environmental impact of the economically volatile mining industry—and remain a significant part of the state's cultural fabric. As aggressive development erases the tangible artifacts of Arizona's historical identity, these images sharpen our appreciation of the ongoing dialogue between past and present. Arizona was the last territory in the continental United States to achieve statehood, and its Anglo history is young. Because many current residents were not born here, the state has been slow to come to grips with much of its heritage, preferring hoary old Western stereotypes of the noble cowboys, bad Indians, and lazy Mexicans of a mythologized Arizona, at odds with the economically leveled and diversely textured view offered by the Depression-era photographers.

The FSA/OWI Photographs

The thousands of government-sponsored photographs taken under the New Deal comprise an extraordinary visual record of America during a critical period of its history. Best known are those made for Roy Stryker's photographic section of the Resettlement Administration and Farm Security Administration and the agency into which the section was transferred in 1942, the Office of War Information. Photographers were sent to each of the states, as well as to Puerto Rico and the U.S. Virgin Islands, and the resulting images exemplify the competing agendas of the agencies that funded them. The impetus for the pictures they shot was federal directives: as official portrayals, they are simultaneously historical documents of record and consciously constructed images of propaganda. Although revisionist history has taught us to be rightly suspicious of words like "document" and "truth" in analyzing the official conveyances of visual culture, these photographs remain rich historical texts.

The photographer's purpose, delineated by agency mandates, was to produce prints of historical record that could be used either to answer questions concerning government programs or to justify their existence. Although incomplete, the body of work these artists produced conveys a strong sense of region by specific imagery, yet one that is grounded in a national aesthetic and political agenda. Roy Stryker encouraged the photographers working for him to record distinctive regional features so that a collective portrait of America could be created. Accordingly, Lee took pictures of Frank Lloyd Wright's recently established winter headquarters at Taliesin West, a site having nothing to do with the FSA's mission, while also photographing the agency's central Arizona migrant camps.

For reasons of economy and efficiency, and to ensure the broadest

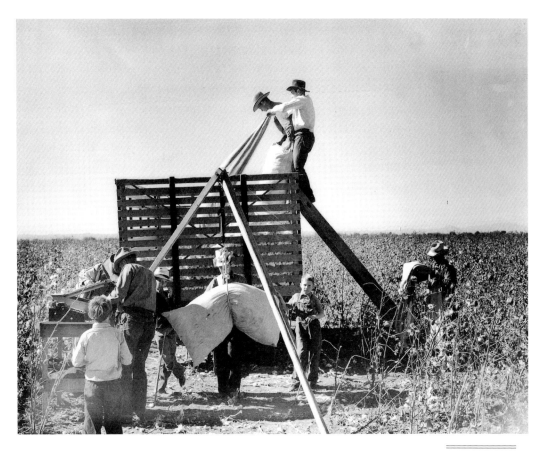

"These families are picking their own cotton. Mainly they are members of the Casa Grande cooperative farm." Near Coolidge. Dorothea Lange, November 1940.

possible coverage, the photographers were assigned to different sites throughout the state (there is some overlap), though each might be asked to record similar subjects when sent to work in other states. Other agencies—the Bureau of Reclamation, the Bureau of Indian Affairs, and the War Relocation Authority, for example—also sent their documentarians to the same sites for their own agendas.[7] The photographers, none of whom were native to Arizona, tried to be as well prepared as possible, despite considerable geographical distance from their assignments. Equipped with shooting scripts, itineraries, and other information, they often were accompanied by local agency representatives. The readings they had done ahead of time reinforced the narrative sensibility that informs their photo essays, which were accompanied by captions written by the artists (or in Lee's case, by his wife, Jean, a journalist).

The images created for the FSA were disseminated through a variety of official (government reports) and unofficial (newspapers, magazines, books) publications. The sponsoring agency was not always identified, nor were the artists, but the photographs were widely distributed. Officials could not predict which ones might be requested, but topical and geographical coverage was broad, and they hoped to be able to respond to the needs of those seeking visual material from the agency.

When some one hundred thousand FSA/OWI photographs were transferred to the Library of Congress in 1946, they were organized according to a lexicon of key words and categories that reflected the many uses Stryker anticipated. Not every state was represented in each category, and images of the same subject appeared in multiple sections. The topics illustrated were comprehensive. Collectively, the taxonomy of broad categories sets out a typology of daily life in the thirties, and the hundreds of subsections enabled a search for visual information by virtually any topic from locomotives to lettuce, health care to mining. Anything adults and children did involving work, play, or everyday activities was recorded. That government programs were positively and deeply intertwined in the lives of ordinary citizens was an important subtext.

The Arizona landscape was given broad coverage in the FSA/OWI file. Dry vistas of sagebrush, mountains, and clouds were common subjects. Also prominent were agricultural enterprises made possible by irrigation, as seen in a photograph by Lange of a cotton field south of Phoenix. Government cooperative farming ventures were extensively covered, with livestock and crops prominent subjects. Sufficient agricultural products were perceived as key to surviving the Depression. But this category embraced also archaeological ruins, forests, rivers, desert, foothills, grazing land, farms, and ranches. Distinctive rock formations and plants were recorded, as were buildings and structures—barns, schools, houses, apartments, tents, shacks, and tourist courts; these were documented inside and out. Highways, roads, streets, automobiles, and railroads suggested transportation. Pictures were made of cities and towns (deserted and populated) as well as of cemeteries. As the photographers tended to stick to the most traveled roads—Arizona was largely unpaved in that period—there are no images of Jerome or Prescott, and Flagstaff is only a stop along the train tracks. Few images appear of Phoenix and Tucson, mainly due to the agency's mission to focus on rural agriculture, rather than on urban areas. Lee did a photo essay on the Phoenix Union High School, and the only Tucson image is one by Lange of the Labor Temple, shot in May 1937. Other broad subject areas in the FSA/OWI file include mining, medical care, food preparation, housework, and gardens.

Photographers recorded conditions in need of help, as well as those "clients" whose circumstances had been stabilized or improved with New Deal assistance. Adults and children in groups and alone were photographed participating in a wide variety of work and leisure activities. Migratory workers were a specific category, as were members of various ethnic groups (particularly Spanish Americans and Mexicans). Radical political agendas were not part of the photographers' scripted assignments (of course, critics of New Deal programs regarded Roosevelt's overall initiatives as radical). Social tensions might be alluded to by the presence of guards at mining

sites, but generally, the images celebrated American values of community and cooperation. Those pictured are shown playing baseball, horseshoes, basketball, and volleyball during leisure time and helping their neighbors. The tone projected is hopeful and affirmative. Individuals also performed according to traditional gendered roles, with comfortable images of a social order maintained despite a nation's distress on other fronts. There is a clear emphasis on the family unit as fundamental to America's national harmony. Racial divisions were also maintained. Camps were segregated, and African Americans were paid lower wages for their labor than their White counterparts.[8] Governmental euphemism abounded, with metal shelters and tar-paper shacks referred to in captions as "apartments" and tent residences identified as being part of "mobile camps."

By interpreting these photographs within the context of the ideas and events that generated them, they emerge as resonant cultural artifacts. In microcosm, they are significant exemplars of the governmental perspective of this Western state, and can be read from several angles. For instance, they reflect the agendas set by Washington bureaucrats regarding the official image they desired of conditions in Arizona.[9] The needs of the West, vast and distant from the eastern urban centers of political power, were necessarily more difficult for officials to apprehend.

"Irrigated field of cotton seventy miles from Phoenix." Dorothea Lange, May 1937.

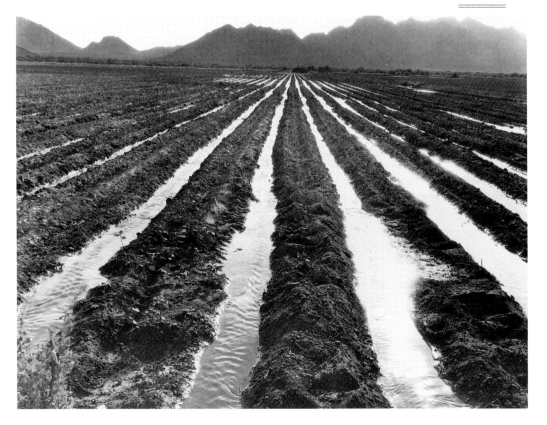

Photographers and Artists in Arizona

Faced with such a plenitude of visual material, historians have often found it easy to ignore the intentionality of the artists who produced the images that constitute this immense archive; photo-historians generally fail to discuss the interrelationships among the photographers and the other visual artists, whose agendas were mutually reinforcing. Thematic album presentations—the typical publication format for the easily accessible FSA/OWI imagery—have also served to submerge the individual accomplishments of the specific photographers. By foregrounding the artists and the photographs they made, their role as participants in a broad governmental effort of cultural production, as opposed to being treated as mere visual adjuncts to historical analysis, may be better understood. Taking an intermedia, interdisciplinary and interagency approach to the study of New Deal photography in Arizona—this state makes an excellent case study—and considering the larger art-historical and cultural context in which these images were made permits a far richer interpretation of this work. The government lens negotiated the perspective of works produced in all media.

The New Deal photographers who came to Arizona are among America's most noted, and their Arizona work is thematically and aesthetically emblematic of their entire oeuvre and chronologically spans the full period of New Deal patronage nationwide. Ordinary people and their lives fascinated the photographers, particularly Dorothea Lange and Russell Lee. Many of the scenes they chose to record still form part of the visual character of the state. Wickiups, hogans, adobe houses, and dude ranches remain strongly identified among the state's residential parameters and as accommodation for visitors. A marriage mill in Salome (Arizona did not have California's waiting period) is as vital a part of the state's social history as are the more conservative and tightly knit Mormon and Spanish American communities. The smelters and open pit mining operations of the Phelps Dodge Corporation have contributed indelibly to the image of the "Copper State." Agriculture is still defined by crops of chili peppers, oranges, lettuce, and cotton, although the historic five Cs of Arizona's economic identity—cotton, citrus, copper, climate, and cattle—face devastating challenges from development.

The photographers participated in a broad program of governmental cultural support. President Franklin Delano Roosevelt's bold relief programs, collectively known as the New Deal, included several that specifically benefited the visual arts. The Public Works of Art Project (PWAP, 1933–34) was a forerunner of the Works Progress Administration (renamed the Work Projects Administration in 1939). The WPA served as an umbrella agency, under which the bureaucracies of several programs were based, including the Federal Art Project (FAP, 1935–43). The Treasury Department's Section

of Painting and Sculpture (known as the Section of Fine Arts, or The
Section, 1934–43) and the Treasury Relief Art Project (TRAP, 1935–38) pro-
vided support for the decoration of federal buildings. As artists, the photog-
raphers paralleled and supported work produced for these other agencies
more specifically focused on the arts. When Russell Lee visited Safford, for
example, he documented the work of folk sculptor Homer Tate, whose art
had been inspired by the WPA.[10]

These arts agencies funded several major Arizona programs, and also
supported smaller projects. In 1936, the Federal Art Project sent painter
Philip Curtis to Phoenix, where he supervised area artists painting govern-
ment murals and established the Phoenix Art Center, which funded a broad
range of art programs. Thomas Wardell, who took over the directorship of
the Arizona Federal Art Project after Curtis, continued the work, organiz-
ing art and craft classes and touring art exhibits throughout the state. Ross
Santee, a cowboy artist and illustrator, led the Arizona Federal Writers'
Project. Paralleling other states' efforts, Santee and his staff created *Arizona:
A State Guide,* a volume in the American Guide Series. Published in 1940, one
of its purposes was to spur tourism, a sharp contrast to FSA mandates for
relief programs. Yet photographs from the FSA files as well as those by local
Arizona photographers, such as the McCulloch Bros. Studio, found their

"WPA work as
visualized by
Homer Tate."
Safford.
Russell Lee,
May 1940.

way into the book's photo essays. And FAP-funded Arizona artists created posters to promote its sale.[11]

Arizona as emblematic of the stereotypical Old West was the image projected for tourists and marketed through dude ranches. It continues through events like the annual exhibition of Cowboy Artists of America (founded in 1965). Arizona cowboys were not represented by the FSA, but that classic Western figure does appear in the WPA guide to the state, which remains an important document of cultural identity. Archetypal Western imagery also dominated the Arizona murals.[12]

Federal arts funding for public murals was generally awarded to artists through regional and national competitions. As a result, such work often went to out-of-state artists, especially in states like Arizona, where the number of resident artists was small. Such embellishments of public buildings and spaces enjoyed great visibility. They provide a counterpoint to the work of the photographers. The Public Works of Art Project supported murals for the Arizona State University library by Joseph Morgan Henninger, in 1934. Henninger's murals, *Spanish Influence in Arizona* and *Industrial Development in Arizona,* especially in their subject matter, exemplified the approaches taken by other Arizona muralists.[13] Historical subjects and celebratory themes abounded. In 1940, Jay Datus executed eight historical murals for the Department of Library and Archives, for example, on the theme of the "Pageant of Arizona Progress." In their ability to simultaneously reference the past and the present, painters and sculptors were able to do something that photographers could not. Their portrayal of scenes inspired by the state's history not only celebrated progress, but also reinforced the positive role of government.

Painters could more readily respond to community concerns regarding suitable imagery. In 1939, Seymour Fogel won the 48 States Competition for a mural in Safford.[14] His elegantly abstracted competition sketch of Southwest Indian ceremonial dancers was not well received in the Mormon farming community, whose original pioneer settlers had a troubled history with the Apache, and therefore did not wish to highlight Native American culture. Fogel produced new designs celebrating the pioneer history of the Gila Valley.

Proposals to competitions varied, with some picturing specific events from Arizona's history, while others presented more generic Western imagery. Most celebrated rural agricultural values or pictured narrative historical scenes. Typically, the painters, working in a representational style, favored powerful Western archetypes, whereas the photographers were of necessity grounded in the contemporaneous, and conveyed a specificity of place. This difference explains why entries submitted for one site could often be executed with little alteration in another. In creating their images, painters could draw

on the deep resources of art-historical precedent. Although several of the photographers had training in the visual arts, except for rearranging a scene or using artificial lighting, their choices had more to do with making a decision not to record something, rather than altering what was in front of them. In their ability to reconstruct a picture of history, painters and writers did not have the same imaginative restraints imposed by the inherent nature of the medium of photography. Artists in other media could manipulate potent icons to convey state identity in a manner not readily available to documentary photographers, whose invention of meaning was achieved through a more limited repertoire of pictorial strategies. That the photographers primarily worked in black and white further narrowed the aesthetic means at their disposal.[15]

Though few of the photographers would have had contact with painters and sculptors, such a broad art-historical vantage provides the cultural context for the government-sponsored photographers who came to Arizona. Dorothea Lange, whose iconic *Migrant Mother* of 1936 is the most famous photographic image surviving from the Depression, made several trips to Arizona between 1935 and 1940. During each visit, she focused her attention on migratory agricultural laborers, a subject that had become her specialty, along with that of her second husband, economist Paul Schuster Taylor.[16] A childhood bout with polio had left her with a limp, and because she preferred to use a large-format camera, her working methods were of necessity deliberate. She had also learned to listen carefully to what her subjects had to say, a trait reinforced by Taylor's pioneering research techniques that stressed practical field study over abstract theoretical constructs. She may have produced far fewer Arizona images than Lee, but the strong compositional skills she had learned as a portrait photographer, as well as her eye for telling detail, gave Lange's work a focused power lacking in Lee's more scattered approach.

Between 1935 and 1938, she worked with the FSA to record migrant farmers throughout the Southwest, an assignment that brought her to the Phoenix and Tucson areas. Her first trip was sponsored by the FSA and resulted in relatively few images, but a second in 1940 was for the Bureau of Agricultural Economics, for whom she produced an extended series on seasonal cotton workers—many of whom were children—in Casa Grande and Eloy.

Sponsored by the FSA, Russell Lee produced the largest number of Arizona images, shot during three extended trips. Of all FSA artists, he worked the longest for the agency—from the time he was hired, in September 1936, until the agency disbanded, in 1942. At least one thousand of the some thirteen hundred FSA/OWI Arizona images are by Lee. He traveled widely throughout the state, recording agricultural industries, farm rehabilitation loan clients, cotton fields, and migrant workers. In April and May

"Tourist attraction
on the roadside.
Maricopa County."
Russell Lee,
April 1940.

1940, he covered the northeastern, central, and southeastern parts of the
state, with assignments taking him through Gila, Apache, Navajo, Greenlee,
Graham, Maricopa, Pinal, and Cochise counties. He recorded scenes in
Bisbee, Phoenix, Tempe, Tombstone, Wilcox, Morenci, Miami, Springerville,
and Coolidge. In October 1940, he made stops in Concho and the Grand
Canyon. He made his final trip in February and March 1942, working in
Yuma and at government-sponsored cooperative agricultural projects in
Maricopa and Pinal counties.

 In his series of photo essays, Lee created extended portraits of sev-
eral diverse communities. One was the Casa Grande Valley Farms, an
experimental agricultural collective venture set up by the Resettlement
Administration, the FSA's predecessor. Chandler Farms and Camelback
Farms were two others. Several of his series recorded migratory labor
camps (Agua Fria, Yuma, Eleven Mile Corner, and Friendly Corners), whose

unsettled populations constantly changed. The scale of such camps spoke
to the scale of the migration with which officials attempted to cope. A con-
trast to these planned agricultural community photographs may be seen
in his images of Concho, a town whose original Mormon settlers had been
supplanted by Hispanic sheepherders. For contrast, he recorded the last
Mormon family in residence. His Concho images convey a sense of commu-
nity lacking in the migratory camps, as well as an apparent prosperousness.
Isolation of necessity created self-sufficiency.

 The images made by New Deal photographers have telling compari-
sons and contrasts with the work of contemporary Arizona painters and
sculptors who, too, received federal support. The themes that painters Lew
Davis, Philip Curtis, and Lon Megargee, as well as sculptors Emry Kopta
and Raymond Phillips Sanderson explored parallel those recorded by the
photographers. In Bisbee, for example, Lee photographed the main features

"Miners monument in
Bisbee. This monument
is cast in cement, sprayed
with molten copper, and
mounted on a block of
Colorado granite used for
miners' drilling contests in
the nineties. The monument
was erected in 1935."
Russell Lee, May–June 1940.

"An open-pit copper
mine of the Phelps Dodge
mining corporation."
Morenci. Fritz Henle,
December 1942.

of that Phelps Dodge company town, along with The Miner's Monument, "dedicated to all miners who had worked in the mines in Bisbee." Sanderson's nine-foot-tall sculpture of cast concrete holds a hammer and chisel in his hands. Sprayed with molten copper, the statue, which celebrates the mining industry central to the state's history, had been funded by the Federal Emergency Relief Administration (FERA).[17] Mining was the transformative industry of the American West, and the subject had inspired painters during the thirties. In *Copper* (1935–36), California artist Philip Latimer Dike compresses open pit and underground mining operations into a powerful canvas.[18] Both are positive images, but the painting and the sculpture portray the meanings of mining to the state and its residents, whereas Lee was bound to the specifics of time and place. So too was German American artist Fritz Henle, who took photographs during December 1942 for the Office of War Information. He concentrated on Arizona's copper and tungsten mining and its meanings for a nation at war. Tungsten was essential in the production of steel alloys for the armoring of tanks and battleships. At Morenci, Henle recorded the massive Phelps Dodge extractive and processing operations. Their open pit mine challenges the scale of the surrounding landscape.

The FSA sent Lee and Lange to Arizona during the 1930s, but other agencies guided federal photographic work in the early 1940s. Between 1941 and 1942, Ansel Adams worked on a commission from the Department of the Interior to execute a series of photo murals for its Washington offices. His broad subject was America's national parks in the West, and in Arizona he made images of several well-known sites—the Grand Canyon, Canyon de Chelly, and Saguaro National Monument. He also turned his camera to other often-photographed subjects—Navajo mothers and children and the Hoover Dam. His Arizona work is strongly linked with nineteenth-century landscape traditions, as well as with twentieth-century environmental concerns. He conveyed both the grandeur of the landscape and the optimism of the New Deal. The commencement of World War II halted work on the project, and although he returned to many of these same subjects throughout his career, the murals were never realized as planned.[19]

Adams's work has intriguing connections to that of other contemporary photographers and artists who worked in Arizona during this period and pursued parallel themes.[20] Hoover Dam, for example, is featured in artistic works created by photographers, painters, and muralists. Photographer-painter Charles Sheeler pursued the subject of American industry when he came to the state on assignment for *Fortune* in 1939 (as part of their "Power" series), shooting a series of images of the Hoover Dam. Ben Glaha, who has interesting connections with the f.64 group, worked for the Bureau of Reclamation between 1931 and 1935 to record the

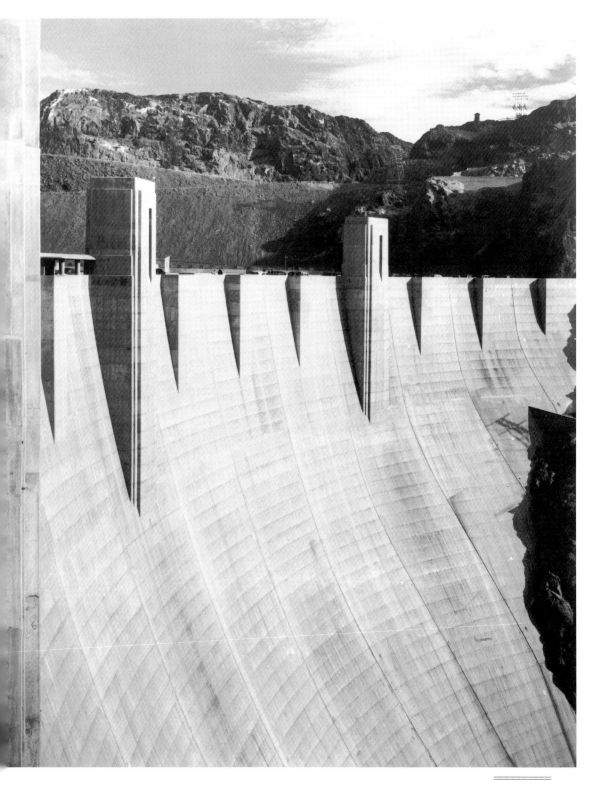

"Close-up of
section of the dam,
'Boulder Dam, 1942.'"
Ansel Adams.

dam's construction. *Construction of the Dam,* a mural by William Gropper and executed in 1939 for the Department of the Interior, also celebrated the creation process.[21] As portrayed by these artists, Hoover Dam was a great public work in the service of flood control and irrigation, signaling the commencement of a modern Arizona.

America's entry into World War II, in 1941, effectively ended the Depression and the relief programs the government had put in place to mitigate its effects. Although initiatives supporting the visual arts and other cultural programs were soon ended, the need for photographic documentation of federal activities remained. Lee returned to Arizona in February and March 1942, photographing a Defense Department training project near Yuma.[22] The Office of War Information opened in June 1942, and some of Stryker's photographers, including Lee, were transferred to this agency. The

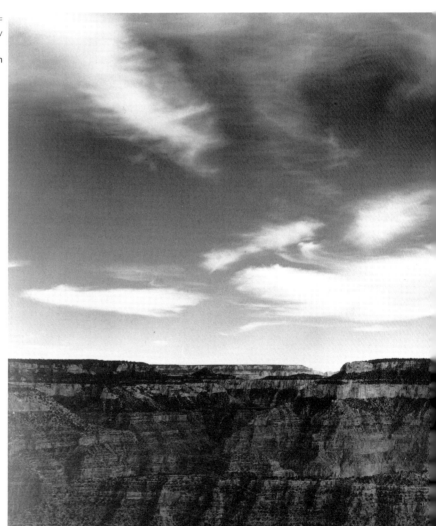

"Canyon edge, low horizon, clouded sky, Grand Canyon National Park, Arizona." Ansel Adams.

OWI sent several photographers to Arizona, and their focus exemplified a shift from images of agricultural agencies and the rural poor that were the specialty of the FSA to images related to mining and transportation—enterprises necessary to support the war effort.[23] The projected images became more affirmative and prosperous, as their purpose was more overtly propagandistic.

Depression-era photography, in conjunction with other government-sponsored artistic works, suggests the richness of material available for the explication of the New Deal in Arizona. Collectively, the photographers and artists created a document of historical record that continues to speak deeply to us today. Within the context of government-sponsored cultural production during the 1930s and early 1940s, Lange, Lee, and Adams presented their aesthetic visions of Arizona.

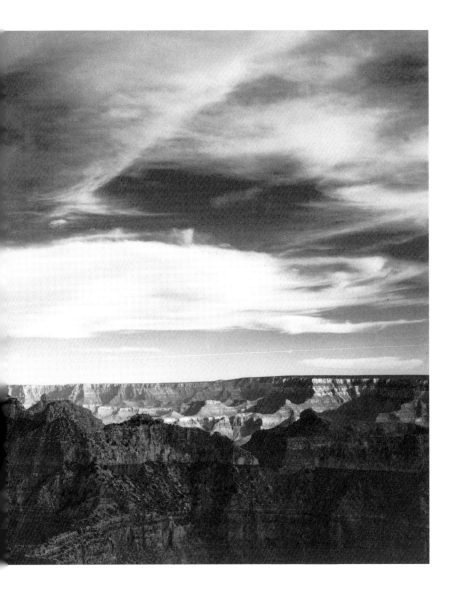

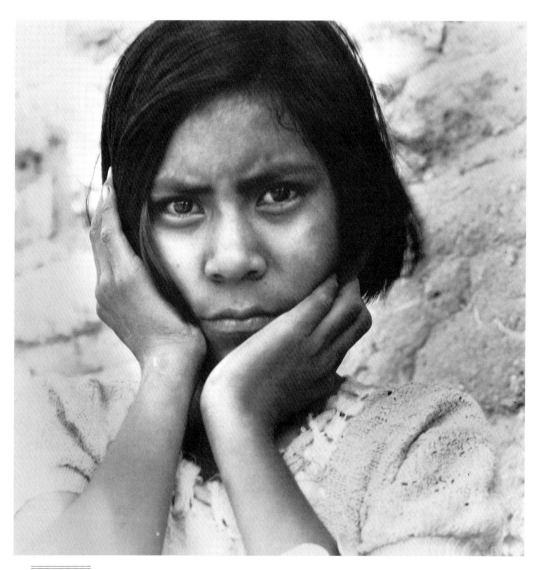

"Daughter of
Mexican field
laborer.
Near Chandler."
Dorothea Lange,
May 1937.

KATHERINE G. MORRISSEY

Migrant Labor Children in Depression-Era Arizona

Cradling her face, a young Mexican American girl stares steadily at the camera. This daughter of a field laborer in Chandler, Arizona, stands in front of an adobe wall and, with a furrowed brow, suggests the pain and suffering endured by the most vulnerable. Such children were often the subjects of the government-sponsored photographers who documented New Deal efforts during the Depression. In Arizona, they frequently turned their lenses on the children of migrant laborers. Their officially sponsored photographs helped to convey the need for federal government programs for migrant laborers, to document the impact of existing federal government programs, and to argue for maintaining funding for such programs. These complex political documents drew on shared social ideas for political ends.[1]

Images of children served as effective tools for conveying distress and eliciting sympathy. And, unlike their parents, the destitute boys and girls were not seen as responsible for their predicaments. As representations of innocence, spontaneity, hope, and the future, needy children presented the problems of the Depression in a palatable form. In the coded familial language evoked, the governmental response was clear—to parent and to provide guidance, funds, and support.[2]

"Children in cotton picker's camp." Eloy District, Pinal County. Dorothea Lange.

Several New Deal programs specifically targeted youth—the Civilian Conservation Corps established camps where young men, ages eighteen to twenty-five, worked on forest and conservation projects, whereas the National Youth Administration focused its programs on students, ages sixteen to twenty-five, helping them with part-time work and on-the-job training. Other agencies also addressed the concerns of children. The U.S. Children's Bureau, established in 1912, documented the Depression's impact on children, instituted the Child Health Recovery Program, and campaigned effectively for federal policies, including the Social Security Act and child labor reforms. In Arizona, state and federal relief programs, as well as the Resettlement Administration (later the Farm Security Administration) most directly addressed the needs of migrant labor children.[3]

This photo essay explores two sets of photographs, each of which used children to raise social and political arguments. They emerged from distinct government agencies at different moments—one during the early New Deal, the other near its close. Despite variations in their underlying messages, they agreed on the need for governmental intervention and shared social-reform agendas. The migrant labor children photographs clearly participated in political discussions of the decade and, as cultural documents, they also reveal societal ideals about the roles of children in the 1930s. As artistic works, they display the skills and perspectives of their creators. Less apparent are the perspectives of the children themselves. How did these girls

"Children at the FSA (Farm Security Administration) Camelback Farms inspect the photographer's camera, Phoenix, Arizona." Russell Lee.

and boys respond to their circumstances? To the photographers? To the relief programs? The photographs only offer partial answers.

Emergency Relief Administration Summer Camp Photographs

During the early New Deal, state agencies administered federal relief programs. In Arizona, Florence Warner, a University of Chicago–trained social worker, served as the executive secretary of the State Board of Public Welfare and the federal administrator of the Federal Emergency Relief Administration (FERA). Along with work programs, transient camps, and other relief operations, she helped establish a summer camp program for children staying at government migrant camps in Arizona. The program, which lasted only one year (1934), set up fourteen summer camps in mountain regions of Arizona, and brought 3,452 children to camp for two-week sessions.[4]

The camps, and the photographs of them, reflected Warner's social work perspective about the roles and needs of children. As the clearly staged photographs suggest, the camps had a didactic purpose. Modeled after those run by Boy Scout and Campfire Girls organizations, the overnight camps celebrated nature as an antidote to the societal ills and emphasized manual skills. The

"Drought refugee families are now mingling with and supplanting Mexican field laborers in the Southwest." Near Chandler. Dorothea Lange.

accompanying explanation of the camps' structured nature concluded that "through the wise supervision of the camp directors a notable percentage of maladjusted children were guided into the paths of happy living. . . . Timid little girls and stubborn little boys learned to work and play harmoniously."[5]

These photographs, taken by an unidentified photographer(s), were used by the Arizona ERA in its report on the summer camp program. The report carefully recorded effective uses of the resources of other government programs to cope with the ill fed and ill clothed. Undernourished children were sent to special health camps, where they received medical attention. Although not all the camps provided the children with clothing and shoes, many did. Camps located in Maricopa, Yuma, and Yavapai counties, for example, distributed 3,234 garments that had been sewn in the Relief sewing rooms, another government program that paid Arizona women for their work. "The girls' sun suits were attractive pastel shades that could not help but be dear to the hearts of little color-starved girls," opined the ERA publicity in exuberant prose. "Soft greens and delicate orchids were strikingly limned against the deep green of the pines as the children worked or played in camp and the surrounding forest."[6]

Doing their share of work, these campers peeled potatoes for KP duty. They also stood for inspections and participated in a range of supervised camp activities and sports.

This outdoor nature study group poses for the camera. The tie-dyed halter top worn by the girl on the right was likely made at camp.

As the language of the Arizona ERA report suggests, the camps fostered Anglo middle-class values for achieving success, and modeled productive work—"Busy boys and girls are happy boys and girls"—class-laden leisure activities, domestic gentility, and gendered behavior. They followed the accepted precepts of social reformers: wholesome, controlled environments would help reshape the children. "Teaching children to use their leisure time," for example, "was the object of the hobby groups." One girls' hobby activity, tie-dying scarves, produced pragmatic as well as symbolic results; "These rainbow-colored squares were used in their dances and made a notable addition to their suits. At night as the girls sat or danced around the fires, these scarfs [*sic*] and suits lent a brightness of color that carried with it all the romance of a Gypsy camp." Tapping into "the romance of a Gypsy camp," "the pulsating heart of peasant folk," camp leaders clearly had class ideals in mind when they devised music classes "to increase an interest in and create a taste for the higher types of music." "Music knows no geographical boundaries but is carried from sea to sea as gently as the soft summer zephyrs blow. The dominant purpose of the music group was to create this appreciation of beauty, harmony and melody which helps to make life itself a song." While nature study, music, archery, and tie-dying constituted girls' feminine camp activities, boys engaged in supervised boxing matches, carved wood, and played baseball. Gendered chores also followed typical social norms: "The

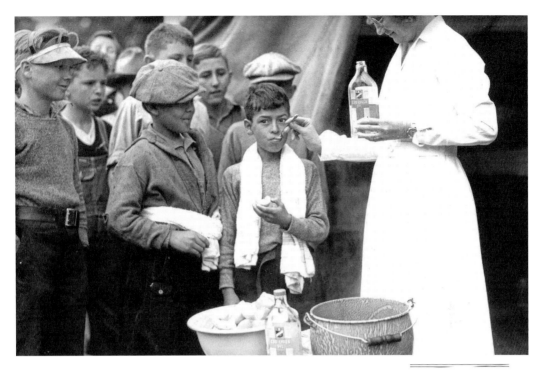

A dose of cod liver oil was the standard treatment for malnourished children. Boys' camp.

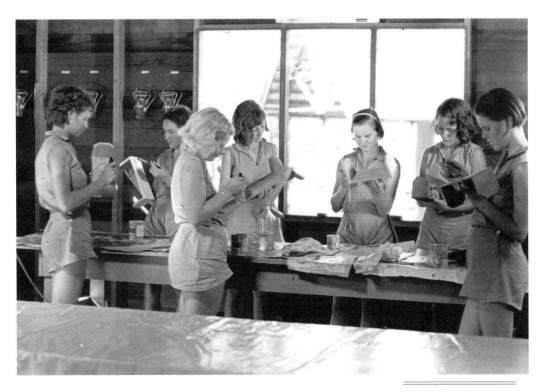

Dressed in their uniform sun suits, these girl campers are shown intensely focused on their handicrafts.

Singing class.

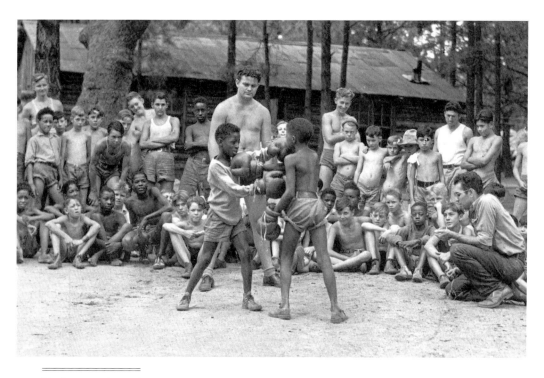

The integrated crowd
following this boxing match,
one of the boys' camp activities,
reflects the ethnic and racial
diversity among the campers.

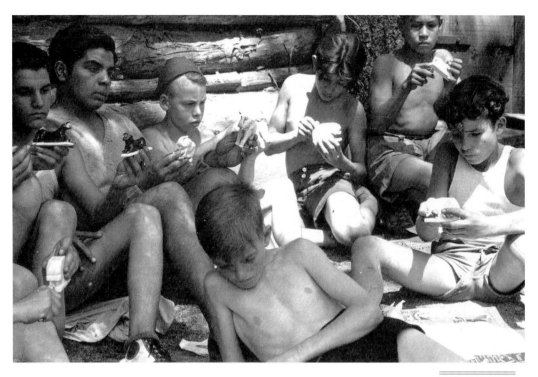

Boys of different ages and ethnicities keep their eyes on their carvings in this staged shot.

correct setting of tables . . . and the serving of food was part of the duties of the girls, duties from which they gained an experience which will carry over in their homes and later lives." The varied expressions, stances, and engagements on display in these posed images suggest that these gendered activities may or may not have dovetailed with the children's own interests.[7]

Run by social workers often trained in child development, camps were devised as places where children could develop good habits and character, as well as become "socialized" in specific ways. As part of the program's "civilizing" mission, the orderly camps kept to a strict schedule and emphasized routine. Strikingly, the children were mixed by race and segregated by gender, especially since the camp supervisors considered the inclusion of African American children to be "an additional problem": "This difficulty was encountered and solved last summer in the government camps. The colored boys and girls found a nitch [sic] in the camp scheme and became part and parcel of camp life, doing their share of work and receiving their share of joy." In sometimes myopic ways, the camp directors worked simultaneously to highlight and erase racial, ethnic, and class differences. Consider, for example, the discussion of camp benefits that singled out and conflated "American children, who are Spanish descendants, and the children from the Mexican immigrants." As these children's "social attitudes changed," reported the directors, in praise of the Americanization process, "they learned more of American ways; they materially increased their English vocabularies, and they became and felt a part of the life around them."[8]

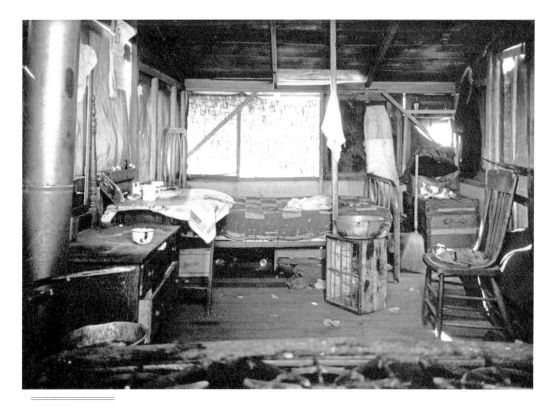

Entitled "Home of Child Attending Camp," this photograph was one of several similar non-camp photos included in the ERA report on the Arizona Children's Health Camps. The camps were presented as a corrective to these materially handicapped children.

Together the photographs and text told a transformation narrative, one in which not only the children's health was improved. Changed attitudes could also be found among other family members: "The parents now feel that the government has a heart. . . . Many of these same people, prior to last summer's encampments, felt a resentment against the world in general and the relief agencies in particular; they were surly and quarrelsome. . . . Now they are more tractable. Optimism and cooperation in many cases have replaced sullen resentment; pessimism has been slowly but surely stilled by hope; and hatred by a feeling of gratitude." The benefits of learning "to work and play harmoniously" extended to the nation's citizens, averting potential unrest. As U.S. Children's Bureau Chief Katharine Lenroot articulated the perceived threat in a 1939 speech to the American Association of University Women, "Democratic philosophy will give way, in time, to other philosophies if means for maintaining standards of living furnish too meager a basis for individual satisfaction or personality growth."[9]

Dorothea Lange: "Children in a Democracy" Photographs

Photographer Dorothea Lange also focused on Arizona children. A series of her photographs, taken in central Arizona in 1940, are now housed as part of the Bureau of Agricultural Economics Community Study, Arizona. Like her earlier photographic work for the Farm Security Administration, the Arizona series presents a sympathetic portrayal of migrant families.[10]

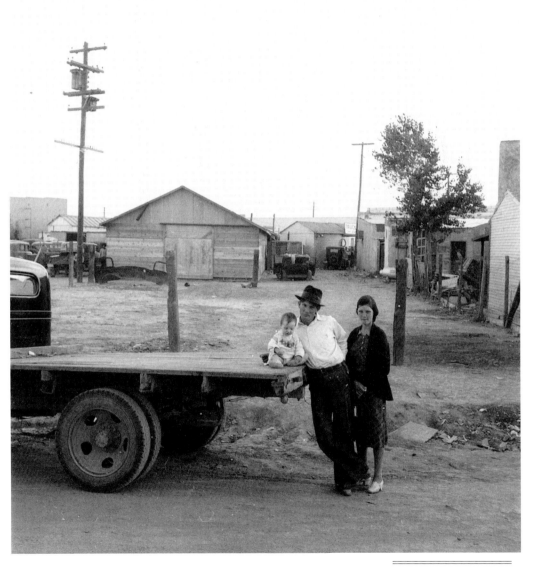

"Young American family—
migratory cotton pickers,
in town on Saturday." Eloy
District, Pinal County.
Dorothea Lange.

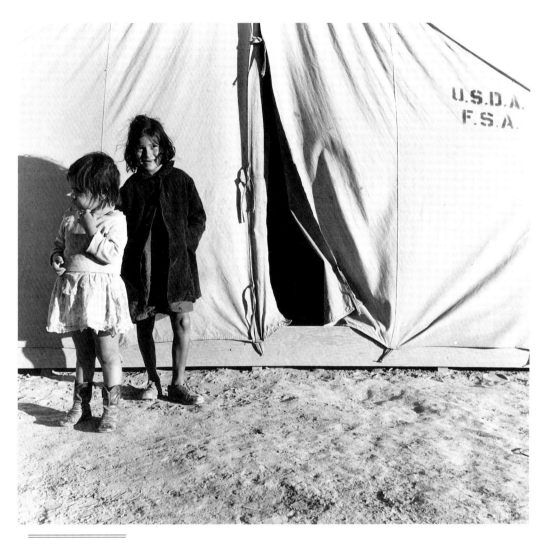

"7:30 a.m. Migratory cotton picker's children come out of the tent into the morning sunshine. Photograph was made in the FSA mobile unit recently established to serve the migratory families employed in this district." Eloy District, Pinal County. Dorothea Lange.

Labeled "Children in a Democracy," Lange's images included children of migrant laborers who were living in federal government–sponsored camps, alongside photographs of children who were not living in such camps. The implied political message linked economic well-being with democratic citizenship. Her photographs draw the viewers' attention to the expressions, gestures, and postures of the children as a means to convey her message.

As the title of the series suggests, Lange's work was also part of a broader political conversation. A White House conference on Children in a Democracy had convened in January 1940. Eleanor Roosevelt, addressing the assembled experts and politicians on the topic "Children of the Future," made explicit the connections that Lange sought to make pictorially. "You may think that it does not matter what happened to the migratory laborers in the Southwest and on the West Coast, but it does," the First Lady explained. "It matters a great deal. Those children who cannot get schooling, who grow up in unhealthy conditions—they are going to be citizens some day, and how do you suppose they are going to become intelligent citizens of a democracy?"[11]

"Children in a democracy. On Arizona Highway 87, south of Chandler," Maricopa County. Dorothea Lange.

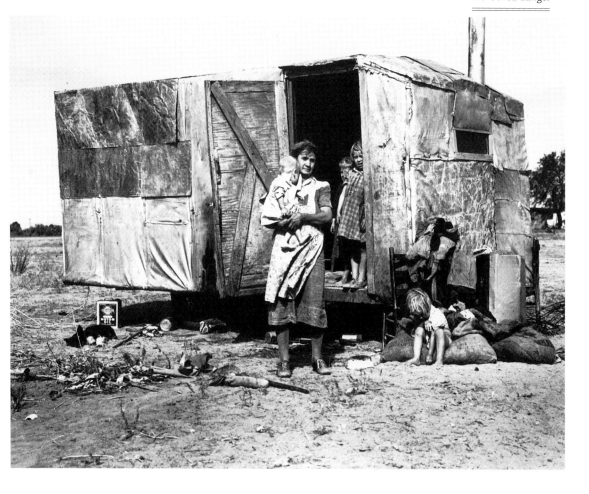

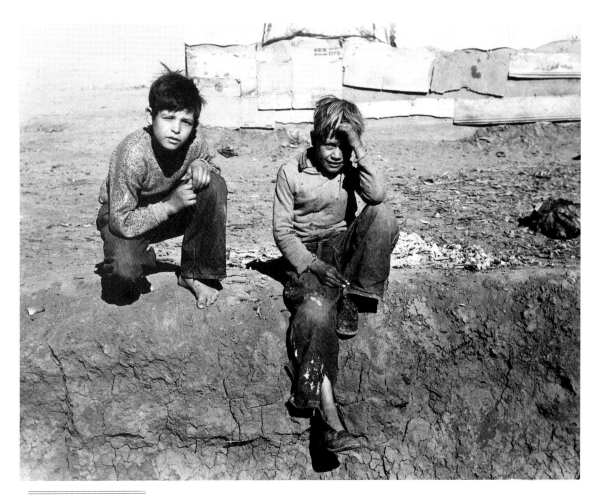

"Cotton pickers, Mexican children, in ditch bank at edge of grower's camp. Boy at left picked fifty pounds of short-staple on preceding day. Boy at right picked twenty-five pounds of Pima, long-staple. He is ten years old and when last attended school was in grade 1-A." Eloy District, Pinal County. Dorothea Lange.

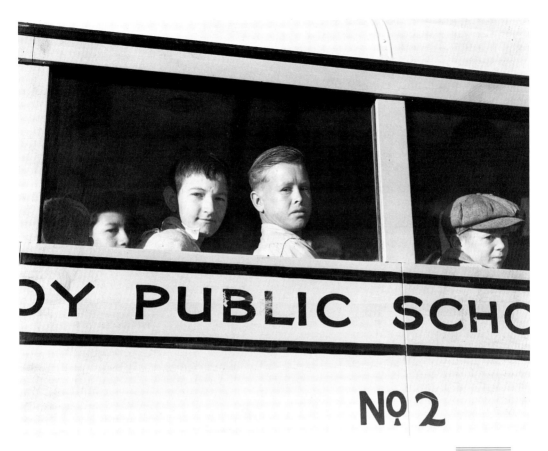

Her words reverberated throughout the political arena, especially within the context of the European conflict. In his radio address to the conference, President Franklin Roosevelt explained, "A succession of world events has shown us that our democracy must be strengthened at every point of strain or weakness." And Congresswoman Caroline O'Day, addressing the House Committee to Investigate the Interstate Migration of Destitute Citizens, noted that same year that "children suffered first and most deeply from the appalling conditions we have heard described as common to migrant agricultural labor. They are more seriously affected by crowded and unsanitary living conditions and lack of health protection. They are, of course, the chief sufferers from the complete absence of educational facilities. The exact consequences, in figures and tables, of the effect of this type of life on their emotional growth has, unfortunately, never been estimated. We do know, however, that any child needs a certain amount of stability to develop into a useful citizen."[12]

Lange's husband, Paul Schuster Taylor, testified in front of the same committee, describing at one point a recent visit to Eloy, Arizona, where migrant families swelled the population during harvest. Although he does not mention the circumstances of his travels, Taylor had accompanied

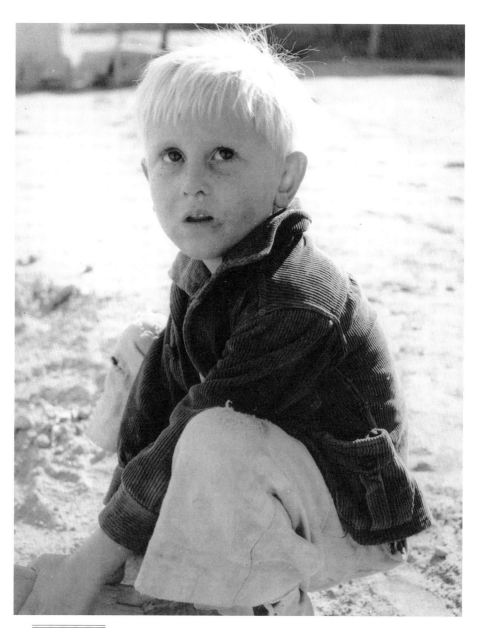

"Child in cotton picker's camp." Eloy District, Pinal County. Dorothea Lange, November 1940.

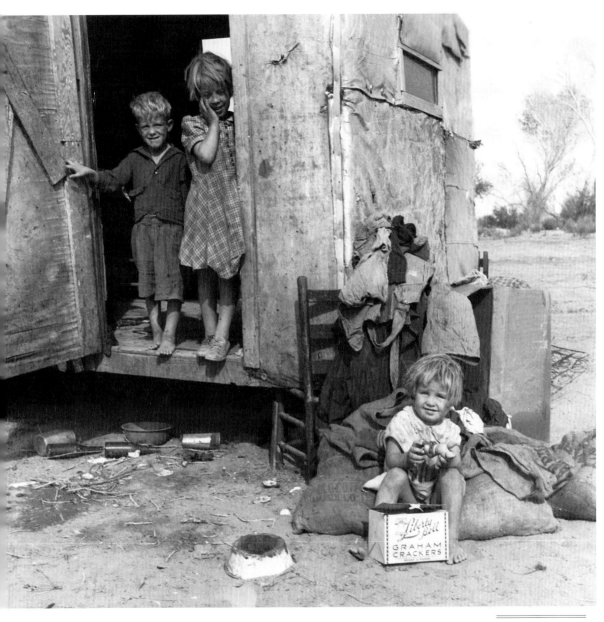

"A migratory family living in a trailer in an open field. No sanitation, no water." Children in a democracy. On Arizona Highway 87, south of Chandler, Maricopa County. Dorothea Lange.

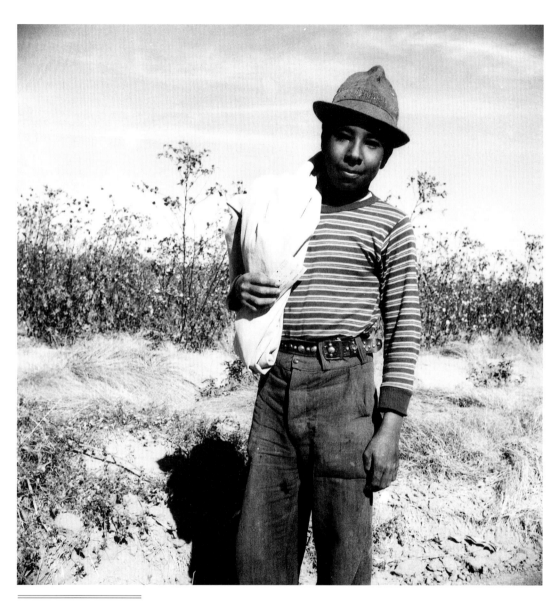

"Mexican boy age thirteen, coming in from cotton field at noon. He picked twenty-seven pounds of Pima cotton (earnings about 45¢) during the morning. Note stamped work ticket in his hand." Pinal County. Dorothea Lange.

Lange on this November 1940 trip during which she had photographed her "Children in a Democracy" series. On the irrigated thirty-five thousand acres that he visited, there were few signs of stability—"not, to my personal knowledge, a first-rate house," and only "350 people stable enough to register to vote." His message to the committee echoed the one he and Lange had presented in *An American Exodus: A Record of Human Erosion,* published the previous year. They had worked together, and independent of governmental support, to create a photo essay with an urgent message—"We were trying to spread the information of the current condition and the need for doing something about it now," recalled Taylor in a 1970 interview.[13] Indeed, the House committee chairman credited Taylor as the driving force behind the establishment of the ten-part hearings that gathered testimony on migrant workers in several cities across the nation. "There is a social set of books which may balance very differently than a private set of books."[14]

What happened to the boys and girls who attended those Arizona summer camps, to the migrant labor children who were the attention of such political and photographic scrutiny? Their individual stories are recorded only tangentially in these photographs. For Dorothea Lange, Paul Taylor, Florence Warner, and others engaged in these programs and broader politics, there was an inherent irony in their effective use of such images. They employed these abstract representations of children, images of individuals divorced from their particular identities, in the service of children's needs. Whether the photographs worked to balance a "social set of books" or expressed the desire to maintain social balance, a comparison of Dorothea Lange's familiar images with those of the unknown photographers of the 1934 summer camp programs points to the value and meanings of the photographs for Depression-era viewers. But not to the private lives of the children themselves.

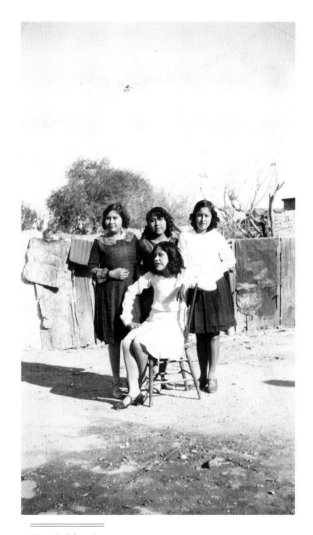

Cruz Robles sits
to the center
surrounded by
two unidentified
friends. Her sister
Maria Luis Robles
is directly behind
her. 1930.

LYDIA R. OTERO

Refusing to Be "Undocumented"

CHICANA/OS IN TUCSON DURING THE DEPRESSION YEARS

In childhood, a particular photograph of my mother, Cruz Robles, always captured my attention.[1] In the picture, she deliberately exudes a flirtatious and somewhat reckless character. Cruz is surrounded by her younger sister, Maria Luisa, and two other unidentified young women, dressed in their finest and most fashionable attire. As a group, they served as the supporting cast that highlighted and encouraged an emboldened Cruz to emulate the posture of a sexy and carefree Hollywood starlet. I must confess that as a girl I felt uncomfortable that my mother, as this photograph confirmed, once delighted in her risqué and unreserved youthfulness. Mostly, however, this image caused me to wonder about the dramatic changes that had occurred in my mother's life. Traces of that playful young girl had all but disappeared. I knew my mother as a hardworking and rather self-effacing woman who went out of her way to avoid cameras. My mother, too busy in life to answer the endless questions this photograph evoked in her young daughter, hid this photograph when I was thirteen years old. It would remain hidden for several decades.[2]

The photograph reemerged in the fall of 2001 when I began to explore how the Depression affected Chicana/os in Tucson, Arizona.[3] Locating oral histories, documents, and especially photographs proved to be a challenging

task. Initially, I had assumed the availability of ample photographs that chronicled the participation of urban Chicana/os in various works programs in Arizona. I was wrong. For a host of reasons, the most well-known images created by federal government photographers are not those that documented the lives or work of urban Chicana/os. Idealized images of rural Mexican people in pastoral settings abound, such as Russell Lee's photographs of Concho, Arizona. These photos, however, deployed ahistorical images of a provincial and picturesque lifestyle that the vast majority of Chicana/os did not enjoy.[4] By 1930 in the United States, most of them lived in cities.[5]

As I researched this period, I was struck by the increased racism and suffering that Chicana/os experienced, exacerbated by the scapegoating that occurred during the nation's most severe economic crisis. I never knew the aspirations and dreams that filled my mother's life as a young girl, but I looked anew at the photograph, taken in the worst of the Depression years, with sympathetic and enlightened eyes. Heightened exclusionary policies and attitudes that swept the country targeted Chicana/os regardless of citizenship status, and precluded their inclusion in the heroic national saga of "ordinary people" who valiantly rallied as they battled to survive hard

"Farmstead, Concho, Arizona." Russell Lee, October 1940.

times.[6] Nevertheless, personal photographs, like those of my mother and other *Tucsonenses,* survive to tell their story on their own terms. Most of these photographs are of working-class people, who looked directly into the camera and resisted being "undocumented." These photographs foster alternative representations that challenged manufactured stereotypes designed to construct Chicana/os as a rural and foreign people. Throughout an apprehensive time, and living in a nation that insisted on absolute loyalty, Chicana/os publicly celebrated and articulated their multifaceted ethnic identities in their private photographs. Self-affirming personal and family photographs chronicle the story of indisputable Americans who did not consider themselves "aliens," and challenge contrived representations by asserting their citizenship, ethnic pride, and humanity.[7]

Although the Depression affected everyone across the nation, poor people and people of color experienced additional burdens and hardships. Historically, during times of economic crisis, citizens and public officials avoid examining the complex and inequitable economic forces at the root of problems, and instead prefer to seek simple solutions. During the Depression it became easier to scapegoat women and immigrants, holding them responsible for the nation's soaring unemployment. Throughout the nation, from Washington, D.C., to Los Angeles, many, even President Herbert Hoover, considered Chicana/os to be disposable "aliens" who took jobs away from more deserving "Americans." An estimated one million were both voluntarily and forcibly repatriated back to Mexico during the 1930s.[8]

Although most of the repatriation and deportation fervor is associated with Southern California, the Pima County Welfare Board in Tucson also used these tactics to rid itself of an unwanted population. Historian Charles Leland Sonnichsen documents the large numbers of Chicana/os who were rounded up in Tucson and banished across the border.[9] In Mexico, news reports expressed concern for the repatriates and deportees due to their deteriorated condition. The Mexico City paper, *Excélsior,* reported in 1931 that "thousands of deportees have arrived during the last week through the border port of Nogales, presenting a pitiful and pathetic spectacle, for many of them are hollow-cheeked from hunger."[10] Locally, Organized Charities, a designated relief agency of Pima County, paid to transport Chicana/o families, including minors born in the United States, to the border. Interestingly, the president of this organization, C. Edgar Goyette, simultaneously served as the chairman of the Pima County Welfare Board. This position made him the most important administrator responsible for the direction and implementation of New Deal policies and the distribution of private and public relief funds in Tucson.[11]

Similar to welfare boards in the South, officials in Tucson sanctioned discriminatory policies in their work and relief programs, and designed

them to enforce regional and local racial hierarchies. In her trip through the Southwest, Lorena Hickok, a special investigator for Harry Hopkins and the Federal Emergency Relief Administration, singled out the discriminatory conditions she encountered in Arizona. "In Tucson—without any publicity, but so quietly that people didn't even know they were being classified," Hickok noted, "they divided their case load into four groups, Classes A, B, C, and D." A brief description of this classification system indicated that sixty "A" families received fifty dollars a month. Engineers, teachers, lawyers, former businessmen, and contractors composed the bulk of this elite group. The largest numbers of families, 1,490, were classified as "D." Hickok describes this group as "the low class Mexican, Spanish American, and Indian families." This group received ten dollars a month.[12]

Instead of providing assistance when the faltering economy had already inflicted hardship on Chicana/os, public officials placed additional burdens that undermined their survival. These unjust actions give added historical significance to the individual agency, and subjectivity, of Carmen Gomez. In her 1930 photograph, she depicts a public self that counters every prevailing stereotype assigned to Chicanas. Foremost, she does not wish to come across as a deprived or even religious woman. Instead, she prefers to convey sex and glamour. At a time when family and kinship played a central role in survival, Gomez instead chooses to highlight her independence. The lack of children in the photograph underscores her single status and suggests her sexual availability. Far from depicting a solemn frugality, Gomez's aggressive pose, up-to-date dress, hair, attitude, and posture are strikingly different from the suffering and passive Spanish madonnas depicted in Russell Lee's Concho photographs. Instead Gomez's attire and attitude follow a pattern typical of other young Chicanas. As historian Vicki Ruiz notes, the manifestation of Chicana flappers a decade earlier make it plain that "consumer culture . . . [had] hit the barrio full force."[13]

With each decade in the twentieth century the power of advertising, and advances in photography and motion pictures, confirmed the importance of manipulating and controlling visual representations. As federal policymakers attempted a national makeover, they drew on photographs to support their visions, such as the powerful rural agenda of the Farm Security Administration (FSA). The omission of urban populations from the FSA documentary record can be attributed in part to the specific needs of that agency. However, the limited representations of Chicana/o urban life in the larger corpus of New Deal photography need to be considered. This absence echoes, in part, the complicated place Depression-era urban woes held at the national level. The praise heaped on rural works programs that built roads, dams, and rural electrification projects, and on established farm cooperatives and relief camps, strengthened and idealized a national rural myth. This intentional

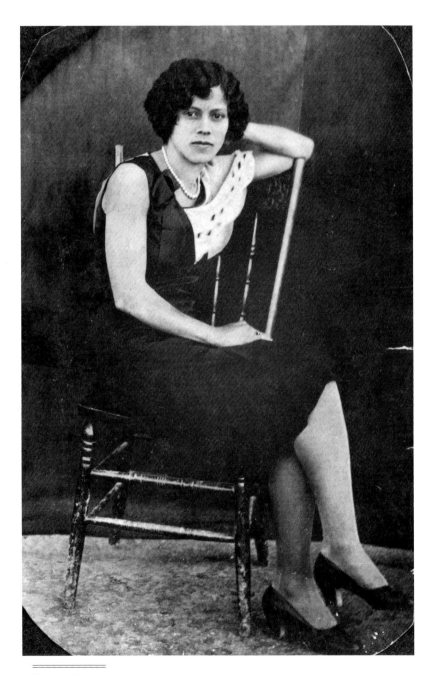

Carmen Gomez
showcases her
glamorous dress,
hair, and
attitude, 1930.

This typical 1930s
promotional pamphlet by
the Tucson Chamber of
Commerce offers
an ahistorical
representation designed
to lure tourists to an
"exotic" past and place.

propaganda may have also fueled the belief that cities "tainted" their residents. The presence of Chicana/os complicated this conviction and contributed to the convoluted reasoning that furthered the idea that "tainted" cities created a hybrid of unmanageable Chicana/os.[14] These notions buttressed a social reluctance to confirm the presence and lives of Chicana/os who lived in cities. Fueled by the negative stereotypes of the time, images of a hypothetically "uncontained" urban population remained suppressed while more palatable and comforting images of "Mexican" people proliferated.

During the 1930s, New Deal promotional literature and photographers advanced ahistorical propaganda that fueled representations of Chicana/os as being indolent and premodern. In the Arizona state guide, a member of the Federal Writers' Project of the Work Projects Administration (WPA) projected what he thought the nation would find compelling about Chicana/os in Tucson. Depicting them as "local color," he described scenes where "Mexicans stand against the warm buildings with their sombreros pulled down, their Spanish conversation punctuated with long silences."[15] Far from being accurate, this observation reveals preferred and engrained ethnocentric representations, which, despite reality, advanced stereotypes of Chicana/os as lazy, backward, and nonproductive citizens. New Deal photographers also pursued similar disingenuous, preindustrial images through their photojournalistic emphasis on areas like Concho.

Regional and local tourist agents included similar images in their promotional material designed to lure moneyed newcomers to the area. Idyllic and romanticized images of Mexican people and culture flourished. Contented, imaginary *señores* and *señoritas* enjoying a leisurely lifestyle, and devoted to songs that reflected their cultural investment in romance and chivalry, appealed to tourists. These invented and unassimilated Mexican people willingly accepted their "exotic" status and, like those in Concho, were too well mannered to demand citizenship rights. These imaginary and idealized premodern people willingly accepted their marginalized status in society. In these photographs, image-makers bestowed an admirable "strong and good" character to those who expressed no desire to brandish either their consumer goods or their ambitions to acculturate.[16]

Undeniably, Mexicans were neither foreign nor newcomers to Tucson. The histories of Chicana/os and Tucson are inextricably linked. Demographically, Chicana/os dominated Tucson until the turn of the century. Founded in the Spanish era as a presidio, Tucson was established before the arrival of Anglo Americans. It is doubtful that "Mexicans luxuriating in the shade" flourished during any period of the city's development; its demanding desert environment made mere survival a constant undertaking. Tucson became part of the United States in 1853 with the signing of the Gadsden Purchase. The arrival of the railroad in the 1880s brought

larger numbers of Anglo Americans and solidified the implementation of a new capitalist economic system that cast Chicana/os down an economic and political spiral. By 1929 Chicana/os composed about 33 percent of the city's population. Most of them lived in Barrio Libre, located in the center of the city. There were other barrios, but because of its size and its economic and cultural vitality, Barrio Libre was often referred to simply as *el barrio*.[17]

Throughout the Southwest, Chicana/os in urban barrios were forced to cope with the consequences of unfair and inaccurate representations that flourished during the Depression. Yet in their own photographs, in spite of the repressive period with its threat of possible exile, they created alternative images. A 1933 photograph of Adolfo Morales, for example, reflects a personal portrayal at odds with the cultural understandings that underpinned the promotional literature. Instead of portraying himself as dependent, Morales attempts to empower himself, selecting to showcase not only his car but also his contemporary attire. For a single man, a car enhanced his attractiveness and manhood as he positioned himself to be the center of attention.

The Tucson barrio in the 1930s. Today the Tucson Convention Center, which obliterated most of *el barrio* when it was built in the late 1960s, is located behind St. Augustine Cathedral.

His vehicle provided more than transportation or a temporary seat; it was a culturally meaningful accessory. These snapshots—portable yet durable images—confirmed individual accomplishment in a society that reserved its bottom rungs for Chicana/os. Adolfo Morales does not look like a poor man in this photograph; he looks confident, striking, and self-reliant.[18]

Adolfo Morales
flaunts his
contemporary
clothes and
automobile,
Copper Creek,
Arizona, 1933.

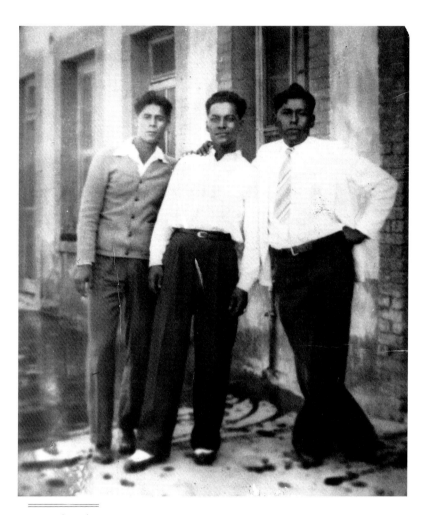

My uncle Pedro
Robles (right) with
his friends "Chapo"
Olea and Armando
Valencia, ca. 1935.

Although holding a job and protecting and providing for one's family made one a man in both Chicana/o and American cultures, county officials attempted to take that role away from Chicanos. Minutes of a county meeting to distribute relief funds under the Emergency Relief and Construction Act of 1932 confirm these intentions. The committee agreed that Pima County deserved more funding, and Goyette informed the group that "in Pima County men are getting work only every ten weeks, while in Cochise County they get work about every four weeks." Apparently, work relief paid more than direct relief, and Goyette recommended that "many Mexicans and aliens could be taken care of by direct relief with very little work relief, since they have few expenses except for food." In this telling statement, Goyette separates "Mexicans" from "aliens," yet proposes to treat both in the same way. By "Mexicans," as the rest of the report makes clear, he is referring to U.S. citizens of Mexican origin—distinguishing them from "other men." The diversion of funds would take "Mexicans and aliens" off work relief and allow those "other men" to enjoy the psychological boosts and political entitlements that being a breadwinner and working for wages provided. Goyette questions the manhood of Mexican men by implying that "other men" were more qualified and deserving of societal and institutional support. In the end, the committee unanimously agreed that "direct relief should be increased and that all aliens should be put on direct relief in order that men who had a higher standard of living than the Yaquis and the Mexicans could be given work more often."[19]

In addition to suffering economic hardship, it is also clear that Chicana/os suffered a crisis of representation in the 1930s. On one hand, officials judged poor Chicana/os as morally deficient due to their meager material living conditions and lack of material possessions; yet city and county officials continued to reinforce this condition by depriving them of equitable assistance that would improve their living conditions. Perhaps this accounts for Chicana/os insistence on portraying their independence, not dependence, in their personal photographs. The photograph of my uncle, Pedro Robles, for example, with his friends in 1935, highlights a masculine and aggressive character. Comradeship is accentuated in this photo, as are the fine clothes and shoes. The young men's posturing highlights a masculinity that county officials may have preferred to control and suppress. A few years after this photograph was taken, my uncle and his friends encountered no problem finding a new occupation. Along with more than a quarter million Chicana/os across the nation, they served and defended this nation in World War II.[20]

Cars, clothes, and accessories were, and continue to be, potent cultural symbols. Chicana/os in these photographs integrated popular culture, to varying degrees, and created their own individual styles in the process. Young

Chicana/os appropriated these visual markers, which they could purchase, to stake their claim as Americans. The people in these photographs dispute the official record that claimed Chicana/os had "few expenses except for food" and the misleading characterizations manufactured in tourist and promotional material. Despite contradictory messages, Chicana/os continued to believe in the power of the American Dream that promised equality, success, and more material goods.[21]

Although expressing their individuality, the young people in these photographs also understood that it was dangerous to be of Mexican descent in this period of massive deportation, repatriation, and racist welfare policy; U.S. citizenship did not guarantee equal rights or safety in this nation. On the state level, in 1930, the Arizona legislature passed the Box Bill to curb Mexican immigration. Policymakers justified this legislation by holding immigrants culpable for the Depression, asserting that "Mexican peons . . . are in direct competition with American men and women, thus making beggars and tramps of many of our native-born citizens."[22] Chicana/os continued, however, to claim Tucson, and the United States, as their home. Their personal photographs, like those of my mother, indicate that they refused to see themselves as either state burdens, foreigners, or "peons."

The experience of my mother, Cruz Robles, born in *el barrio,* mirrors the lives of working-class Chicanas living in Tucson during the Depression years. She was sixteen in 1929, when the Depression began. Cruz was the oldest girl in a family of ten children; three of her siblings were born in the 1930s. Her family's economic setbacks had been in motion before the Depression had taken hold of the nation. My grandfather, Luis Robles, an aging hod carrier, increasingly found himself out of work. Thus, economic necessity required that Cruz forfeit her education in the seventh grade and work for wages.[23]

The Depression further encouraged a family economy where all the family members jointly contributed to the family's survival. During the 1930s, my mother's younger sister, Maria Luisa, also left school in order to contribute to the family economy. Job opportunities were limited. During the first three decades of the twentieth century, as historian Alberto Camarillo documents, Chicanas concentrated on two principal areas of employment: domestic services and agriculture-related work. So, like many other Chicanas throughout the Southwest, with limited career choices, Cruz and Maria Luisa became domestics. Both sisters are listed in the early-1930s Tucson directories as "maids" living on Meyer Street in the barrio.[24]

My mother often told me that as a young woman people would comment on her resemblance to Gloria Swanson. As her 1930 photograph makes clear, finding a likeness to the Hollywood screen star requires stretching the imagination, but the photo and her story provide insight into my mother's

identity. Maids are not featured in this photograph. It depicts Chicanas flaunting their investment in girl, youth, and consumer cultures. Despite the poverty apparent in their physical surroundings, these young women captured a moment in which they stepped beyond the confines of their working-class occupations and created a visual statement that testified to their modernity and independence. Even if my mother had failed to share her Gloria Swanson story with me, this photograph reveals that she aspired to be more than a "maid" and that her dreams and desires were typically American.

In a political environment full of daily reminders that highlighted their vulnerability, it is not surprising that my mother's family avoided relief programs despite their immense need for assistance. Officials diverted most repatriates on Southern Pacific trains from Los Angeles County, which deported the largest number of people to Mexico, through Tucson.[25] Many Chicana/os who voluntarily repatriated passed through the city in loaded automobiles en route to Mexico. The constant flow of repatriates that passed

Maria Cruz Robles' U.S. citizen's identification card, 1936.

through Tucson served as a daily reminder to Chicana/os of their unwanted status. Amidst claims of "jobs for Americans" it is no coincidence that my mother, a third-generation Tucsonan, felt the need to acquire a photo identification card that confirmed and allowed her to claim U.S. citizenship status. The public face on this card, however, contrasts sharply from her private photographs. My mother could not control this image. Instead of the glamorous image that she preferred to exhibit, this card accented her flaws by pointing out her "pin moles on face." That the identification card is tattered indicates that Cruz always needed to have it in her possession, testimony to the precautions a young Chicana in 1936 needed to take in a time of heightened xenophobia.

Chicana/os not only faced economic and political burdens—a major health crisis had developed by the 1930s. Tucson touted itself in the first two decades of the twentieth century as an ideal place to battle tuberculosis. Some cited the low rates of tuberculosis among its long-term residents to substantiate the advantageousness of the local climate by asserting "it is well known that tuberculosis is very rare among Indians and Mexicans." But by the 1930s the disease had become racialized.[26] Limited access to health care forced infected and otherwise ill Chicana/os to seek out traditional community healers, or *curanderas,* but the death rate of Chicana/os escalated. As the photograph of Rosendo Perez indicates, poor Mexican families continued to honor their dead in difficult times. Unable to afford a marble or machine-made marker, Rosendo proudly holds a homemade marker that will be placed on his grandmother's grave. The fact that the Perez family chose to take a photo of their well-scrubbed child carefully holding and displaying the marker indicates that they felt this moment, like their deceased family member, deserved to be remembered.

Private photographs fostered a family identity and provided a way to remember individuals, but they also captured Chicana/os collectively celebrating their ethnicity. A photograph taken at the Riverside Ballroom indicates that despite the anti-Mexican backlash, Chicana/os continued to identify with and support their former homeland. This photograph raises an interesting paradox, and indicates that Chicana/os needed to execute a tenuous balancing act by openly celebrating their links to Mexico and Mexican culture while claiming to be Americans during the 1930s. Whereas public officials attempted to promote Chicana/os as "aliens," this photograph depicts an unidentified organization's members staking their claims to citizenship on a public stage. In order to highlight their patriotic stance, two large United States flags dominate the stage. The flags, however, frame and draw attention to past Mexican heroes known for advancing equality and civil rights.

All of the Chicana/os included in this chapter carefully manipulated

Rosendo Perez
holds his
grandmother's
homemade burial
marker, 1930.

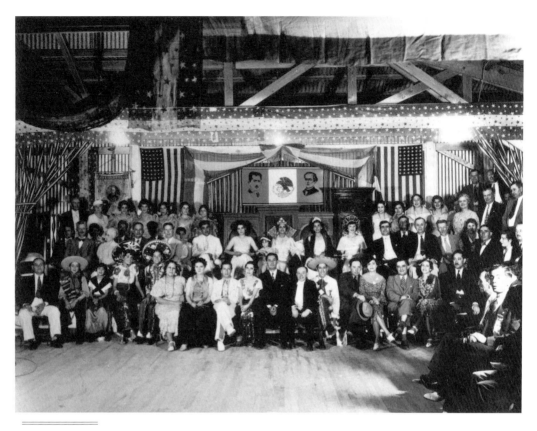

A September 16, 1937, celebration at the Riverside Ballroom in Tucson.

their images to claim their rightful place in American society. The desires and attitudes these photographs capture, and the strategies this targeted population employed to dignify themselves and their position in society, provide important information for those who wish to understand the past. The photograph of Alicia Morales Mendoza best exemplifies the struggle to counter dehumanizing stereotypes by disguising poverty. Hoping to ground her identity in good hygiene and generate a sense of modernity, the Mendoza family carefully positioned Alicia in the photograph. This calculated placement and the child's contemporary attire, especially the shoes, required that a curtain obscure reality. This photograph was taken in front of an outhouse.[27] The Morales family, like most Chicana/os in Tucson, did not live in a vacuum. They understood and endured the consequences of the intolerance that had taken hold of this nation. The Depression brought much hardship, but instead of portraying themselves as suffering and poor, Chicana/os highlighted their survival and their urban lifestyles. They sought to define and represent themselves and insisted on being recognized as equals in their empowering photographs. Alicia Morales, Cruz Robles, and other Chicana/os refused to be "undocumented" as they pursued their visions of equality and success in a city and a nation that attempted, but failed, to render them invisible.

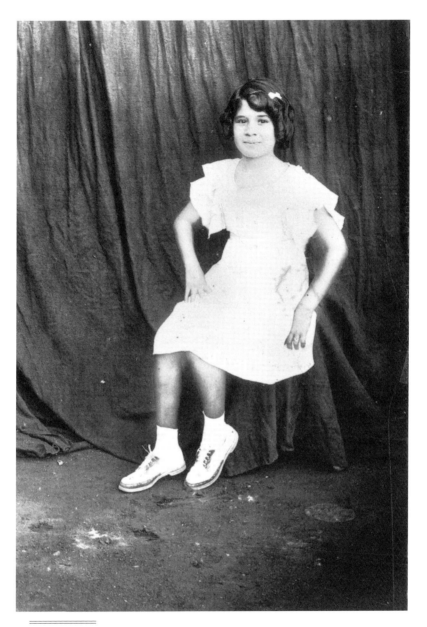

Alicia Morales
 Mendoza.

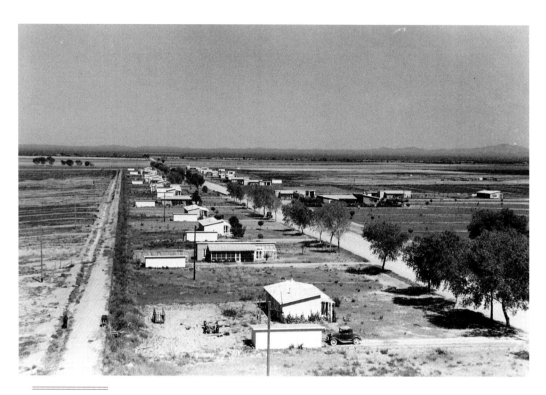

"General view of
houses at the
Casa Grande Valley
Farms," Pinal County.
Russell Lee, 1940.

BRIAN Q. CANNON

Casa Grande Valley Farms

EXPERIMENTING WITH THE HUMAN AND ECONOMIC PHASES OF AGRICULTURE FOUR

During the Depression, the federal government constructed homes and developed farms for over thirteen thousand needy farm families through its rural resettlement program. Most participants in the program relocated to small family farms, but the New Deal resettlement agencies also developed a handful of large cooperative farms in order to enable groups of low-income farm workers to benefit from economies of scale. Casa Grande Valley Farms was the only large-scale cooperative farm established in the Rocky Mountain West by the New Deal's rural resettlement agencies, the Resettlement Administration (RA) and the Farm Security Administration (FSA). It was, moreover, the only resettlement project in Arizona designed to furnish full-time employment for its residents.[1]

Regarded by some as a visionary utopian experiment and by others as an insidious Communist plot, Casa Grande attracted attention nationwide because it fundamentally challenged the role of agricultural laborers in agribusiness. The cooperative's brief and tumultuous history extended only from 1938 to 1943, when the majority of its members rejected the government's offer to sell the farm to them and pressed instead for liquidation of their cooperative association. During those years federal government–sponsored

photographers visited the project; Dorothea Lange came once and Russell Lee twice. Lange's and Lee's photographs document facets of life at Casa Grande, enabling us to envision the cooperative farm, the members, their homes, and their community institutions. Viewed in isolation, though, these idyllic photographs can easily mislead, conveying an impression of prosperity, order, comity, and cooperation that makes the farm's demise in 1943 seem inexplicable. Augmenting the FSA photographs with contemporary records and with reminiscences of former residents, this essay briefly traces the history of Casa Grande Valley Farms, evaluating the value of the FSA photographs as historical documents and showing that the photographs illuminate key facets of the project's history while they conceal others.

In 1938, when Dorothea Lange traveled to Casa Grande Valley Farms, sixty-five miles southeast of Phoenix between Florence and Coolidge, she found a five-thousand-acre farm watered from deep wells and canals of the San Carlos irrigation system. Residents had moved to the project after having been selected by federal employees from hundreds of applicants. Some were longtime residents of the state whereas others were recently arrived farm laborers. All were landless and all had previously worked in agriculture. In the caption to one of her photographs, Lange alluded to the diverse regional backgrounds of the residents, noting that a group of children playing on the project had moved there from eight states. Driving the project's dusty roads, Lange saw sixty modern adobe homes built on two-acre lots adjoining the farm's fields. An attractive community building located near the center of the village provided a comfortable setting for banquets, parties, dances, religious services, and other social events. At a nearby cooperative store products from the farm, such as eggs and milk, were sold to residents at cost.[2]

When Lange arrived at Casa Grande in June of 1938 the project was barely underway—its first residents had arrived only the previous November. Casa Grande appeared stark and bleak; no shrubs or trees shielded the homes lining the project's dusty, unpaved roads from the searing desert heat. To humanize and soften this sterile landscape, Lange photographed groups of children racing across the fields and down the streets of the town, with the homes in the distance. The children's enthusiasm and their new dwellings contrasted sharply with a photograph Lange took "near Casa Grande project" of the children of less fortunate migrant laborers seated atop a dirt mound and surrounded by shacks made of corrugated tin.

The most unusual feature of Casa Grande Valley Farms at the time of Lange's visit was its cooperative structure. The project had originally been planned as a community of individual family farms. Economists estimated, though, that the profit margin for individual households on 40-acre farms would be negligible. In order to justify the government's investment,

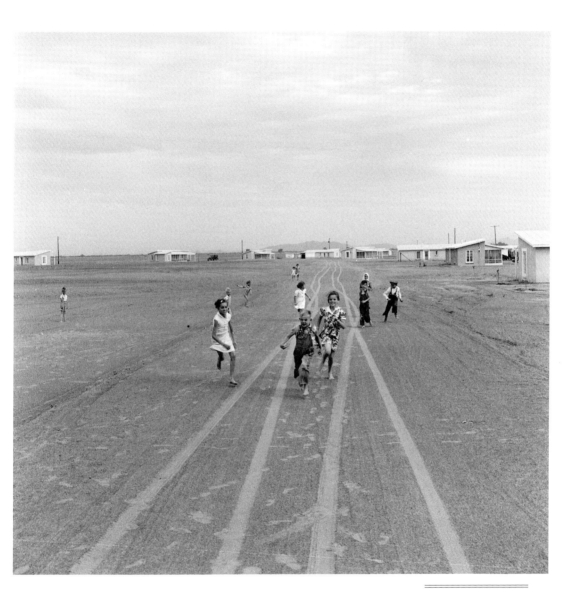

"Casa Grande project.
Large-scale corporate farming
by sixty-two families who
divide profits. Children in this
group came from eight
different states."
Dorothea Lange, June 1938.

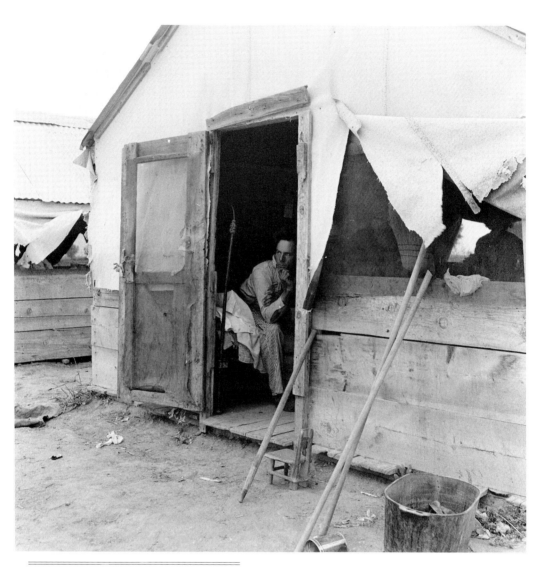

"Refugee agricultural laborer on the roadside,
near the Casa Grande project (Farm Security
Administration). 'I was on this here project, Work
Projects Administration, at twenty-three dollars
and ten cents in Durant, Oklahoma. I sold a cow
to get here. I'd go back tomorrow if I could. The
project over there? I wouldn't like it. Your chickens
would get all mixed up with the other people's, and
then there'd be trouble. It's kind of socialism over
there.'" Dorothea Lange, June 1938.

increase resident income, and bolster prospects for repaying that invest-
ment, planners eventually settled upon the idea of a large-scale cooperative
farm. In contrast to the yeoman ideal, residents at Casa Grande owned nei-
ther the farm nor the homes in which they lived, although planners antici-
pated that eventually they might become prosperous and experienced
enough to purchase the farm jointly. For the time being, though, their coop-
erative association farmed under a five-year renewable operating loan from
the government, payable at 3 percent interest. Each year, the cooperative
was to repay a portion of the operating loan and, depending upon how well
the farm fared, between $8,324 and $22,847 for maintenance, depreciation,
payments in lieu of taxes, and use of the farm and homes. Members of the
cooperative expected to share in the farm's income through dividends, but
they also received wages for the work they performed under the direction of
a professional farm manager.[3]

Rehabilitating sixty families through cooperative agriculture at Casa
Grande was expensive and controversial; hence the potential need for favor-
able publicity, including photographs to counter allegations of waste and
mismanagement. The government had paid $345,810 for the land at Casa
Grande and invested $465,050 in improving it; building irrigation struc-
tures; constructing farm buildings, homes, and a community building; and
bringing electricity, gas, water, and other services to the project. In sum, the
cost to the government amounted to well over thirteen thousand dollars
per household—well beyond the New Deal agencies' average investment per
household on resettlement projects nationwide.

Casa Grande's cooperative organization and the FSA's decision to
cluster inhabitants in a village rather than scatter them on individual farms
concerned many residents of the surrounding area, who branded the com-
munity "Little Russia." One early participant in the cooperative recalled
that "people from town came out—working on the houses and stuff—and
they talked about Russia . . . and wondered if we had free love there." The
chamber of commerce in nearby Florence criticized the clustering of farm
laborers' homes around a community center because such a system "would
deprive [residents] of individualism [and] freedom of action" and "be in
controvention [sic] of our democratic form of government."[4]

Due to its cooperative, communitarian organization, Casa Grande
Valley Farms attracted nationwide media attention and spawned public
relations challenges for the FSA and its photographers. After an Associated
Press release characterized the project as communistic, the FSA's regional
director, Jonathan Garst, privately admitted, "I suspect this is so."
Disingenuously, this geographer and expert in agriculture averred, "I have
never been able to find out much about the communistic farms." Garst and
others preferred to emphasize the similarities between Casa Grande and

privately owned industrial farms like "Allen Hoover's (Herbert's son) corporation farm in California."[5]

In her photographs taken in 1938, Lange acknowledged the project's cooperative organization while dismissing criticism of it through her portrait of a "refugee agricultural laborer" camped in an unkempt, rudely constructed shed "on the roadside" near the government project. Her caption for the photograph highlighted both the lack of economic opportunity for farm laborers on privately owned farms in the area and the controversial nature of the cooperative farm. Lange reported that the man had sold his possessions to pay his passage from Durant, Oklahoma, to Arizona, but he said he would "go back tomorrow if I could." In response to her query regarding the possibility of his moving to the new cooperative farm project, he replied, "I wouldn't like it. Your chickens would get all mixed up with the other people's, and then there'd be trouble. It's kind of socialism over there." By reporting this unfounded, knee-jerk judgment, Lange dismissed opposition to the project's cooperative organization, implying that the opposition was shallow and based upon misconceptions of cooperative farming.

If some outsiders were alarmed by the project's bold break with tradition, how did the residents themselves feel about the place in which they lived and worked? The farm's first professional manager told a reporter in 1939 that most of the association's members "probably don't realize or care that the project is basically communal." In their interviews with reporters, though, residents evinced a clear understanding of the project's communal orientation. As historian James Gregory has shown, most Anglo migrant laborers from the southern plains in the 1930s championed an ethic of rugged individualism. But at least initially, those at Casa Grande were willing to set that ethic aside: they appreciated the cooperative experiment because it offered them far more material advantages than they had known previously. As one resident stated, in 1938, "We wouldn't be here if we didn't think there was a bright future on this cooperative farm for us. Look at our houses, the equipment we have to work with! They beat wages working for another man and living in a shack."[6]

Despite some defects in the design of their dwellings, without exception residents appreciated the small but comfortable, modern homes at Casa Grande. Indeed, in the short run, modern housing—which had more to do with government largesse than cooperation—was probably the foremost advantage of living on the project. Women, who spent far more time at home than their husbands, particularly appreciated the standard of living. Onetime resident Mildred Frederick recalled that Casa Grande Valley Farms "was a nice place to live" with "real nice" homes, irrigation water for the yards, and "a large garden spot" behind each home. Compared to the other homes she and her husband had inhabited as farm laborers—tents

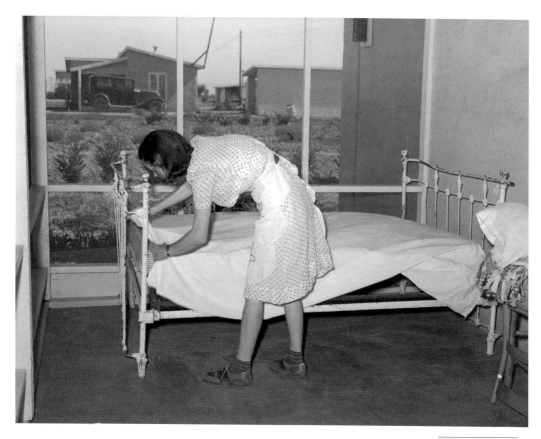

"Wife of member
of the Casa Grande
Valley Farms, making
up bed on her porch.
These large porches
on all the homes are
used for auxiliary
living quarters."
Russell Lee,
May 1940.

and one-room cabins with dirt floors—the house at Casa Grande with a living room, kitchen, small bedroom, bathroom, and screened porch seemed like "a mansion." Mrs. Ewell Bennett enthusiastically told a reporter, "Our houses are nice, we've got electric washing machines, radios, natural gas for our cooking."[7] Lange did not photograph any adult residents of the project or the interiors of their homes, but two years later Russell Lee did so in his first visit to the project. Lee's photographs underscored the appeal of modern housing for women living there, portraying immaculate kitchens and tastefully furnished living rooms. Collectively, the photographs convey an impression of comfortable, clean, and orderly living.

Although residents appreciated facets of the lifestyle at Casa Grande, including their homes, they disliked other aspects of life there, aspects that were not documented in either Lange's or Lee's photographs. George Hussey, one of the youngest members of the cooperative, recalled one disadvantage: "There were sixty houses and we had one meter for the gas and one meter for the electricity, and they divided it among you." As a result of cooperative, bulk purchasing each member paid reduced rates for utilities. But Hussey disliked the idea of sharing his neighbors' heating expenses, particularly those of one family who "would leave the doors of the house open and the stove turned to full blast so they'd get their fair share of the gas." The selfishness of Hussey's neighbors and

"Singing at Sunday school in the community building. Casa Grande Valley Farms, Pinal County." Russell Lee, May 1940.

Hussey's resentment were typical responses to cooperative living on the project, Hussey believed: "Everybody was jealous," he said, "of everyone else."[8]

Some residents also were concerned about being associated so closely economically and socially with others who differed from them in important ways. To outside observers, the similarities among residents were striking. Although Dorothea Lange did note in a caption to one of her photographs that families on the project hailed from several states, the FSA photographs themselves emphasized unity rather than diversity. This was particularly true of Lee's images of residents unitedly singing hymns at a worship service in the community building. From the perspective of many residents, though, important differences in regional origin, culture, education, class, and religion—differences that were not documented in the FSA photographs—made economic cooperation difficult. As one member of the cooperative, Ewell Bennett, learned, "When you get a group of people together they can't all agree." One resident who had been born in Kansas and had grown up in Arizona characterized some of his neighbors as "people from back in Oklahoma and Arkansas that had been raised up in the hills." They "didn't know what an inside toilet was" and "didn't have any idea that you got to keep things clean." Their background "was just a different world . . . compared to what I'd been raised with." Motivated by similar sentiments, a

group of women berated the project manager when he reminded them that all members of the cooperative were on an equal footing. "We're not equal," they protested. "That is, some of us are a lot cleaner and a lot better educated than some of the rest."[9]

Residents also recognized important and objectionable differences between most farmers' cooperatives and the one at Casa Grande. Here again, the FSA photographs glossed over the differences. Lee's photographs of interaction between members of the cooperative and the farm's managerial staff emphasized mutuality and respect. One image displayed a combination hay loader and chopper that had been "developed by members of the cooperative with the help of Mr. Walton [Waldron], regional FSA farm supervisor." Another showed the assistant manager and two workers jointly inspecting a piece of machinery. Lee's photographs also minimized distinctions between the two groups, showing members of the cooperative and the management visiting with each other. One photograph showed the assistant manager discussing a report with a member of the cooperative in an office; both were attired in button-down shirts and dress hats, as if to confirm their equal footing socially and educationally.

In reality, though, the palpable distinctions between management and workers rankled many residents. Although theirs was a cooperative

farm, the members did not own the land or the buildings, and they labored under the direction of a manager who, some felt, treated them contemptuously as "just a bunch of peons." Supposedly the association employed the manager and owned the farm's livestock, tools, and machinery, but the FSA, as mortgage holder, was the real owner. Residents technically could not even use tools belonging to the cooperative without the farm manager's permission. Recalling how FSA employee James Waldron advised members to vote with their feet and leave the farm if they disliked managerial decisions, one resident complained, "It made this seem just like a job where we worked for a boss, instead of our own place. . . . This is supposed to be different." An incident at the end of 1938 showed George Hussey and his coworkers how little power they possessed in managing the cooperative. Hussey recalled that at the end of the first year of farming, the cooperative "made some money." Members of the cooperative had been told that "at the end of the year if there was a surplus, why, you was to divide that. But that didn't happen." Instead, the management insisted on allocating the surplus for loan repayment. "They said, 'No,' says, 'you fellows don't want to do that. You want to pay the loan off quicker than that.' So that was the story they gave us why they didn't divide the money that year." Hussey believed that "if they had divided it, you'd have found an entirely different attitude towards the project from the people that were living on it, because we were, well, you figured you were working for something and then you didn't get it."[10]

The superior status of government employees, including the farm manager, was apparent in social settings too. Raymond Larue recalled a "big feed" for settlers and FSA officials. He, along with eight fellow residents, occupied a table on the sidelines "with three water glasses and a couple of dishes of fried potatoes," while the functionaries surrounded a table in the middle of the hall, "loaded down with food running all over." Larue spitefully queried, "But did they ever think of passing it? We passed water glasses and fried potatoes."[11]

Although Lee's photographs idealized relations between FSA employees and residents of the cooperative, his portrait of agricultural productivity and abundance at Casa Grande was accurate. Thanks to that productivity, Casa Grande Valley Farms turned a profit every year. The profits of the farm were small during the early years: $1,513 in 1939 and $7,274 in 1940, when Lee first visited. But thereafter, due in part to wartime inflation, profits soared. In 1941, the farm cleared $33,183 and in 1942, when Lee next visited, profits reached $36,803. Lee's photographs of productive milk cows, including a Guernsey that yielded 472 pounds of butterfat in 316 days; well-fed hogs; mountains of baled hay; and huge specimens of garden produce; documented key sources of that prosperity. Lee's images of satisfied shoppers at the well-stocked community store underscored the standard of living

enjoyed by residents of Casa Grande. "Even the cats know the refrigerators contain plenty of food at the Casa Grande Farms," announced one caption (see page 89).[12]

In 1942, and again in 1943, with its eye attuned to military victory in World War II rather than to perpetuating controversial New Deal experiments, Congress ordered the FSA to divest itself of its rural resettlement projects, including Casa Grande Valley Farms. A bipartisan entourage of congressional investigators who called at the project in 1943 charged that the FSA had wasted millions of dollars in developing such projects. Agency administrators believed the order to sell Casa Grande was premature and that residents were not yet fully ready to manage the farm. Having no choice, though, they prepared the farm for sale by having the property appraised. The appraiser valued the project at $788,415—slightly less than the amount of $810,860 that the FSA had spent in developing the project.[13] On July 10, 1943, the FSA offered to sell the farm to the cooperative association over forty years for $800,000 at 3 percent interest. Here was an extraordinary opportunity. Roughly three dozen landless farm laborers—other members of the association had left the project for higher wartime wages elsewhere—were being invited to purchase and cooperatively operate a vast ranch. In light of

"Dairy cattle eating while being milked. Casa Grande Valley Farms, Pinal County." Russell Lee, April 1940.

Lee's overwhelmingly positive photographs of comfortably dressed, industrious, and astute members of the cooperative; neatly kept, inviting homes; and well-managed, prosperous farming operations, one would assume the residents would eagerly seize this opportunity. Instead, residents rejected the government's offer by a margin of two to one, and the majority pressed instead for liquidation of the cooperative association.[14]

Deep-seated problems with the project that were not documented in Lange's and Lee's glossy images galvanized the majority's opposition to purchasing the farm. Among these considerations was the future profitability of the enterprise. The farm rated only "fair to good" according to the FSA's

"Hay picker-up and chopper at the Casa Grande Valley Farms, Pinal County." Russell Lee, May 1940.

appraisal, and the irrigation district that furnished water had a history of water shortages along with bonded indebtedness amounting to ninety-five dollars per acre. The farm had consistently turned a profit, but as the FSA's district supervisor, Fred Campbell, observed, this owed "largely [to] the ability of Mr. Beatty, the manager," in buying and selling livestock. Beatty had recently left Casa Grande for another job, and the residents lacked his training and experience in managing a large-scale farm or ranch. In a petition filed in Superior Court, residents singled out this inexperience as a key factor in their inability to assume control of the farm. Unable to spend or borrow money, employ a manager, or amend key bylaws without the government's consent,

the association had always been "powerless to carry on or manage its operations except as directed and approved by the Farm Security Administration." How could the government expect an association that possessed such limited administrative experience to purchase and profitably operate a cooperative farm, the petitioners wondered.[15]

As one FSA administrator reported, members of the cooperative also found the association's business matters, particularly the astronomical costs of agribusiness, to be "inconceivable." Under these conditions, the price of the farm frightened the membership. Although payments on the farm would be no higher than the lease that the cooperative had paid in recent years, there was no guarantee that high prices for farm products would continue after the World War had ended. Fearing that the purchase price was simply too high, one member suggested that the cooperative offer the government $350,000 for the farm.[16]

Residents also rejected the government's offer because the farm was organized as a cooperative. Given the welter of personality types and cultural backgrounds of the inhabitants of Casa Grande, it was inevitable that some residents would disagree with others, particularly regarding important matters pertaining to farm management. For years, competing pressure groups among the membership had jockeyed for positions of power and the best-paying jobs on the farm. The competition had engendered hard feelings, and now it seemed "impossible for members to cooperate or work in harmony for the welfare of the Association," they wrote. In light of these social realities, association member Henry Moore believed "it would be more profitable for each person to have a homestead."[17]

In light of the risks associated with assuming ownership of the farm—the underside of Casa Grande Valley Farms that FSA photographs did not document—it seemed prudent to call instead for liquidation. After estimating that the association's liquid assets and cash reserves totaled $237,000 and that its liabilities amounted to $141,800, those who objected to buying the farm calculated that liquidation would yield roughly $2,500 for every household.[18]

After months of debate and disagreement members of the cooperative unitedly supported a formal petition for liquidation, in November 1943. Despite last-minute legal maneuvers by the FSA to stymie the association and its lawyers, on November 30, a local Superior Court judge named his brother-in-law, Leon M. Nowell, a large local landowner, as receiver. After a federal judge upheld Nowell's appointment in mid-December, liquidation proceeded rapidly. By mid-January the beef cattle, appraised at $82,000, had been sold for over $90,000. The following month, 280 dairy cows were auctioned, principally to local residents, for $26,500. By the end of 1946, Nowell had completed his work as receiver and had been paid $15,000.

The thirty-six members of the association received $63,698.69, which was divided among them based upon the number of hours they had worked since January of 1940.[19]

After liquidation, the federal government retained ownership of the land and homes, which the association had merely been renting. Several former members of the association continued to lease homes from the government. Early in 1945, several of them asked Arizona senator Carl Hayden to help them secure loans from the FSA to buy family farms on the former project. Three years later, in September of 1948, seven former association members and three children of former members purchased farms ranging from 90 to 130 acres from the government. Additionally six other former members purchased homes on the project. By October of that year the government had sold all of its holdings at Casa Grande. Its innovative attempt to alter the relationship of farm laborers to corporate agriculture had vanished—an outcome one could hardly predict from the rosy images of Casa Grande captured on film by FSA photographers Lange and Lee.[20]

Although it was a small part of the New Deal's rural resettlement program, the government's innovative foray into cooperative farming at Casa Grande Valley Farms provoked significant cultural commentary. Some writers championed the project as a revolutionary democratic initiative and deplored its demise, while others branded the experiment as dangerously socialistic and triumphantly regarded the residents' call for liquidation as evidence that "the American people do not like to be collectivized."[21] Such cultural commentary, including the photographs of Lange and Lee, may be the most significant legacy of Casa Grande Valley Farms; certainly it is the most enduring legacy.

As members of the FSA's only large cooperative farm in the Southwest—the destination of most migrants from the southern plains during the Dust Bowl era—the inhabitants of Casa Grande Valley Farms powerfully symbolized the plight of refugees from America's heartland searching for greater opportunity in the Southwest. Similarly, the photographs of Casa Grande and its residents by Dorothea Lange and Russell Lee sought to demonstrate the needs of itinerant farm laborers, the redemptive impact of New Deal policies at Casa Grande upon those laborers, and the gratitude of those whom the FSA assisted.

Dorothea Lange's and Russell Lee's positive photographs were intended to be promotional propaganda for the FSA. It is not surprising therefore that the photographs showcased the positive aspects of Casa Grande while bypassing the project's deficiencies. Yet the FSA images also reflected the photographers' and other FSA employees' conviction that projects like Casa Grande Valley Farms would benefit farm laborers. Although

the photographs do not help us understand the reasons residents voted to liquidate the cooperative, they do accurately reflect the vantage point of FSA personnel and their sense of betrayal and disbelief in response to the farm workers' call for liquidation of the cooperative.

Sincerely convinced that the farm proffered unparalleled economic opportunity to members of the cooperative, they could make no more sense of the call for liquidation than can modern-day viewers whose vision of the project is limited to Lange's and Lee's photographs. Proponents of liquidation complained that agency personnel responded to their call for liquidation by charging that they must not be "intelligent or competent enough to do business with." The FSA's regional director felt personally wounded by the association's rejection of the government's offer and confided, "The way they are behaving I would just as soon have somebody tell me somebody in my family was a criminal." In 1951, Edward Banfield, a former public relations officer for the FSA, most fully expressed the shock of paternalistic administrators in the agency. Banfield wrote that the residents of Casa Grande had experienced "success beyond anyone's expectations" and prosperity that was "unparalleled" in their past. Nevertheless, this "group of ignorant sharecroppers" had "killed the goose that laid the golden egg" by refusing to purchase the farm or to "cooperate with each other and with the government." Banfield maintained that the settlers' "irrational" tendencies arising from their "aggressive" or "neurotic" personalities or from their "acute need to assert claims to status" in an "undefined and fluid" social situation led them to press for liquidation. The settlers lacked the necessary refinement, discipline, and reflective skills to pursue their own economic interests. In short, they "were not reasonable men."[22]

Produced by photographers who embraced the liberal reforms of the New Deal, Lange's and Lee's photographs help to make the perspectives of FSA officials and their reactions to the call for liquidation understandable. But do they reveal anything about the actual residents of the project and their views? Historian Charles Shindo has maintained that New Deal officials and photographers like Lange and Lee "sought to represent a [Dust Bowl] migrant that did not exist." "Assuming that the migrants' plight, as an expression of industrial capitalism's inherent inequality, required a radical social democratic response," these artists and reformers sought to portray the migrants as willing participants in an experiment to "proletarianize" and collectivize the migrants. In reality, maintains Shindo, the migrants clung to "the traditional ideas of independence, family, and God," which clashed with the New Deal's emphasis upon social and economic cooperation.[23]

Indeed, as Shindo maintains, the FSA photographs do distort the worldview of migrant agricultural workers in the Southwest. Moreover, the photographs were used by New Dealers to promote a cooperative ethic that

"Workers on the hay-gathering and chopping machine taking time out for a cigarette. The goggles and masks are essential because of the severe dust. Casa Grande Valley Farms, Pinal County."
Russell Lee, May 1940.

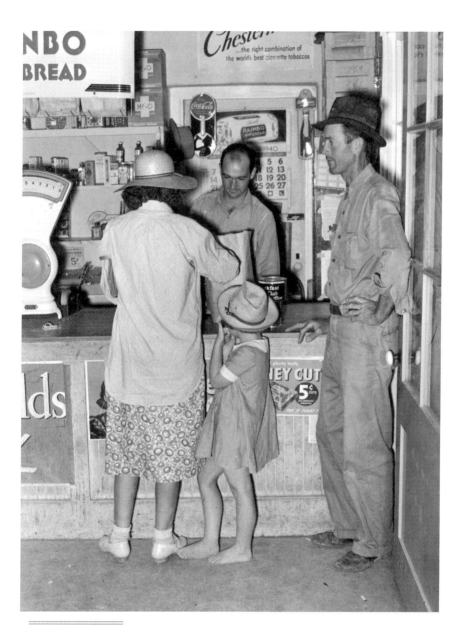

"In the grocery store
of the Casa Grande
Valley Farms, Pinal
County." Russell Lee,
May 1940.

few Southwestern migrants fully and permanently embraced. But in certain respects the photographs do represent their subjects' aspirations and values faithfully. The men and women who appear in Lange's and Lee's photographs of Casa Grande were not "displaced" by photographers, as Shindo maintains was the case with the subjects of FSA photographs generally. When they posed in front of the cooperative store, agreed to have their pictures taken while singing hymns, or invited Lee into their homes and permitted him to photograph them as they set a beautiful table, they were not surrendering their values or identity or becoming "unwilling publicists" for the New Deal. The majority were individualists, but their words captured in newspaper reports early in the project's history show they were also pragmatists who were willing to experiment with New Deal programs in order to promote their economic welfare. The fact that they ultimately rejected cooperative agriculture and pressed for liquidation should not obscure their initial willingness to experiment with it. The images captured by Lange and Lee at Casa Grande reflected that willingness.[24]

Those images also reflected the individual interests of those who agreed to be photographed. Lange and Lee controlled the cameras, but those who were photographed participated actively in the process. Some may have posed mainly because they liked Lange or Lee or wanted to be helpful. But their dignity and values entered the equation too. If they consented to be photographed in certain poses and settings, it was because Lange's and Lee's images would project themselves, their personalities, their lifestyles, or their ideals in ways that they valued. Dorothea Lange's and Russell Lee's photographs do not tell the full story of Casa Grande Valley Farms, but they do faithfully depict facets of the project, from the residents' delight in modern homes and bumper crops to their economic aspirations that drew them, however briefly, to experiment with collective farming at Casa Grande.

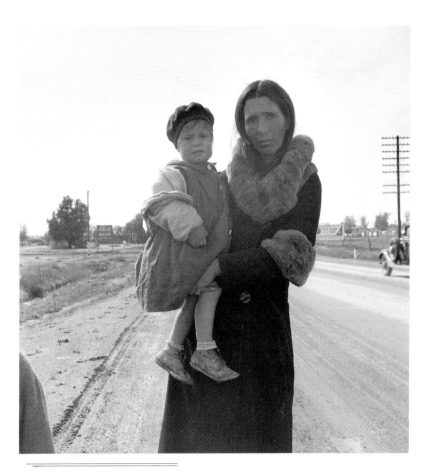

"Homeless mother and youngest
child of seven walking the highway
from Phoenix, where they picked
cotton. Bound for San Diego,
where the father hopes to get on
relief 'because he once lived there.'"
On U.S. 99. Near Brawley,
Imperial County, California.
Dorothea Lange, February 1939.

Dorothea Lange
and Russell Lee

DOCUMENTING AND IMAGINING WOMEN

During its early years, the Farm Security Administration (FSA) frequently used images of women to represent national suffering and to galvanize public support for Depression-era government relief programs. FSA photographers relied heavily upon their audiences' belief in, and adherence to, a set of treasured values—self-reliance, religious faith, ingenuity, and family—and in the perception of women's role as nurturers and guardians of culture in American society. Many of these images are well known; Dorothea Lange's series of a starving and careworn migrant mother and her children are the best-known depictions of women in this vein. Lange created similar photographs of migrant women in Arizona, such as "Homeless Mother," produced three years after her now-famous visit to California pea farmers.[1] In this photograph, Lange framed her subjects within a recognizable religious and artistic theme: the Madonna and child. As such, they link the viewer to a shared cultural value system that emphasizes the sacredness of a mother and her children and their role in perpetuating society and culture. The mother and child embody the national impact of the Depression, demonstrating to the public that the ramifications of the crisis were much deeper than homelessness. They went to the root of American values.

This and other images have become part of our national lexicon and form a significant visual impression of women's lives during the 1930s. Women, frequently portrayed by government photographers as displaced mothers and wives, symbolized the crisis in American society during the Depression era.[2] The government-commissioned photographs emphasized the contrast between these values and the reality of the Depression. However, by the late 1930s, and certainly by the end of the decade, portraying Americans as helpless victims of the Depression began to change as the nation shifted its focus from its suffering to a reimagining of the American ideal. Photographs depicting Americans as weak or as victims of circumstance were no longer popular. The government now wanted to convey a positive national image, as well as inspire public support for its relief and migrant resettlement programs.

The representation of women in government-sponsored photographs changed to fit this new vision, and the images of Arizona women created in 1940 by the FSA's two most prolific photographers, Russell Lee and Dorothea Lange, illustrate this effort. Photographed during visits to Arizona in 1940 for the FSA and the Bureau of Agricultural Economics (BAE), these images described the lives of women in Arizona in ways that showed how the government's efforts were both democratic and effective, and that also suggested American lives and American families would return to normal.[3] The 1940 photographs also suggested new visions for a recovered America that not only incorporated images indicative of renewed prosperity, but also expanded this new vision to include images of those women frequently absent from it: African and Mexican Americans.

The significance of the Westernness of the location and of their Arizona subjects—even if only implied in their captions—is in fact crucial to understanding how the two photographers approached their assignments and the visual documents they produced. The West has always been symbolic of American renewal, and this imagery was not lost on Lange or Lee and their supervisors. Roy Stryker, director of the FSA's historical section, urged Lee to capture "upbeat" images and document Americans showing "a little spirit," to "make a rush" for a boomtown. "We have pictures of a town dead and dying," Stryker explained, "but to date we have nothing from the boom side."[4] Boomtowns and people with spirit are synonymous with the American Western ideal; Lee noted in a letter to Stryker that he considered the Southwest America's last frontier.[5] In their photographs of Arizona women, Dorothea Lange and Russell Lee capitalized the mythology of the American frontier and the perception of the West as a place of hope, individuality, self-sufficiency, and renewal. The methods the two photographers employed to distill these collective values through their Arizona images in many ways reflect the government's attempt to reenvision America through its social welfare programs and to rally public support for this new outlook.

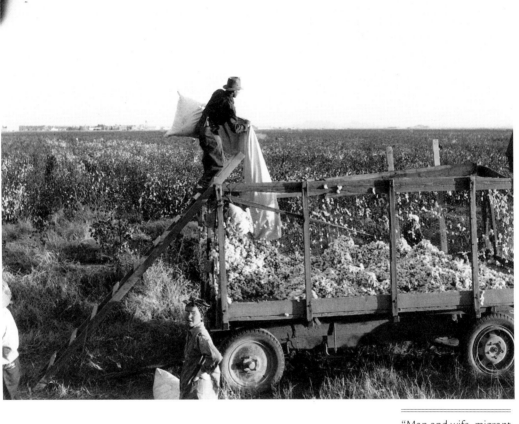

"Man and wife, migrant
cotton pickers. He dumps
his sack and hers into
the cotton wagon. Town
of Eloy in the distance."
Eloy District, Pinal
County. Dorothea Lange,
November 1940.

Dorothea Lange came to Arizona in 1940 on assignment with the BAE as part of its Community Studies program, which intended to evaluate why some government migrant camps were failing while others were successful. Lange's photographs were important visual documents to aid in this evaluation. She had visited Arizona earlier, during the late 1930s, photographing migrant workers on the California-Arizona border and producing photographs like the one on page 80 that mirrored her "Migrant Mother" series in their depiction of loss and desperation. Lange had been photographing the effects of the Depression since 1934, when she began working with Paul Schuster Taylor, then field director of the Rural Rehabilitation Division of the newly formed State Emergency Relief Administration, and soon to become her second husband. Her photographs of women in the government's mobile migrant camps at Eloy District, Pinal County, near Tucson, were part of this effort.

In their composition, the series of photographs she produced during November 1940 at Eloy recalls an earlier ideal of pioneering America. Indeed, the photographs interact directly with the visual and literary traditions of the American frontier past, in which individuals display courage and ingenuity in the face of adversity and are challenged by their experiences and made larger by them. Her photographs of the women at Eloy place them squarely within frontier context by framing them in the external environment, often as workers in the fields alongside their husbands. In "Migrant Cotton Pickers," a couple empty their cotton sacks before heading back out into the fields; the light in the photograph and the relatively empty wagon indicate that it is early in the morning, and the two have a long day before them. Although the cotton fields in which they work seem to dwarf the couple, Lange's technique draws the viewer's eyes directly to them. The wide band of sky at the top edge of the image, and the cotton fields to the right of the photograph, frame the man as he walks up the ladder with the cotton sacks. Yet it is his wife that draws our attention, as she gazes directly at us. She resides within an inner frame, formed by the vertical lines of the cotton truck and the slanting ladder. This frame-within-a-frame is parallel to the larger outer frame of the photograph in which her husband figures.

By arranging her subject in this manner, Lange forces us to see the woman and her work as the photograph's significant focal point. Her direct gaze at the camera and the viewer is reminiscent of the gaze of Lange's earlier image of the Arizona migrant woman, but something has changed. Whereas the migrant mother in the earlier photograph was inactive, this woman is striving to make a living in the fields. Her wearied face and tired body evoke a sense of dignity.[6] Contemporary viewers seeing this image in a government report or in a government-sponsored exhibition probably would have recognized the photograph's subjects as migrant workers who were receiving

some form of government support. Thus, Lange's objective was to celebrate the migrant couple's work ethic and desire for independence, thereby engendering greater support for the government assistance programs like the one at Eloy.

Additionally, the photograph has a composition that recalls other contemporary paintings and imagery celebrating the mythology of the pioneer West, such as William H. D. Koerner's *The Homesteaders,* which had been completed only eight years earlier, in 1932.[7] In the painting, a young wife holding a baby stands with her husband in the field, the plow and team of horses resting behind them; they are framed by a large sky and a seemingly endless prairie. Koerner's images celebrating the iconography of the West were widely distributed as magazine illustrations and covers, and therefore well known to Lange's intended audience.[8] By aligning her photograph's composition with familiar pioneering themes, such as those popularized by Koerner, Lange revivifies and reincorporates this migrant couple into the American paradigm and value system. Although the couple in her photograph may be receiving support from the government, Lange's use of the frontier motif and her framing of them within it as "pioneers," encourages the viewer to see her subjects as self-reliant individuals.

In another image from Eloy District, "Water Supply for Migratory Cotton Pickers," Lange again emphasized the pioneering traits of dignity and self-sufficiency in her migrant subjects and incorporated those values into the photograph's composition. The photograph of the family group, composed so that they are placed in contrast against the baked earth and the spare camp behind them, is a highly romanticized portrait. The shadows play on their faces and bodies, softening the glare of the Arizona sun, which, even in the twilight of a late fall day, is hot. Lange's composition creates a vision of familial harmony that would have been recognizable to her viewers.

The message Lange conveys here is clear. Once again, she recalls the iconography of the frontier by placing the family within a self-reliant context—the mother and her children are determined to survive against the odds. There is a timelessness to the image; without the trucks, the image could be one from an earlier era in Arizona's history. Lange emphasizes the taut tendons in the woman's forearms, her bunched muscles as she strains to hold the weight of the filled bucket off the ground. These are the arms of a woman who has been doing this work for some time. This migrant mother does not intend to rely on "relief." In arranging her subjects against a spare background, Lange forces the viewer to confront their situation as she represents it. Like the migrant couple in the photograph on page 83, they become symbols of discipline and self-determination.

Although Lange is using pioneering imagery to portray the government's agenda in these two images, she is also subtly manipulating it.

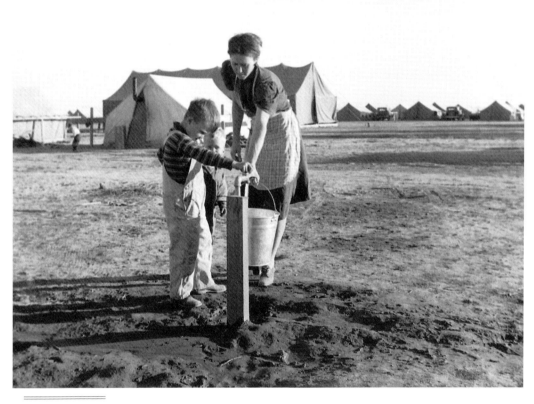

"Water supply for
migratory cotton
pickers in FSA mobile
camp just established
in Eloy District."
Dorothea Lange,
November 1940.

Traditional visual representations of the American frontier such as Koerner's largely portray frontier women as dependent and inactive. Painterly conventions for Western "cowboy art" differ markedly for men and women in pose, background, and gaze. Men are depicted in heroic action, women are posed and inactive; men focus on action or objects within the picture frame, women focus on the viewer beyond it.[9] Lange chose to place the women in these photographs squarely within the context of the American frontier imagery as actors, thus turning it on its head. Perhaps Lange was making her own subtle commentary on a shared set of cultural values that had largely left women in the margins as passive, rather than active, figures. These were values that were challenged consistently by the Arizona women she photographed.

Russell Lee chose a different, more traditional thematic framework for his photographs of women at the Casa Grande Valley Farms and the Arizona Part-Time Farms, Chandler Unit, both FSA programs near Phoenix. Lee had begun working for the FSA in 1936, when Roy Stryker hired him to replace Carl Mydans, who had left the agency's photography unit to work for *Life* magazine.[10] In five short years, Lee became the agency's most prolific photographer; only Dorothea Lange approached or rivaled his sheer mass of work.

In the spring and fall of 1940, Stryker sent Lee to the Southwest to look for something new, perhaps a "boomtown," which Lee documented more or less in Pie Town, New Mexico. Stryker suggested that while Lee was in the area, he should also visit the government projects in Arizona and photograph them as well.[11] Like Lange, Lee capitalized on familiar Western themes, but he incorporated them much more indirectly in his photographs of the women living there. The end result was a visual prescription for a new vision of America—one that emphasized domesticity and stability in the American familial landscape through its documentation of the removal of women from the roadside and their reintroduction into new homes provided by the government's social programs in the West.

At the time Russell Lee visited Arizona, detractors were condemning government cooperatives there and elsewhere as "radical social experiments in cooperative living." Earlier cooperative projects, such as Arthurdale, in West Virginia (1932–33) and Jersey Homesteads, in Hightstown, New Jersey (1934), had received scathing reviews in which opponents accused Roosevelt advisor and undersecretary of agriculture Rexford Tugwell of using taxpayers' money to create "model Russian communes."[12] Indeed, during a stop in Phoenix in April 1940, Lee visited a sociology class at Arizona State College (present-day Arizona State University), where he explained the purpose of the cooperative and migrant farm projects to a professor and students who "seemed afraid that the migrants would become communistic."[13]

Lee and Stryker were aware of the importance of photographs to counter these accusations by portraying the cooperative projects in a positive

"Picking roses from
her flower garden."
Casa Grande Valley
Farms, Pinal County.
Russell Lee,
May 1940.

"Even the cats know the refrigerators contain plenty of food at the Casa Grande Farms, Pinal County."
Russell Lee, May 1940.

light. Lee's assignment was to demonstrate the efficacy of the government's attempts to address the migrant problem, while emphasizing that the projects actually promoted American values and that government assistance to those participating in its programs was part of the American democratic tradition. Consequently, his Casa Grande and Chandler photographs highlight and reinforce women's domestic role by portraying them fulfilling their familial responsibilities. The message of these images is clear: in its Arizona programs, and at similar projects elsewhere, the government was helping Americans resume stable lives governed by traditional American values.[14]

Immediately after his arrival in Phoenix, in April 1940, Lee informed Stryker that he planned to "give full coverage [of daily life]—perhaps even following one family through the day." In an exhaustive set of series photographed at Chandler and Casa Grande in May, Lee did just that—documenting the daily activities of cooperative members' wives.[15] The women's youth and freshness, and the suppleness of their bodies, imply newness, activity, and promise. They occupy well-kept houses with electric washing machines on their back porches. When their day's work is completed, they have leisure time to read a magazine or pick flowers from their gardens.

In contrast to his earlier photographs for the FSA, Lee's images from Casa Grande and Chandler convey a visual promise of a new American life. They not only encourage the viewer to tacitly approve of government projects like the ones they depict, but they also invite the observer to imagine a new American life by providing a visual bridge to what that life might be. Lee composed most of the photographs in this series so that his subjects were perceived less as individuals and more as a universal standard to which Americans could aspire. The way in which he angled and focused his camera draws the viewer's eyes to the objects surrounding his subjects—appliances, furniture, and sparkling kitchens. After lingering on the edges of the photograph, the eye is drawn finally to the woman herself, who is almost always standing or sitting to one side. Closer scrutiny leads the viewer to question whether any action is taking place: Is there anything in the pot the woman pulls from the oven? Is she really washing clothes, or just lifting the washing machine lid for effect? The absence of individuality, or particularity, forces the viewer to perceive the subjects as models, rather than as individuals.

Lee underscored his subjects' universality in his captions. The women in this series are identified most often as "wives" of working members of the cooperatives—and not as members themselves.[16] This technique reemphasized the traditional roles of women and men in American society. The term *wives* referred to their traditional role in the domestic sphere—a role that in many cases had been upturned when the Depression and the loss of their husbands' jobs forced many women to seek other means by which to care for their families. The men, on the other hand, are described according

to their role in society: cooperative member, doctor, laborer, worker, camp manager.

Unlike Lange's active migrant women, or even Lee's images of the women of Pie Town, New Mexico, created during the same spring, Lee's unnamed Arizona women became ciphers, symbolic of the American housewife, and American life returned to normal. The Casa Grande and Chandler photographs advertise the promise of a new American life, filtered through the lens of what the government proposed as traditional values. Lee's camera captures hope and promise, rather than despair. His images reassured Depression-weary Americans that the government was meeting the needs of its people and that traditional values and norms remained constant in a changing nation.

As if to emphasize the point, Lee photographed an entire family at home in the evening—a rare example in which he posed together a mother, father, and child. Here, Lee excised all background objects in order to focus the viewer's eyes on the family in the center of the photograph. The parents gaze adoringly at their son, who places his hands together as if in prayer. The child, his head slightly angled to the side, looks directly at the camera, his posture and his serene face mimicking classical poses of Christ. What makes this photograph so striking is not just its thematic undertones, but

"Member of the Arizona Part-Time Farms with his wife and child." Maricopa County, Chandler Unit. Russell Lee, May 1940.

also its composition. Other photographs in the Casa Grande and Chandler series depict husbands and wives together, usually posed in front of their houses or shelters; groups of children; and family groups gathered at church activities. When Lee photographed mothers and children, it was mostly within the frame of the traditional Madonna and child. Rarely in this series did Lee photograph the family together in a private setting.

The placement of the child on his father's lap is equally significant in its reinterpretation of a traditional religious theme to convey a contemporary message: the father is the source of strength and support, capable of protecting and providing for his family. Lee extensively explored the theme of fathers and children—especially fathers and daughters—while he was in Arizona. His purpose was to demonstrate how government programs had reinstated fathers in their traditional relationship with their wives and children. Placing his male and female subjects within a domestic environment enabled Lee to carry on a visual dialogue with his audience. With this particular photograph—the last in his "day in the life of" shots—Lee conveys his most important message: government programs encourage stable family life. The photograph interprets a shared set of traditional norms and values that could serve as a model for the country's future.

The Western setting of the Casa Grande and Chandler photographs is critical to reading them as a revisioning of the American family and the American dream. In 1940, Arizona had been a state for less than thirty years. Both Lee and his audience perceived the Southwest as the last American frontier. Arizona and the West were places for renewal—literally, in the case of the migrants, and figuratively in the broader American imagination. Like Lange's images of Arizona migrant women, Lee's Casa Grande and Chandler series implicitly plays upon a frontier mythology. His emphasis on modern technology and relative prosperity at the Arizona projects evokes the possibility of a *new* frontier: a New Modern America.

Within this context, Lee's photographs of the women at Casa Grande and Chandler cooperative farms are advertisements for what this new modern America should be and the good life it promises. They reenvision the American dream for a public exhausted by years of images of despair and want and foreshadow advertising campaigns of the postwar 1940s and 1950s. The American media of the postwar period resonated with images of June Cleavers and Donna Reeds, the classic portraits of happy female domesticity. Ads for household appliances, such as Maytag, showed women standing in their kitchens, next to their appliances, smiling broadly, arms raised to indicate the product in question. Instead of using the appliance, they are instead demonstrating how the appliance changed their lives from one of drudgery to one of leisure. New appliances, these ads imply, made women's lives easier, and the woman who had the new appliances was able

to relax—rather than having to do housework all the time, a woman would be able to unwind during her busy day.[17]

However, other photographs taken by Lee and Lange suggest that both photographers felt strongly that this "new" vision for America as presented by the government should incorporate those who were largely absent from traditional imagery of American society, yet who had always been a part of it—Native Americans, African Americans, and Mexican Americans. This was particularly true within Arizona, a state traditionally represented within a context that routinely excised or miscast non-white inhabitants and settlers. As part of their Arizona assignments, both photographers sought to document the lives and contributions of these Arizonans as well, and to reintroduce these groups into the American imagination by reinforcing traditional values and themes in their photographs.

Lee wrote to Stryker that he was anxious to photograph Mexican American migrants in Arizona and New Mexico as part of his assignments there, noting that he felt he would be "able to get many phases of this [Mexican American] life that [had] not been generally pictured."[18] These photographs are provocative when compared to his series of domestic scenes from Chandler and Casa Grande. Women are frequently depicted as workers in the vegetable fields, or in family and individual portraits. But in a group of photographs from Concho, Lee focused on similar domestic themes that had characterized his Casa Grande and Chandler images—thereby incorporating Mexican American women into his overall visual message. One photograph in this vein, of a woman whom he described as being of "Spanish extraction," resembles Lee's photograph on page 88. The soft focus romanticizes the portrait of the migrant woman and child; the image associates the woman with the domestic rather than the agricultural realm and aligns her within the same context as the Casa Grande housewife.

In another photograph, Lee captures his subject at the end of a long day of canning, with the fruits of her labors literally arrayed around her on the table. In contrast to the young wives of Casa Grande, who merely seem to be *performing* their domestic roles, this woman is actually *producing* something—we can see the food she is preparing arrayed around her on the table. No doubt the women at Casa Grande and Chandler canned food, but Lee chose not to portray them in those activities. In fact, several photographs by Lee depict children picking vegetables from the kitchen garden, but rarely their mothers. Lee chooses not to focus the viewer's eyes on the kitchen or household appliances, as he does in the photograph on page 89, but rather, he draws the viewer's eyes to his subject and to the work she is doing. The viewer needs to see the products of her labor; in the Casa Grande and Chandler series, the emphasis is on leisure. The Mexican American woman pictured here is not important as a symbol for all American women,

but rather a symbol that reassures white, middle-class America that the Mexican migrants are not threats to stability but are also productive and viable members of society.

Similarly, Lange produced a large series of photographs of African Americans at Cortaro Farms and near Buckeye as part of a larger documentation of those projects, of which "Migrant Colored Cotton Picker" is

"Spanish farmer's wife and daughter picking chili peppers. Concho." Russell Lee, September 1940.

one.[19] As with Lee's portrait of the Chandler family, the religious overtone in this photograph is hard to overlook. Lange incorporates religious iconography into her portrait to manipulate the viewer's perception of the migrant worker as an individual subscribing to, rather than threatening, American values and the traditional "American" way of life. At the same time, she manipulates those traditional values and themes to include those

"Woman of
Spanish extraction
putting up dried
meat with other
produce of the farm.
Concho." Russell Lee,
October 1940.

"Migrant colored cotton picker and her baby." Near Buckeye, Maricopa County. Dorothea Lange, November 1940.

Americans who had been traditionally left out of them, such as the African American migrants living and working in Arizona. The soft glow of the photograph, the mother's tender expression, and the angle of her neck create a sense of warmth and domestic harmony that offset the potential shock of seeing an African American woman portrayed in the role of Madonna—a role traditionally inhabited by a white woman. Placing her subject within a domestic environment tinged with religious overtones allowed Lange to carry on a visual commentary with her audience, playing upon traditional norms and values—even if a majority of her viewers would not have placed African Americans within that context. Through her photographs and the themes she portrayed in them, Lange sought to insert African Americans into the American and Western cultural fabric and value system.

Lange did not feel the need to romanticize these subjects, however—especially when harsh realities of segregation were evident in the communities they photographed. Cortaro Farms was a multiracial camp that included white, African American, Mexican, and Yaqui Indian migrant workers. But despite its multiracial makeup, the camp had serious flaws when it came to the treatment of non-white migrants. That Lange was outraged by the discrepancies is obvious from her general caption for her Cortaro Farms photographs. She highlighted the differences between the quality of the quarters for white workers, described in a WPA study as a "spacious tent city" that provided shelters "well equipped with showers, laundries, electric street lights, etc. . . . have a nursing service, and are generally clean," with those of the non-white workers. Lange found the quarters for African Americans as "below the standard for whites in that neither shade nor wooden tent platforms are provided."[20] Her captions betray her own anger that the workers should receive different treatment—an anger that she carried through in her photographs of African American workers in Arizona.

Lange's and Lee's photographs provided visual documentation of the lives of these "other" Arizonans, making a not-so-subtle commentary that while the government projects were changing the lives of many displaced Americans, for a large percentage of them, things had not changed all that dramatically. Lange's portrait, "Sister of Cotton Picker"—the sister of the woman in "Migrant Colored Cotton Picker"—provides such a contrast. By referencing the other photograph, Lange's caption implies that she wanted them to be seen together, so that the viewer could compare them and be confronted by the messages each photograph conveyed. The contrast between the glowing portrait of the mother and child, with the shelter in which she and her family must live, is emphasized by the sense of loneliness of the sister in relation to the "togetherness" of the mother and child. This relationship reinforces the isolation of the women within the larger frame of the Cortaro camp, and of black Arizonans within the larger society. Similarly, Lee's photographs

"Sister of cotton
picker." Near Buckeye,
Maricopa County.
Dorothea Lange,
November 1940.

force the viewer to see the discrepancies between the homes (and kitchens) of the Mexican Americans and their white counterparts in the government projects—there were no gleaming appliances or sparkling linoleum floors in their kitchens.

There are multiple vantage points from which to view Lange's and Lee's Arizona photographs. Both photographers knowingly incorporated traditional American values and cultural themes in their photographs of Arizona women in order to encourage the viewer's positive perception of government projects. They were, after all, employed by a government agency that had specific agendas regarding the portrayal and promotion of its projects. Jean Lee later described her husband's attitude toward his work and his puzzlement when his photographs were elevated to the level of art. "The fact that these photographs became what people call 'works of art' was something that happened," she recalled, "but it was not at all the purpose, nor was it of any interest to [Russell]. . . . As far as I know Russ had no pride one way or another in these photographs. It was just a job." Lee was a salaried government employee hired to create visual documents that supported Roy Stryker's purposes at the FSA. According to Jean Lee, he willingly practiced his photographic art to accomplish Stryker's goals.[21] Russell Lee was aware of the dual nature of his photographic work for the FSA: he recognized his significance as a documentary photographer capturing a particular time and place, but he also knew that his photographs had a practical use—to convey information.

To critics, the FSA's shift to images celebrating American self-reliance and stability smacked of political manipulation. In fact, the content of these later Depression-era photographs reflected changes that were occurring throughout the country, most notably in the West. The American economy was beginning to rebound at the end of the 1930s, and World War II would spark an economic boom that would transform the postwar West into a "pathbreaking self-sufficient region with unbounded optimism." Most of Lange's and Lee's Arizona images fit squarely within this context and reflect the optimism of people who had migrated to the state, either as a final destination or a transition point, and were beginning to put their lives back together.[22]

Dorothea Lange was fully aware that there was often a difference between what she chose or wanted to photograph and how the government wanted to demonstrate the benefits of its projects, although Lange preferred her instinct to scripts. She declared in an oral interview, "It's a somewhat questionable thing to read ahead of time in a situation like [the camps] because you're not going under your own power. It is often very interesting to find out later how right your instincts were if you followed all the influences that were brought to bear on you while you were working in a

region."[23] In more than one instance, Lange referred to some of her photographs as "hardboiled publicity negatives."[24] In an oral interview conducted shortly before her death in 1996, Jean Lee stated that "these photographs were designed to show people what was happening in other parts of the country. It was also to influence Congress to appropriate more money in areas where people really needed it. They worked. They were used in newspapers and magazines and all sorts of places. The Congressmen saw them and kept money coming for FSA projects."[25]

The ways in which each photographer chose to capture and portray their subjects speaks volumes about their own agendas as much as it provides a means of understanding the complex structure and fabric of a nation attempting to extricate itself from the brink of disaster, and a new state trying to find a place for itself within the American cultural landscape. The Westernness of the location and the ideal of frontier promise provided an opportunity for Lange and Lee to construct a visual bridge for their audience to transcend current circumstances in search of new models for the future. While their photographs documented Arizona in ways that were in keeping with the government's purpose, Dorothea Lange and Russell Lee found ways in which to convey their own social commentary on what America and Arizona were, as well as what they could be.

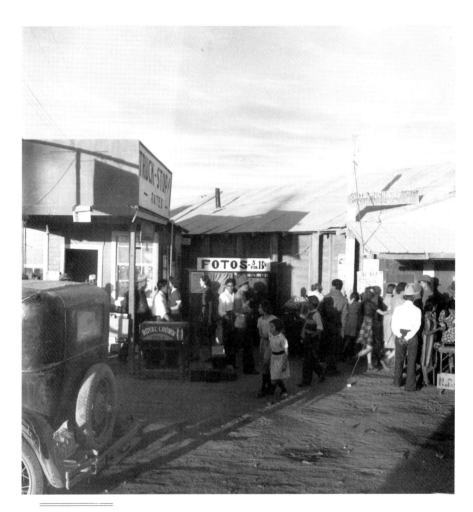

"Photographers
also migrate with
the cotton pickers.
Saturday afternoon
in Eloy." Eloy,
Pinal County.
Dorothea Lange.

Pictures for Sale

MAKING A LIVING THROUGH PHOTOGRAPHY

O n a sunny November Saturday in the town of Eloy, located in the heart of the irrigated cotton fields of central Arizona, Dorothea Lange captured the local scene on film. At work on a federal government assignment, Lange snapped images of family outings, dusty streets, and stores to document the experiences of migrant laborers. But she was not the only photographer in town. As the caption accompanying her photograph reproduced on page 102 points out, "Photographers also migrate with the cotton pickers." There on a sign, just visible as the long afternoon shadows obscure the crowd, are the words, "FOTOS—3 for 15¢."

The sign's presence, as well as the photograph itself, suggests a seemingly endless supply of photographers, cameras, and images in 1930s Arizona. It points to photography's popular appeal for Depression-era Americans. Perhaps, as photo historians Pete Daniel and Sally Stein suggest, "people feeling deprived of material goods were attracted to those images that most closely resembled the look, surface, and solidity of things. Maybe, too, people feeling suddenly insecure about the future were comforted by photography's apparent matter-of-factness, even when the 'facts' were often distressing. Most likely, the appeal of photography contained contradictory

"One Picture is Worth 10,000 Words"

Photographs *Create* Confidence

Photographs eliminate doubt and dispute.
~ Let 'these' silent arguments help win your cases
~ They Build Believability
~ Use photographs to tell your story

Studio *of* AL BUEHMAN
Phone 3
15 E. Congress
Tucson

This is an actual photographic copy ~ on non cracking photographic paper.

Promoting the power of photographs and pursuing profits during the Depression, Tucson studio owner Al Buehman advertised his craft. The shadow of the photographer and his camera can be seen in the bottom center of the picture.

impulses: to document and transform, to gain familiarity and distance."[1]
Ultimately, the Eloy sign reminds us that photography was more than a
salve, a government agency tool, and an art—it was also a business.

Although the documentary photographs of Dorothea Lange, Russell
Lee, and other New Deal photographers have created a familiar visual imag-
ery of the 1930s, they comprise a relatively small portion of the images cre-
ated during the decade. The "fotos" of the itinerant Eloy photographer, along
with those of numerous other commercial photographers at work in the state,
provide another angle of vision. This photo essay considers the products and
production of Depression-era photography businesses in Arizona.

Professional photographers in 1930s Arizona engaged in a range of
activities—they maintained studios; worked for hire; sold photographs to
magazines, newspapers, and advertising agencies; and developed film for
amateurs. A complex combination of hard economics, Depression-era

The colorfully
named and attired
"Kit" Carson,
owner of Carson
Studios, Flagstaff.

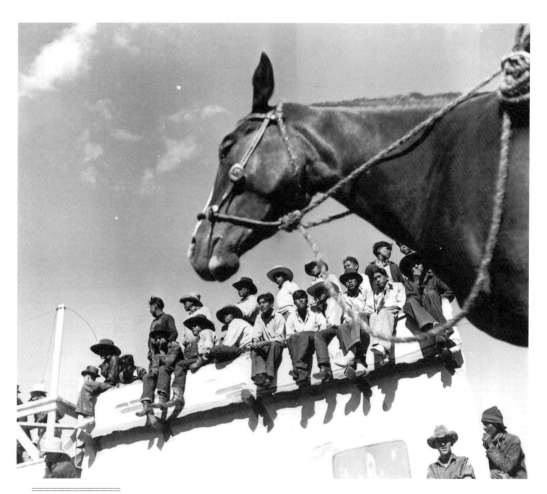

The Fronske Studio
regularly took
photographs at the
Flagstaff All Indian Pow
Wow and Rodeo. Here's
a 1938 crowd watching
the rodeo.

politics, and technological innovation shaped their work during the decade.

The persuasive power of photographs was far from a novel concept to the Arizona public. During the previous decades, Arizonans had been exposed to vigorous boosterism campaigns, tourism promotions, and ongoing, frequently solicited federal investigations, which typically netted voluminous reports laced with commissioned camera studies. Wave after wave of peripatetic photographers went head to head with resident studio owners for rural and mining town portrait dollars, all the while generating Indian and landscape scenes to sell to eastern presses then stoking the fires of one of the publishing industry's cyclical waves of nostalgia for the bygone days of the Great West.

As the act of selling evolved to both define and shape American culture, camera art found a colorful new nexus that translated into the largest single economic venue for Arizona images by 1940—print advertising. Economic changes in early-twentieth-century Arizona, along with technological innovations, contributed to the development of commercial advertising and its use of photographs.[2]

Modern times brought modern methods and a corresponding business aesthetic that slyly transformed photographs into capitalist storytellers for reasons endemic to both time and setting. Arizona residents were neither parochial nor amenity starved. Even though the majority of residents were sentient enough to realize that all advertising is essentially a performance, mythical promises evoked real wishes, personal anxieties, and a full battery of commonplace behaviors unique to a people and place willfully caught in a perpetual state of redefinition.[3]

Few were immune to advertising photography's sibylline lure and

Advertising for tourist dollars, photographs pointed the way; in this case, the arrow led one to the air-cooled Sunset Court on the road between Tucson and Phoenix.

In this posed advertisement distributed by Keystone Photo Services, *Arizona Highways* editor Raymond Carlson and his party enjoy an alfresco meal as part of an Arizona Biltmore Tour.

A woman
dives into the
Biltmore Hotel
pool.

Arizonans proved no exception. Premium-priced resorts like the Arizona Biltmore in Phoenix were among the first to implement the new technology by hiring Madison Avenue advertising agencies to generate slick publicity packets illustrated with photographs empowered by the overt contrast of palatial opulence against a spare and unforgiving landscape.[4]

Working professionals looking for homegrown customers placed Depression-era studio owners in intense competition with each other. Class politics contributed heavily to the outcome in urban settings. Prestigious studio owners like Albert Buehman of Tucson entered the fray with a full arsenal of talents, a respected name, and an outside portfolio of investments to cushion the lean times. He also enjoyed community standing as heir apparent to the pioneer studio founded by his photographer father, Henry, in 1875 and, more important, an affluent client list that viewed professional photography as an everyday entitlement. Dollars from their ranks became the buffer that enabled Buehman to slash prices for in-studio services, as well as hire resident assistants to tend shop while he gathered scenes to filter to a full spectrum of markets ranging from advertising to art exhibitions.[5]

Like other urban commercial photographers, Tucson's Buehman Studios relied on local business clients, such as Dunn's Market.

Phoenix photographers enacted similar strategies, but the rewards went to more than one player. Veteran cameraman Lisle Updike was among the first to implement fully modern marketing methods. In addition to traditional studio wares offered in two locations, he openly practiced a price schedule subject to radical change on whim, published and distributed catalogs, advertised nationally for clients, and regularly participated in Eastman Kodak's nationally juried exhibitions. His advent into the publishing world occurred through the pages of *Arizona Highways*.[6]

The lion's share of portrait revenues in central Arizona filtered to William Patrick and James McCulloch, a pair of enterprising Scottish brothers whose 18 North Second Avenue studio had been a local institution since 1913. Along with a lengthy and lucrative union with Goodyear Tire and Rubber Company founder Paul Litchfield that lasted decades, the McCulloch brothers produced contractual work for all of the big-three auto makers, the Wigwam Resort, the state Tourist Bureau, and Safeway Stores, Arizona's first grocery store chain. Famous faces were a mainstay, including a widely publicized series of photographs of retailing giant J. C. Penney and his daughter taken by William in 1935.[7]

Steinfeld's Department Store, where the Buehman Studios photographer snapped this Stone Avenue crowd, was another of the Tucson studio's clients.

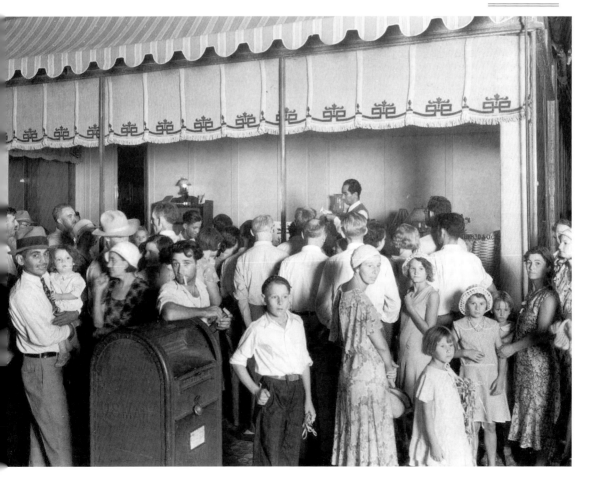

The bread and butter of a commercial photographer's trade: Lisle Updike lines up the Rainbo Bread company employees in this 1930s Phoenix group portrait.

The Bate Studio essentially created its own niche as portrait photographer to the rich and famous. Although Claude and Thomas Henry Bate had operated a successful studio on First Avenue since 1927, the definitive turn in fortune came after Claude hung out a second shingle at the Biltmore Hotel. Between 1933 and 1940, he photographed Hollywood legends such as Harpo Marx and Ginger Rogers, as well as chewing-gum magnate and Biltmore owner P. K. Wrigley, cereal king Howard Kellogg, philanthropist John D. Rockefeller Jr., and department store owner Henry May, among others. The nature of his subject matter granted him entrée to the highly remunerative Hollywood publicity machine and all of the movie magazines that served as its mouthpiece.[8]

Throughout the 1930s, wilderness legend Emery Kolb continued the vast visual diary of the Grand Canyon that he had begun with his brother Ellsworth in 1902. Famous faces, spectacular scenery, and spine-chilling rapids all coalesced to grant him an edge few of his contemporaries dared to challenge. Kolb had been a national name since a daring 1911 river trip netted him the honor of shooting the first full-length feature film of the canyon region captured from the vantage point of a boat. The August 1914 edition of the *National Geographic Magazine* ran a cover story about the feat,

Arizona Highways

Volume 10
Number 2

February, 1934

Yearly One [
Copy Ten C

Picket Post Mountain and Highway
60, about eight miles west of Superior,
share the February 1934 cover of *Arizona
Highways*. During the 1930s, work by
professional photographers as well as
photographs by Arizona State Highway
Department employees, such as this one
by Norman Wallace, increasingly graced
the pages of the magazine.

A female "dude"
meets an Arizona
"cowboy" in this
McCulloch Brothers
promotional
photograph for
Wickenburg's
Wigwam Resort.

ENNUI

Thomas Henry Bate
exhibited some
of his portraits
at the 1935
California Pacific
International
Exposition in
San Diego.

Capturing leaping figures on film
as they spanned Grand Canyon rock
formations advertised the rugged
terrain as well as the photographer's
skill. Here's one of the Kolb brothers'
trademark shots. Emery Kolb.

illustrated with still photographs taken by the Kolb brothers en route. Celebrities charged the ramparts and the Kolb brothers were suddenly en vogue, a fury that raged long after age and its infirmaries compelled them to trim their professional sails. Emery's long and bitter fight with the National Park Service ultimately garnered him the righteously deserved honor of being the first and only Arizona photographer to have his studio/home set aside as a national landmark.[9]

Small-town studios came and went across the decade for reasons ranging from economics to boredom. Those businesses that managed to last typically subsidized their revenues with film sales and on-site processing, along with catering their work to local businesses and interests. In Prescott, photographer Claude Bate turned his hand to the bread-and-butter of the Arizona tourist trade—dude ranches. In Globe, pharmacist and photographer Forman Hanna developed and printed work for customers in his drugstore. He pursued his own art photography for exhibition rather than for sale.[10]

Beginning in the mid-1930s and continuing well up into the 1960s, resident professionals made any number of fruitless attempts to practice the politics of exclusion as a means of forestalling their own obsolescence. Buehman, Bate, and Updike took the lead in organizing a statewide movement that called for everything from revitalizing licensing standards from the late-nineteenth century to setting price floors for basic wares like portraiture, formal events, public-funded ceremonies, and any image freelanced to the local press. They were joined in their efforts by California-based Josef Muench, Esther Henderson, of Tucson, Carlos Elmer, of Kingman, and a host of other itinerants, whose professional acclaim stemmed largely from their frequent contributions to the pages of *Arizona Highways,* the official state magazine that began life as a broadside, then grew with the state into an internationally lauded publication known more for its photographs than its written content. When the Tucson Sunshine Climate Club hired a Palm Springs photographer to take pictures of important people visiting Tucson resorts, for example, the bypassed local studios, led by Esther Henderson, mounted a vigorous protest. As Roy Drachman tells the story in his memoirs, "Henderson called on me and raised the devil about my having hired Chuck Abbott. I told her it was too late to do anything about the matter, but she wrote letters to the editor and kept the pressure on me." Although they met under adverse circumstances, photographers Abbott and Henderson soon found they had much in common; they married in 1941.[11]

Studio professionals' struggles to gain dominance in the local market were little more than background noise to the stalwart, most-often-nameless cadre of press photographers, who day by day created a visual diary of a decade as expansive as it was exacting. *Arizona Republic* photographer E. D. Newcomer was there when Winnie Ruth Judd was arrested, arraigned, tried,

Relaxing at the
Barney York Dude
Ranch in Prescott.
Claude Bate, ca.
1934.

Forman Hanna composed
his classic soft-focus nudes in
a small canyon not far from
Globe. His national reputation
was largely based on these
photographs, exhibited in
London and East Coast
galleries. Forman Hanna,
"Folded Rocks."

and convicted of the notorious October 20, 1931 "trunk murders," which grabbed international and national headlines. He stood lens-ready when Democratic presidential candidate Franklin Roosevelt brought his campaign to Phoenix on September 25, 1932; when a youthful John F. Kennedy learned how to be a cowboy in 1936; and whenever high-ranking governmental officials, Hollywood celebrities, and famous entertainers stopped or stayed in Phoenix. Along with recording virtually every human spectacle and natural scene his editors deemed newsworthy throughout the decade and beyond, Newcomer was the first news photographer to enjoy byline credit for his efforts.[12]

Although newspaper editors in other parts of the state rarely gave such credit, Fourth Estate photographers continued to serve as the people's eye on the scene. During 1934, press photographers in Tucson crafted a two-dimensional diary that recorded the ravages of the Congress Hotel fire and the dramatic arrest and arraignment of legendary bandits John Dillinger, Harry Pierpont, and Charles Makley. Press photographers statewide worked both at odds and in unison to chronicle the arrival of the "Okies" and "Arkies" during the Depression; the construction and staffing of over forty Civilian Conservation Corps camps during the New Deal; and a full decade's worth of sporadic labor disputes between miners and mine owners and between farm migrants and agribusiness. When it happened, wherever

Esther Henderson, well known for her rodeo photography, captures the concentration of a rider in the chute at the 1937 Casa Grande Cowboy Days.

Newspaper photographer
E. D. Newcomer portrays
the action at the
Hoover Dam dedication
as President Franklin D.
Roosevelt, Arizona
governor Benjamin Moeur,
and Senator Carl Hayden
wave to the crowds.

A 1936 newsworthy
event: Amelia Earhart
made an emergency
landing in Judge J. T.
Overfield's pasture.
She is pictured here
with Judge Overfield
at the Casa Grande
Rodeo Grounds.

it happened, press photographers were there and Arizonans reveled in the visual tales filtered back through their lenses.[13]

Whether they called themselves newspaper, itinerant, studio, advertising, or freelance photographers, those men, and few women, who made a living as commercial photographers in the 1930s worked hard at their craft and their businesses. Economic practicalities dictated their positive portrayals of selective Arizona scenes and peoples. As they sought tourist dollars and financial solvency, Buehman, Updike, Bate, and the rest may have competed with each other, but they shared similar visions and end goals. Often complicit in this celebratory mode, the subjects of their photographs participated in shaping the genre. From our perspective, perhaps, the strong emphasis on wealth, stability, beauty, and dramatic moments may seem incongruous in a Depression decade, especially when these images are compared with those captured by Lange. This odd disjuncture, between economic stress and success, becomes even more visible when we add the history behind the pictures for sale. In the end, the photographs themselves remain as testaments to the art, and the business acumen, of Arizona's commercial photographers.

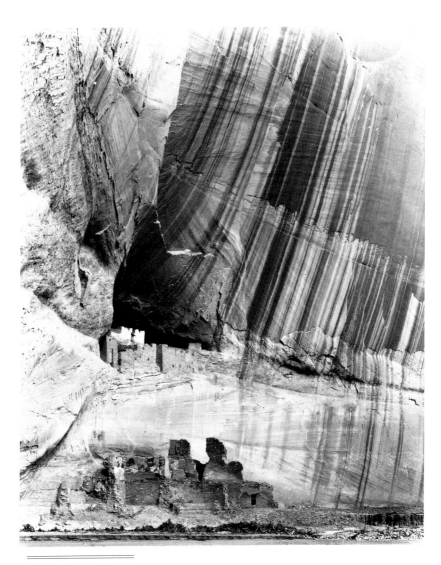

Following a long line of
white photographers
who ventured into Native
American land, Laura
Gilpin photographed the
ancient "White House"
cliff dwellings in the
Navajo Nation. Casa
Blanca, Canyon de Chelly.
Laura Gilpin, 1930.

Paper
Faces

PHOTOGRAPHS OF NAVAJOS AND HOPIS

On a bright fall day in 1930, Laura Gilpin and Betsy Forster made their way across the roller-coaster hills of the Navajo Nation in an old Buick. The photographer and her friend, a nurse, were traveling south over Diné Bikéyah, the sprawling Navajo land in the far northeast corner of Arizona, in search of photographic subjects. They had already been to Kayenta, where Gilpin had made the picture of the ancient "Cliff Dwellings of Batatkin, Arizona," and they were headed for Chinle, so she could photograph the exquisite cliff dwellings carved into rock at Canyon de Chelly.[1] But they got lost, misdirected by a white man, as Gilpin reported in her book, *The Enduring Navaho,* published thirty-eight years later. They ran out of luck—and out of gas—in a remote location twenty miles north of Chinle. In the book, which Gilpin dedicated to Forster, her lifelong companion, she wrote: "We were in the middle of a vast semidesert; visibility in every direction was fifty miles or more, but we saw nothing, not a distant hogan, nor a horse, nor a flock of sheep—just empty land."[2]

The women agreed that Gilpin should strike out on foot for help, with Forster remaining behind to guard the car and supplies. During her hours of walking, Gilpin met a Navajo man and a little boy, but as neither party

knew the other's language, the Indian man simply gave the white woman a gift of three peaches. Gilpin continued on, and after a ten-mile hike, she fortunately found Frazier's trading post. The trader's wife drove her back to the car with gasoline, and when they came upon Forster again, Gilpin wrote, "Never will I forget topping a gentle rise in the undulating desert and seeing the lonely car completely surrounded by Navaho Indians, like a swarm of bees around a honeysuckle. When we arrived, there you were in the midst of the gathering, happily playing cards with your visitors! Your ensuing tale of how the Navaho had arrived, two or three at a time, seemingly from nowhere, to find out what the trouble was and to offer help, both surprised and interested me."[3]

Breakdowns in the desert can quickly turn to disaster, and both women were clearly relieved by the tale's happy ending. But their felicitous encounter with these concerned Navajos went on to become an important footnote in the history of photography. Both women were touched and delighted by this reception, so much so that in the following year Forster accepted an invitation to return to the reservation to work as a field nurse. She spent eighteen months in Red Rock, an Arizona settlement northeast of Chinle, bordering New Mexico, and some thirty miles from the hospital at Shiprock. By Gilpin's account, Forster was a progressive-minded woman interested in Navajo culture. Though she was white and an outsider, she tried to work with the medicine men and to accommodate Navajo beliefs, and in time she became a beloved figure. Gilpin, then living in Colorado Springs, came to visit at least five times, and her status as the nurse's friend gave her an unusual entrée into the Navajo community to photograph.[4]

Thirty-nine years old in 1930, Gilpin had already made a name for herself with her Western landscapes. She had trained in New York with such eminences as Clarence H. White, but she'd been born in Colorado: the West was her native place. Gilpin saw her mission as the creation of a new art of the West, and she delved into the Navajo project with gusto. Between 1931 and 1934 she made lush black-and-white pictures of Navajos, gorgeously printed platinum and gelatin silver prints that became some of her most highly regarded work and probably the best-known images of Native American life in 1930s Arizona. These masterful pictures, beautifully composed and lighted, range from simple portraits of individuals and families, such as "Timothy Kellwood and His Family," a 1932 gelatin silver print that portrays Forster's interpreter and driver, his wife and two children, to complex scenes of Forster practicing her medical art inside the hogans of the sick. "Hardbelly's Hogan," a 1932 gelatin silver print, pictures the nurse ministering to an old man, who lies on his pallet while his family looks on. Light falls on them from above. And Gilpin made compelling images of figures in the landscape. In "Navaho Woman, Child and Lambs," a 1932

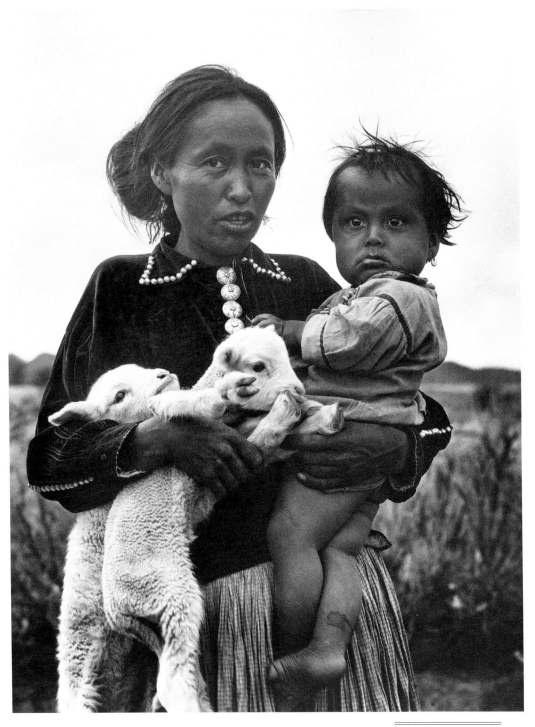

A Navajo woman gazes forthrightly at the photographer in a frank portrait that touches on important Navajo themes of family relationships, sheepherding, and the land. Laura Gilpin, "Navaho Woman, Child and Lambs," 1932.







platinum print, a young woman stands in the open land of Diné Bikéyah, the nation's largest Indian reservation. She's dressed up in her silver jewelry, but she stretches her arms around her greatest treasures, her wild-haired child and a pair of lambs. Gazing frankly at the photographer, the woman is a distinct individual, rather than an idealized type.[5]

These photographs have been praised by Gilpin's biographer, Martha A. Sandweiss, and others for their empathetic and dignified portrayal of Navajo life.[6] Many of the subjects smile back at the photographer. The portraits' intimacy was apparently made possible by Gilpin's relatively close relationships with her subjects—and by the forced "collaboration" required by her bulky large-view camera. The photos give glimpses inside houses, of looms, bedrolls, and dirt floors; they offer some views of Navajo ceremonies and, taken in the years just before the federal sheep "reduction" program, they evoke a landscape still filled with sheep, the traditional measure of Navajo wealth.[7] Gilpin returned in the 1950s to record the changes among the Diné in the intervening years, but "these early photographs, made between 1931 and 1934, have their own particular merit," Sandweiss notes.

> Documenting life in a small corner of the Navajo world, they provide a valuable visual record of a people overlooked by the great photographic surveys of the federal government's Farm Security Administration. Like the photographs made by Dorothea Lange, Walker Evans, Russell Lee, or any of the other photographers who worked under Roy Stryker to compile a photographic record of American life during the Great Depression, Laura's Navajo photographs document a particular people and their way of life.

Though Gilpin thought of herself as an artist rather than a documentary photographer, her Navajo work in time "has acquired the weight of historical document."[8]

Yet others disparage Gilpin's Navajo images for their romanticization of Native American life. Gilpin, argue such stern critics as James C. Faris, continued an already long photographic tradition of white photographers distorting Indian life and exploiting Indians for their own purposes. Faris alleges that Gilpin, like Edward S. Curtis before her, introduced props into her pictures—one of her own blankets appears again and again in photos of different people—and carefully avoided physical reminders of twentieth-century life. Gilpin inappropriately persuaded initially reluctant Navajos to consent to photographs, he charges; Gilpin herself wrote that "soon I learned how to overcome their natural shyness or antipathy to photographs." The photographer adds that her subjects were quite interested in her equipment

and "always wanted copies of the pictures I made," which she was happy to give.[9] But she sometimes exacted permission during times of illness, when family members were unlikely to want to offend the nurse's friend. In the case of the Hardbelly photograph, Gilpin remarked that the family "seemed pleased" she wanted to make a picture of the sick man. "In the circumstances," Faris declares, "they also had little choice."[10] The case against Gilpin is strengthened by the fact that Lilly Benally and her son Norman, pictured in Gilpin's lovely and often exhibited 1932 "Navajo Madonna," eventually sued the photographer's estate. Gilpin had bequeathed her archive to the Amon Carter Museum in Fort Worth, and an out-of-court settlement in 1989 restricted the museum's use of the image.[11]

Monty Roessel, a Navajo photographer working today, admires Gilpin's work, which he believes shows "her compassion and reverence for a way of life different from her own." He has no quarrel with "non-Indians photographing Indians" but finds it ironic that a white outsider's vision has helped shape the tribe's collective memory. A Navajo who looked at Gilpin's book told Roessel: "When my mom talks about riding a wagon to go to town or something, it is a photograph, maybe taken by this lady (Laura Gilpin) that gives me a picture of a way of life that has changed. It is the photograph that helps me understand my people better and tell my kids what life used to be like." Comments Roessel: "Whatever the reason, Indians have been defined by outsiders. Sometimes it is hard to discern what came first, the cliché or the photograph."[12]

The disagreement over Gilpin is part of a larger and troubling debate over the whole enterprise of white photographers photographing Native Americans. Cultural critic Susan Sontag denounced the practice as the "most brutal" and "predatory side" of photography.[13] But while acknowledging long years of photographic exploitation of Indians, some scholars argue that it would be wrong to assume that Native Americans were victims in every photographic transaction. Roessel recounts an amusing story that makes the point. An elderly Navajo woman complained to him that Gilpin's photos of bejeweled women were unrealistic, because "nobody wears their jewelry all the time." But when Roessel asked to take the woman's picture, she agreed, with one caveat: "Wait," she said. "Let me go home and put on my jewelry."[14] Like this woman, Gilpin's subjects may well have insisted on putting on their best for their pictures, and otherwise shaping the pictures for their own purposes. Indeed, for a later portrait of Hardbelly's wives, Gilpin agreed to postpone the shoot for two days "when their clothes would be freshly washed and they would all be ready for more pictures."[15]

Gilpin was acutely aware that she was following a long line of white photographers who had penetrated into Indian country. Her fateful car

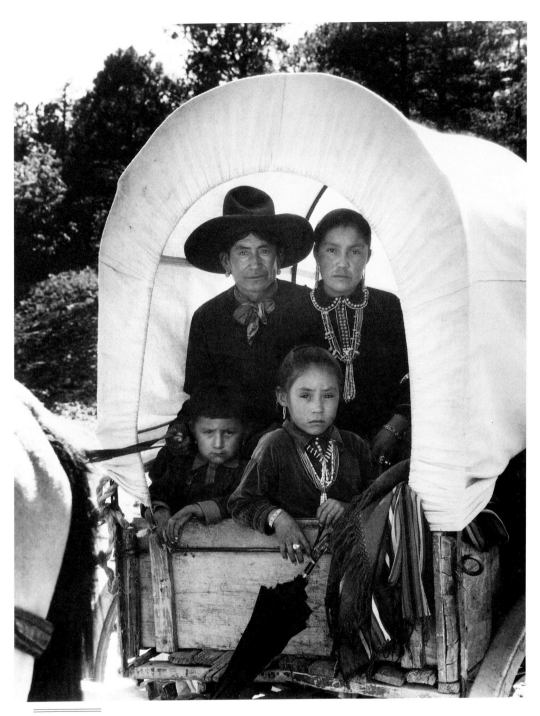

For this formal portrait, a Navajo family apparently dressed up in their finest jewelry and best clothes. Laura Gilpin, "Navaho Covered Wagon," 1934.

trip into Navajo land reprised earlier journeys photographers had made by horse, wagon, and railroad, to take pictures of the "exotic" Southwest land-scape, and its archaeological features and people. Hanging on the walls of Gilpin's childhood home in Colorado was a print of a famous Edward S. Curtis photo, of Navajo horsemen disappearing into the shadows of Canyon de Chelly. Gilpin herself wanted to try her own hand at shooting the ancient Indian cliff dwellings in Canyon de Chelly; after she and Forster got the Buick going again on that day in 1930, they continued on to the canyon. There, Gilpin remarked, she took "the same old shot that everybody has done from O'Sullivan down."[16]

Timothy O'Sullivan, an Irish American photographer who had distin-guished himself during the Civil War as a field photographer with Mathew Brady and Alexander Gardner, was just one of the hordes of nineteenth-century expedition photographers who flocked to Arizona and points else-where in the West, lugging their cumbersome wet-plate collodion equipment behind them. The announcement of the invention of the new medium in 1839 preceded by only a few years the great American project of Western con-quest and expansion. Photography became a new art form for a new land, as whites thought of Indian country. As early as the 1850s, expeditions financed by the railroads took along photographers to record cultural and physical features of the landscape; the government geological surveys undertaken after the Civil War followed suit.[17] The Hopis (sometimes called Moquis in the nineteenth century) and Navajos, living in the spectacular country of mesas, sandstone cliffs, and the Painted Desert in the northeastern corner of the Arizona Territory, were the most photographed of the Arizona tribes.

The Hopis, whose high mesa land is ringed by the Navajo Nation, saw photographers as early as the 1850s. The first known photos of Navajos were taken in the desperate years of their captivity in the 1860s in Bosque Redondo (Fort Defiance), New Mexico. They were confined in this alien territory following the catastrophic Long Walk, in which the U.S. Army rounded them up and marched them out of their beloved homeland.[18] These early captive pictures delivered mixed messages. Photographers wanted to show that these presumed savages had indeed been subdued: an 1868 photo by Henry Lorenzen pictures a desperate girl clad in rags. But photographers also included elements signifying the danger the Indians had once posed, placing, for instance, a bow and arrow in the arms of a young man being photographed.[19] O'Sullivan made some Bosque Redondo pictures, but he also photographed Navajos after they returned to their homeland in 1868. In his 1873 albumen silver print, "Aboriginal Life among the Navajoe Indians," a woman works at a loom that's likely been dragged outdoors for the photo-graph; several men are sitting nearby. Far from romantic, the group looks disheveled and impoverished, and most definitely defeated.[20]

Once the U.S. government had crushed the Native Americans, and the Indian Wars gave way to settlement and land appropriation, the early images of fierce warriors, primitive savages, and conquered hostiles gave way to romanticized visions of fading Noble Savages. Edward S. Curtis believed that Indians were becoming extinct, and his frantic life quest to record what he thought of as their disappearing way of life yielded his enormous twenty-volume work, *The North American Indian.* He photographed both Hopis and Navajos on his repeated journeys to Arizona, between 1904 and 1923. A gifted artist, Curtis was guilty of numerous anthropological lapses—using props, staging scenes, cropping out modern-day intrusions, even posing whites as Indians. Curtis was trying to re-create Indian life as it had been before contact and conquest; his controversial pictures have the dreaminess of a lost world.[21]

The Native American response to this photographic invasion can be gauged partly by the names they coined to describe the strange interlopers. "Shadow Catcher," often applied to Curtis, was actually "a term that appears to have been devised repeatedly and independently," writes Ira Jacknis. This "ominous phrase" suggested photography's ability to "remove some sort of essence of a person's character," or as the common expression has it, steal their soul.[22] In 1871, expedition photographer E. O. Beaman found that the acrid odor of his photographic chemicals so repelled the Ute Indians in Utah that they called him a "'koch weno; (no good) Medicine man.'" The following year, when he went to the Hopi mesas, Beaman found two factions: one camp thought of his camera as an "instrument of death"; the other hailed him as a "great medicine man."[23] A modern-day Hopi elder called Hopi photographer Victor Masayesva Jr. a *"Kwikwilyaqa,"* a katcina who "shadows anyone he can find, attaching himself to that person" and who "rapidly becomes a nuisance." The Utah Navajos in 1872 devised a more neutral term for photographs, the apt and poetic "paper faces."[24]

Indians who had no interest in having their faces turned into paper often resisted the photographers. Beaman described the Hopis looking "with wonder and amazement" on his pictures of their houses, but as soon as he turned his back "they were immediately destroyed or thrown away."[25] Photographers invented ways to thwart their resistance. Frederick Monsen, a Norwegian-born photographer of the Hopis, unabashedly described his techniques in articles he wrote for *Craftsman Magazine.* With the invention of the new easy-to-use Kodak in 1888, he enthused, he could hide three small cameras in his coat and photograph surreptitiously. He boasted that he could "snapshot any number of Indian subjects who are entirely unconscious that they are being photographed."[26]

But by the turn of the century, at certain Indian ceremonials, photographers were so numerous they didn't even try to conceal themselves. Observers described with amazement the crowds of whites who made the trek up to the

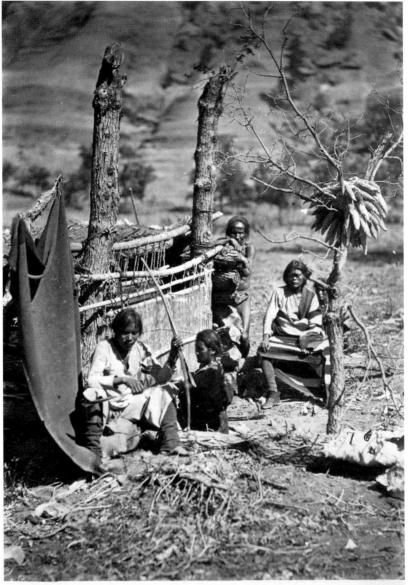

ABORIGINAL LIFE AMONG THE NAVAJOE INDIANS.

Near old Fort Defiance, N.M.

A group of defeated Navajos, including a woman at a traditional loom, are pictured back in their homeland after years of detention in Fort Defiance. Timothy O'Sullivan, "Aboriginal Life among the Navajoe Indians."

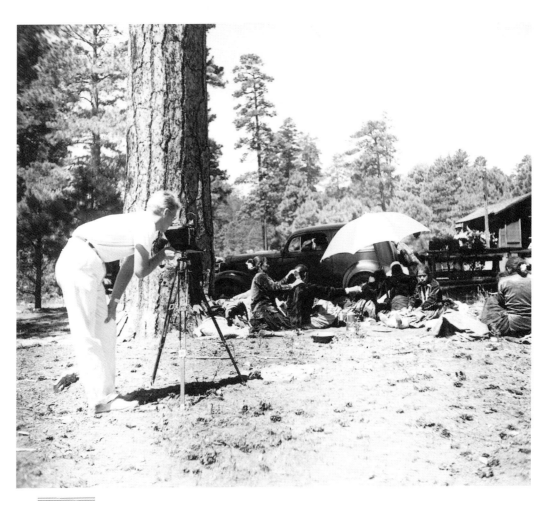

Bob Fronske photographs Navajo women outdoors, including one combing another's hair, at the annual Flagstaff All Indian Pow Wow and Rodeo. Fronske Studio, "Pow Wow," 1938–39.

Hopi mesas in August to see—and photograph—the Hopi Snake Dance. In many pictures from the period, the white visitors appear with their parasols and in their suits, seated on Hopi dwellings, crowding the edges of the plazas. (Curtis was known to fade out these untoward reminders of contemporary life.) Photographer Ben Wittick declared in 1899 that visitors came to Walpi from every major U.S. city, "anybody with a Kodak!"[27] In 1902, photographer George Wharton James recalled a "line of cameras" that scared the snake priests at Oraibi. The wife of Edward H. Kemp, a photographer for the Santa Fe Railway, wrote in 1905 that during the Snake Dance she and her husband had to stand in a crowded "photographer's row."[28]

Teddy Roosevelt, ex-president by 1913, the year he attended the Snake Dance at Walpi, wrote that he "did not happen to run across any Mormons at the Snake Dance; but it seemed to me that almost every other class of America was represented–tourists, traders, cattlemen, farmers, Government officials, politicians, cowboys, scientists, philanthropists, all kinds of men and women." The U.S. Indian agent, Leo Crane, resident at Walpi, got so fed up with the mobs of "ologists" that he proposed to the Hopis that they charge one dollar for "the camera privilege."[29]

The arrival of moviemakers ratcheted up the chaos. Thomas Edison filmed the Snake Dance in 1901; Curtis in 1904; William E. Kopplin, photographer for the Santa Fe Railway, in 1912.[30] The Kolb brothers of the Grand Canyon studio and Victor Miller of the publication *Pathe's Weekly* showed up to film the crowded 1913 ceremonies. Failing to sign a required agreement to use his movie only for "private or historical purposes," Miller was arrested after a dramatic nighttime chase across the reservation. His film was confiscated. It was apparently after this episode that Crane issued a total ban at Walpi: "no photographs, still, animated, or out of focus, should be permitted thereafter," as he put it in 1925.[31]

Most of the Hopi villages followed the example of Walpi, and by 1915, photography of ceremonials was banned nearly everywhere. Navajos enacted no formal ban, but their ceremonials had always been more difficult to photograph. They are not held at regular times and places, as the Hopis' are, and for healing rituals the photographer had to get permission from both the ceremonial singer and the family. The Hopis made some concessions to their photographer friends, allowing some photography of ceremonials well into the 1920s. Hopi photographer Masayesva, born in the 1950s, says that Hopi photographers, like their white colleagues, "wouldn't mind photographing the yearly round of ceremonials, were it permitted." But not photographing has a greater value: "Refraining from photographing certain subjects has become a kind of worship."[32]

By 1930, when Gilpin steered her Buick into Diné Bikéyah, the Depression had come to Indian country. "Hard times are upon us with no

work for the Indians, no market for lambs, no demand for Indian blankets or rugs which brings about a critical situation among the Indians of this tribe," Navajo Indian superintendent Samuel Stacher wrote, late in the year. Some of the families in his district were "almost destitute." Tuberculosis was common, as nurse Betsy Forster surely learned before too long. Gilpin did not photograph signs of this desperate poverty; the people in her pictures clearly do not have material wealth, but they appear to be living out a pleasant pastoral.[33]

And one would be hard-pressed to find signs of the ubiquitous poverty of Native Americans in commercial photographs of the era. The idea of Indians as a threat to white America had long since disappeared, along with discussions of the vanishing race. Instead, on postcards, travel brochures, and railroad advertisements, the American Indian had metamorphosed into something picturesque, even kitsch. Often photographed in culturally inappropriate Plains feather headdresses, Arizona Indians had become a tourist attraction, a cash commodity as valuable to Arizona as the giant saguaros in the southern part of the state and the Grand Canyon in the north.

Arizona Highways magazine was inaugurated by the state in 1925, in part to promote tourism, and, along with pristine landscapes, Indian pictures were a mainstay of its pages. The Hopi ban on photographing Indian ceremonies had been in effect ten years by the time the magazine got underway, but the ceremonies were still open to the public and were a great tourist draw. The editors devised creative—and to a modern sensibility, offensive—ways around the ban. The magazine ran its first article on the Hopi Snake Dance in July 1931, but the editors bypassed Indians altogether in the accompanying photo illustration. Instead they reproduced—darkly—a photo of white people in costume performing the sacred rites. These imitators were the Smokis, members of a men's club in Prescott, who had been "playing Indian" since 1921. The Smokis had their own kiva on main street, closets full of costumes, and their own version of the Snake Dance, which they danced every year until 1991. (The ritual met its demise under "pressure from the Hopi people," who never "viewed their masquerade as anything but insulting.")[34]

In 1932, *Arizona Highways* editors decided against more Smokis. For the vacation issue, they simply published a photo of the Hopi village of Shongopovi (misspelled as Chompovi) on the cover, and noted that it was one of eight villages that staged a Snake Dance. The next month, the editors grew bolder, and ingeniously substituted a carving for human beings. A studio shot of a Hopi katcina doll was posed with dramatic lighting, a stand-in, according to the caption, for an "Eagle Dancer." (By June 1971, the magazine had grown more outrageous: this time the cover featured a whole troop of katcinas in a dramatic outdoor setting, seeming to dance in procession

"Smokis" (members of a white men's club in Prescott) dress as Indians and perform their imitation of the Hopi Snake Dance. Bate Studio, Smoki Ceremonial Dance, 1930.

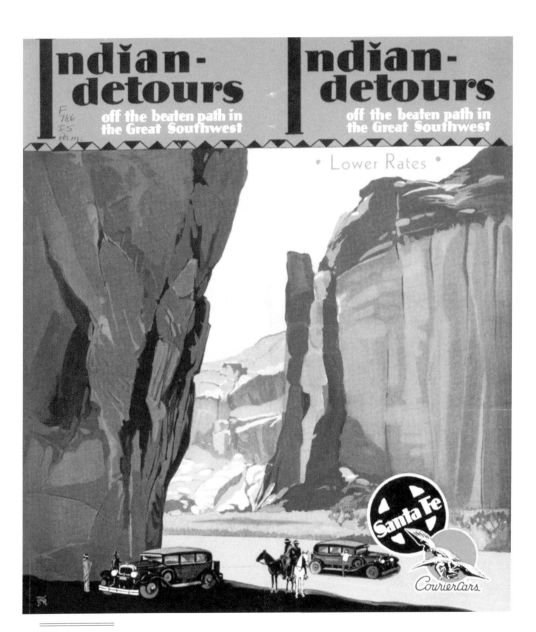

Colorful printed
posters and pamphlets
advertising the
Indian Detour trips
emphasized the exotic
western landscape
and its equally exotic
inhabitants.

over a rocky mesa. Inside, the katcinas were "posed against stormy skies and panoramic vistas.")[35] Such egregious departures from reality violated the spirit if not the letter of the ban, and suggested that the colorful trappings of the state's Indians were more important than real Indian lives, religion, and concerns. If the Indians themselves were not available for photographs, so be it: the image-makers would do without them.

Arizona Highways editors occasionally used old Snake Dance photos taken in the pre-ban days, drawing on the copious productions of the former members of "photographer's row." This practice, though more respectful, tended to situate a living tribe in the static past, conveying an impression of cultural rigidity. Hopis themselves sometimes wanted to record their own ceremonies, but turned to other media. The Hopi painter Riley Sunrise, for instance, painted the watercolor, *Mixed Kachina Dance,* around 1930.[36]

The Santa Fe Railway, eager to promote tourism along its southwest lines, had for years employed photographers to take pictures of the land and its native inhabitants. In 1926, in partnership with the Fred Harvey Company, the railway initiated a brand-new attraction: the Indian Detour. Wealthy tourists would pay to "detour" from the railroad tracks, traveling via chauffeured luxury Packards into the exotic backcountry of New Mexico and Arizona. Along with the pueblos of northern New Mexico, the Hopi mesas and the Grand Canyon were star attractions. On the Indian Detour, the well-heeled travelers couldn't always stay at Harvey Hotels, but they were comfortably lodged in the backcountry in "large tents complete with cots, blankets, pillows, lanterns and wash basins."[37]

Photography was crucial to the Detour enterprise. The slick graphics of the tour's print advertisements intermixed photos of Indian cliff dwellings with Indians themselves, collaged in with dramatic paintings and bold lettering. The Detour guides gave talks of an evening and illustrated their lectures with colored lantern slides of the "scenic and native attractions," provided over the years by the Railway's own hired photographers. And the Detour "was promoted as a photographic ramble."[38] Tourists loaded down with cameras took pictures of Indian subjects, and more often than not they jumped in to get their pictures taken as well. In one of many Grand Canyon photos, hired Indians in Navajo traditional dress (with one in the ubiquitous Plains feather headdress) stand at the railroad station, poised to greet visitors. Hundreds of thousands paid handsome fees to ride the Detours, including such luminaries as Eleanor Roosevelt, Harry Guggenheim, and John D. Rockefeller Jr.[39] In an often-reproduced photo, Albert Einstein and his wife pose with costumed Indians at Hopi House at the Grand Canyon, proving that even the theorist of relativity was not immune to the allure of kitschy tourism.[40] In his picture he sports a feather headdress and holds an Indian child by the hand; his wife has placed a shawl over her head. The

Detour photographs are ostensibly respectful of Indian arts and crafts, but the hired Native Americans surrounding the Einsteins are reduced to colorful props. An Indian man in a velvet shirt plays a drum, while a costumed couple look at the camera matter-of-factly, doing a job that doubtless brought in much-needed income to their families. Tourists treated themselves as well to the many "humorous" Indian postcards on offer during the 1920s and 1930s. The postcard photographs reproduced such amusements as a naked Hopi toddler on a ladder, captioned "Cupid in Hopiland." Similarly, the "Hopi Romeo and Juliet" featured a Hopi man on a ladder peering at a woman seated in the window of her steep stone house.[41]

There were some antidotes to these insulting images. The Museum of Northern Arizona in Flagstaff began sponsoring its respected Indian craft fairs in the 1930s. The museum's fairs promoted quality Indian artists and their finely crafted blankets, baskets, and jewelry as a counterpoint to cheap tourist-market throwaways; photographers made pictures of the craft fair winners. These respectful, if workaday, portraits today are important historical documents: they record individual Indian artisans, who are named and honored for their art. Other photojournalists documented assorted Bureau of Indian Affairs work projects on the reservations, both in Hopi and in Navajo land. These pictures cast an approving eye on "modernizing," hardworking Indians, whose work shirts and trousers demonstrate that they're moving into the American mainstream. One image from the period shows a quintet of Hopi men with shovels, taking a break from their hard labor of excavating a reservoir. Milton Snow and other government photographers on the Navajo reservation engaged in similar work. Additionally, white women married to traders on the reservations generated a whole subgenre of Indian photographs in the 1930s; these women lived in Indian country for years and, while they were not artists, they knew their subjects well.[42]

Documentarians argue that such images are more authentic and more "real" than Gilpin's far lovelier pictures. But aesthetics cannot be discounted. Gilpin saw herself as an artist rather than a documentarian, and as an artist, she felt free to crop and pose and light where she chose. Some of Gilpin's written characterizations of her Indian subjects, such as her clichéd observations on their "dignity" and "acceptance of things as they are," make a modern reader wince.[43] But in the context of the 1930s, Gilpin was a progressive. To understand how respectfully she approached her project, one has only to compare her work to the tourist dreck that trivialized Native American culture and insulted Indian people—or contrast her relations with Navajos to that of early photographers who tricked their subjects and disrupted their ceremonies. It's important to know that her works were often staged—like Masayesva, and like all photographers,

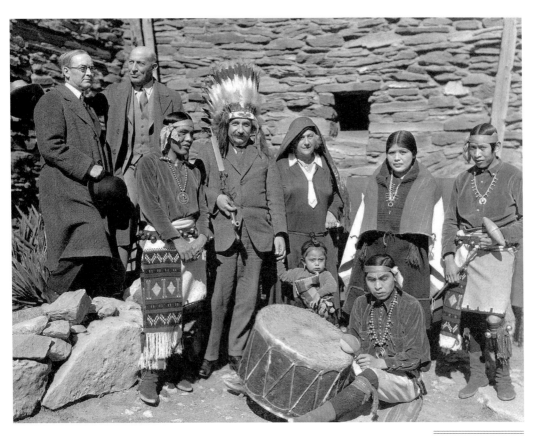

Joined by costumed
Native American
workers, Albert
Einstein and his
wife dress up at the
Grand Canyon's
Hopi House during
an Indian Detour.

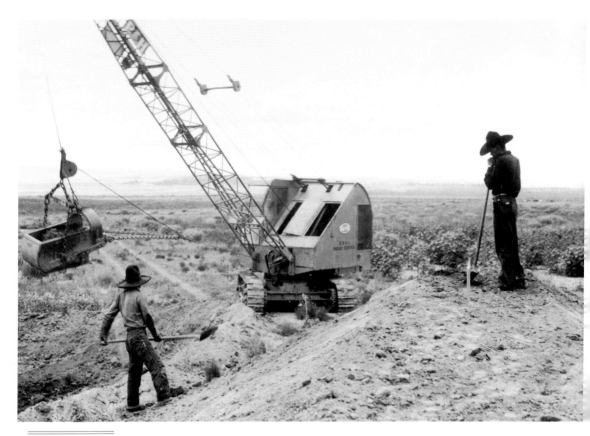

Navajo workers on
the Reservation,
employed by the
Soil Conservation
Service, excavate the
land with old-time
shovels and modern
machinery alike, in a
picture that suggests
they're moving into the
American mainstream.
Milton Snow.

she could be an annoying Kwikwilyaqa—but it's hard to argue against the merits of her work. Her luminous portraits are especially valuable today, now that so many of the elders they picture are dead.

The tricky issue of rights to photographs of nonconsenting Native peoples will continue to stymie ethicists, especially in the wake of the passage of the 1990 Native American Graves Protection and Repatriation Act. As Navajo photographer Monty Roessel notes, one solution to the dilemma of authenticity and ownership is for Native photographers to photograph Native people themselves. Tin Horn, the first known Navajo photographer, was working as early as 1914, making at least one picture of a Navajo family camped out with their horses. The Hopi photographer Jean Fredericks, born in 1906, began taking simple but telling portraits of family and friends by the 1940s.[44]

"What Laura Gilpin thought was important was, I am sure, not what Navajo people thought was important," Roessel has written. "But (her) time has passed. It is now up to the Navajo to define themselves."[45]

Milton Snow
snapped this shot
of Julian Hayden
(below) preparing
to climb up to the
Keet Seel Ruins.

KATHERINE G. MORRISSEY
AND NANCY J. PAREZO

Scientific Photography?

CAMERAS AND 1930S SOUTHWESTERN ARCHAEOLOGY

Riding their motorbikes through the Mohave Desert, two young men from Riverside, California, spent their weekends exploring mountains and mines, sleeping in bedrolls, and taking photographs. For the teenaged Julian Hayden and his friend Milton "Jack" Snow, just a few years older, these wonderful excursions broke up their weeks working construction and doing odd jobs. The young Hayden found new employment in 1929, alongside his father, archaeologist Irwin Hayden, on excavations funded by the Los Angeles County Museum. When he learned they were in need of a photographer, he recommended his pal Snow. Soon both friends were in central Arizona, at Coolidge, the Grewe Site, and Casa Grande. Although their employment was sometimes uncertain, Hayden and Snow worked in Arizona during most of the 1930s and, as their jobs drew them apart—Snow to photographic work with the Navajo Service and Hayden to archaeological work on the sites of Gila Pueblo, Snaketown, and Pueblo Grande—they still took excursions together, at times to visit other prehistoric sites, such as Keet Seel.[1]

In the late 1920s and throughout the 1930s, archaeological surveys and excavations—and photographs produced from them—proliferated in

the Southwest, especially in Arizona.[2] Several privately funded institutions, located both outside and, increasingly, inside the state, sent out expeditions on which self-made and professionally trained archaeologists worked side by side. The Field Museum of Natural History in Chicago, the Peabody Museum of American Archaeology and Ethnology at Harvard University, and the Southwest Museum in Los Angeles were among those that sponsored such Southwestern projects during the decade. The Casa Grande and Grewe Site excavations that had brought Hayden and Snow to Arizona in 1930 and 1931 were part of the Van Bergen–Los Angeles County Museum Expedition from southern California. Other work at these central Arizona sites was done under the direction of Harold Gladwin, who, along with his wife, Winifred, operated the active Gila Pueblo Archaeological Foundation out of Globe. Another couple, Harold and Mary-Russell Colton, pursued their Colorado Plateau archaeological interests from Flagstaff, where they had established the Museum of Northern Arizona in 1928. William S. Fulton began excavations on his own ranch property in Texas Canyon, Dragoon Mountains, during the early 1930s and founded the Amerind Foundation there in 1937 as a third private archaeological research institution located in the state.[3]

More archaeological projects emerged from public institutions, some with private funding, others with government monies. From Washington, D.C., the Bureau of American Ethnology of the Smithsonian Institution sponsored Southwestern work. In Phoenix, the city-owned Pueblo Grande site was developed by Odd S. Halseth and Julian Hayden. In Tucson, Byron Cummings and, later, Emil Haury directed the University of Arizona's Arizona State Museum work. All of this activity crescendoed in the summers, especially in the region's higher elevations, when university students and their professors from Arizona and elsewhere crisscrossed the Southwest, participating in field schools and on multiyear field projects. One of the most sustained operations during the decade, the Rainbow Bridge–Monument Valley Expedition, brought students and scientists to the Navajo reservation every summer between 1933 and 1938. Although privately funded, the expedition had been initiated by Ansel Franklin Hall of the National Park Service.[4]

In the Depression decade, federal government funds for these projects frequently came from New Deal programs. The Federal Emergency Relief Administration and Civil Works Administration supported 1933–34 excavations at Wupatki, Casa Grande, and Tuzigoot, for example, and the Public Works Administration and Civilian Conservation Corps participated in archaeological work in different parts of the state.[5] In 1938, the leading Arizona institutions—Museum of Northern Arizona, Gila Pueblo Foundation, the City of Phoenix's Pueblo Grande Museum, and the University of Arizona's Arizona State Museum—banded together to run an extensive group of statewide Work Projects Administration–funded projects.[6]

Civilian Conservation
Corps workers took part
in the Pueblo Grande
Ruins excavation in
the 1930s.

As the employment of Jack Snow suggests, photography was an integral part of these numerous projects. Cameras had become an increasingly essential research tool; trained as well as amateur photographers produced thousands upon thousands of photographs as part of the scientific work. They captured landscapes for use by surveying and mapping site locations and recording artifacts and activities at excavation sites. In the 1930s, archaeologists experimented with different angles of vision to aid in their off-site interpretations, evaluations, and syntheses. They concomitantly created new data by documenting the changes wrought by the excavation itself through artifactual removals and by cataloging specimens as they were placed in museum collections. This photo essay explores these 1930s

archaeological photographs as scientific documents, cultural representations, and artistic images.[7]

Photographs of ancient ruins and cliff houses have long linked the Southwest with a romanticized archaeology in the cultural imagination. From A. C. Vroman to Laura Gilpin to Ansel Adams, photographers have created evocative images conjuring up lost civilizations, heroic explorations, and exotic treasures. Although most of the 1930s archaeological black-and-white photographs were created with scientific purposes in mind—to document excavation procedures, to record stratigraphy and artifact location in both the horizontal and vertical planes, and to serve as reality checks for field sketches—they resonate with these already established meanings.[8]

This expansive view of the partial excavation of Tuzigoot displays the work accomplished during the ten-month project.

Notice the shadows of the photographer and tripod against the cliff in this stratigraphy photograph.

Photographs of artifacts, pottery sherds, wood specimens, structures, cross sections, and unearthed bones abound. Archaeologists used cameras as extra eyes, recording details that might be unnoticed during fieldwork but might become critical for later analysis. In the field, cameras captured the objects in situ, showing their contextual location, in comparison to other objects and site features, before removal. There were proper procedures for performing this activity, photographic techniques meant to transform "finds" into objective evidence. But there was always an element of artistic ability as well. To capture the nuances of artifacts on film, a talented photographer needed to manipulate the setting—creating shade, shadows, and contrast.

Proper procedures included framing the shot to eliminate foreign objects, especially anything that smacked of modern life—including people. In the darkroom, the film developer often airbrushed field shots that had too many signs of the present, constructing the archaeologists' projection of an imagined past. Telephone and telegraph poles were eliminated from long shots to enable the viewer to focus on the landscape, just as evidence of excavators was removed to keep the focus on the site layout and the stratigraphy.

Despite these and other obvious alterations of the site, the idealized archaeological rhetoric of the time expounded on the need for accuracy, cleanliness, and rigor. "Cleanliness" meant not only a neat and tidy work site, with "irrelevant" items removed from view, but also precision. An arrow, marked with a measurement and pointing north, might be prominently displayed in the scene to show scale. Or perhaps a surveyor's measure, shovel, or pick would be lined up to show depth. Precision, accuracy,

A member of Harold
Gladwin's party took this
"keyhole" photo looking out
of the "White House" cliff
dwellings in Canyon de Chelly
in May 1931.

The man and the surveying stick both serve as measurement references in this excavation trench photograph.

and measurement—these characteristics implied an exact factual rendering of the site, an objective scientific document. But the resultant photographs created a subjective scene that presented a particular ordered vision of a controlled landscape. And individual photographers selected their shots in ways that reflected their own interests—whether scientific, artistic, or both.[9]

A photographer first, and an archaeological worker second, Snow, for example, carefully composed his images in ways often at odds with his employer. As Julian Hayden later recalled, "Jack . . . insisted on taking the metal numerals out of cremations before photoing, which drove Dad to distraction, for he needed the numbers, and Jack swore they were Not artistic!"[10] There was more involved than a beautiful photograph: there was reputation at stake. The 1930s was a period of professionalization and increasingly rigorous field methods, with the divide between professionals and amateurs becoming more pronounced. Irwin Hayden spanned this divide and he wanted to make sure that his excavations and recording methods stood up to the professional scrutiny of individuals such as Emil Haury, Lyndon Hargrave, J. O. Brew, and Alfred Kidder. To take out the metal numbers would be using outmoded recording techniques. Standardization was the watchword of the day. Numbering the items within the photograph allowed later specialists to compare pottery found in different sites, for example.[11]

Along with these abstract items, photographers frequently included human forms for the same purpose—a man curled up in an empty grave,

Artistry and skill are involved in taking photographs of artifacts *in situ*. Here you can see the shadows of cameraman, tripod, and assistant holding a shade over an artifact.

Man curled up
in grave.
Gila Butte.

a woman standing in front of a cliff, pointing to a particular strata. Odd images, perhaps, out of context, these uses of the human form as objects, as abstractions, call attention to the manipulation of the audience as well as the site. For the archaeologist, these posed images provided context as well as scale, focusing the viewer's eyes on critical details or emphasizing how ancient peoples might have used an object.[12]

Once organized and catalogued, groups of artifacts were photographed against a neutral background or graph paper to aid in measurements. In doing so, these carefully arranged artifacts, divorced from their environmental contexts, became part of a different conversation, intended to be analyzed and interpreted. However such items were originally used, now they served as scientific specimens. These photographs articulate the allegiance most Southwestern archaeologists paid to new ways of interpreting ancient cultures, through comparisons of cultural objects.[13]

Activity shots—informal photographs of crew members in the field—required a less-exact form of photography. These were often taken by fellow excavation workers, rather than by the expedition's official photographer, and usually with their own cameras. Hatti Cosgrove, at work at Peabody Museum's Awatovi site on Antelope Mesa, Hopi reservation, was well known for her ubiquitous Kodak. The snapshot of ceramics specialist Anna O. Shepard, hard at work with her father, Henry Warren Shepard, as her assistant, may have been

This typical arrangement of grouped artifacts, photographed against graph paper, is part of the Gila Pueblo Archaeological Foundation work.

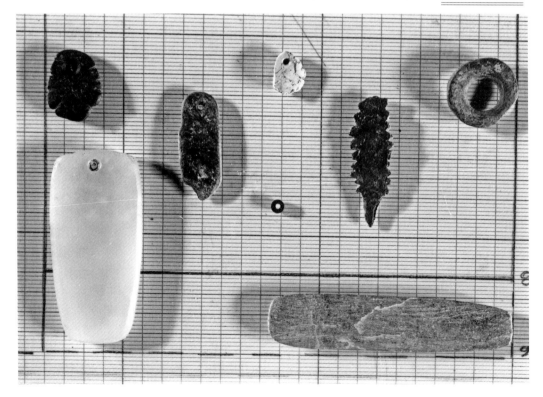

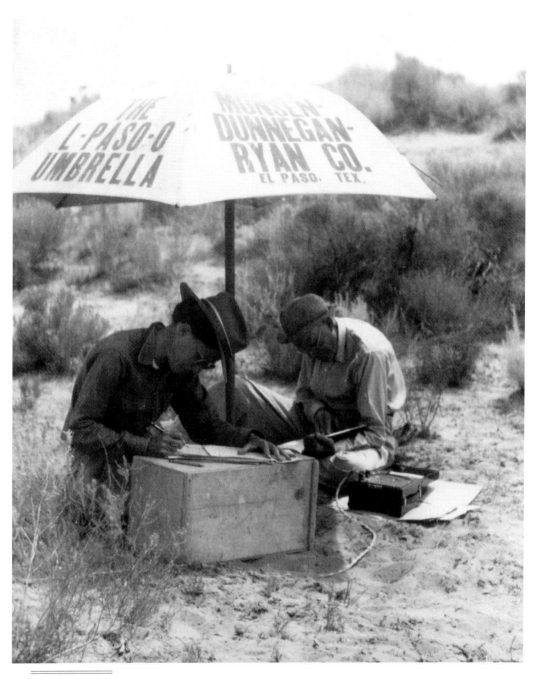

Anna O. Shepard,
making test firings of
sherds and clay samples
at Awatovi, with her
father, Henry Warren
Shepard, as her assistant,
Summer 1938.

taken by Cosgrove. Photographs of field school experiences proliferate with shots of leisure activities—the ever-present games—as well as work activities. Formal group shots, reminiscent of the photographs taken during primary and secondary school, celebrated the end of the season.[14]

In many ways these photographs depicting everyday life as well as unusual events have much in common with tourist snapshots. But they also resonate with cultural meanings specific to anthropological work.

The activity photographs often celebrated the heroic nature of the expeditions, depicting the intrepid archaeologists overcoming environmental hazards, whether sandy roads or snakes. In these instances, the travelogue nature of archaeology, the expedition that involves danger and adventure, was duly recorded for posterity. Cameras documented unpaved roads and camping conditions, especially those lacking amenities in remote areas. They featured cars, especially as archaeologists tried to ford fast-moving streams after a rainstorm, got stuck in the mud, rolled off the backs of cliffs, or had flat tires. Testifying to the difficulties of the outdoor work and elevating physical activities above the static objects of their study, these images also showed the ingenuity of archaeologists in using their skills in working well in the wilderness. They suggest the imagined connections the field workers established with the "primitive" past as they shared the environment and

The five Dennis brothers, Elwood, Leland, Emery, Chester, and Alex, at Keams Canyon dig.

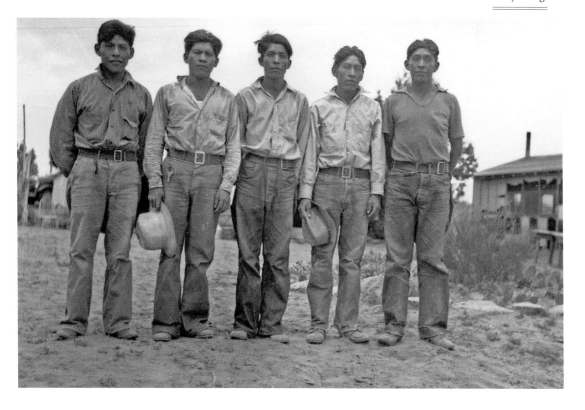

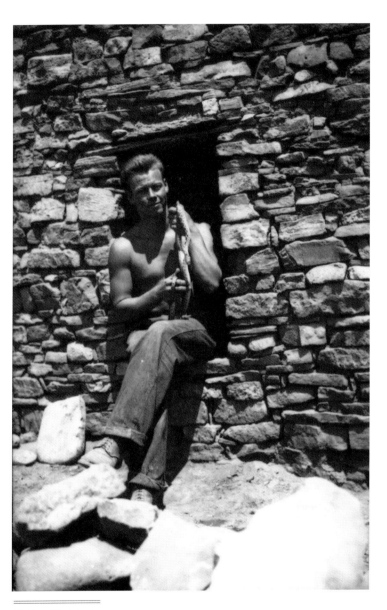

Unidentified Anglo
field worker in ruin
opening, handling a
snake. Tad Nichols.

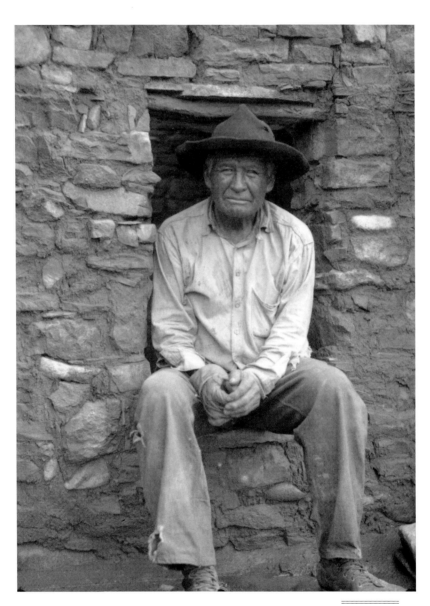

Unidentified
Apache field worker
in ruin opening.
Tad Nichols, 1936.

locale with their ancient subjects. At Wupatki, National Park Service custo-
dians even lived in the reconstructed ruins.[15]

Compared to the images of the heroic archaeologists, representations
of Apache, Hopi, Pima, and Navajo workers, lined up against the ruins, car-
ried different ethnographic meanings. For anthropologists, such images
might recall late-nineteenth-century anthropomorphic portraits, which had
been used to demarcate physiognomic types and to support now-outdated
evolutionary theories. Even for positivist scholars, subject photographs had
long been considered important for documenting the "real." Consider, for
example, the two photographs by Tad Nichols, taken at the University of
Arizona's field camp at Kinishba Ruins, near Fort Apache. Each depicts a
seated field worker, framed in a ruin opening, but the two photographs con-
vey different meanings. The Apache paid laborer, gazing directly at the cam-
era, and a fellow archaeology student, sitting cross-legged, held different
relationships to the photographer, and strike different poses. Whether con-
sciously created or not, Nichols's angled snapshot of the muscular young
student controlling a snake contrasts sharply with his quiet, symmetrical
portrait of the Apache man contained within the view.[16]

As excavation techniques improved and became more fine tuned in
the 1930s, new demands were required of photography, which had come
to be accepted as superior to field sketches for documenting site features.
Individuals developed special skills, whether photographing survey grids or
plotting postholes in room floors. One of the pressing needs was to solve the
problem of photographing large expanses while standing on the ground. A
wide-angled lens helped some; standing on the roof of a truck or a ladder
was also a solution.

Archaeologist Emil Haury, who excavated for the Gila Pueblo
Foundation and later for the Arizona State Museum, constructed a special
ladder to facilitate photographs from a bird's-eye view. Haury, who stood
six feet three inches tall, made the fifteen-foot ladder for his own measure-
ments, which often forced his students and colleagues into awkward stances
when they used it.

Systematic excavation and survey required that a site be photographed
from as many angles and heights as possible. Sometimes this requirement
involved considerable acrobatic skill. On a cliff near Sierra Ancha, along the
Mogollon Rim, Haury had to lean out to capture an expansive view. The pre-
carious perch required someone to hold onto him so he would not fall off.[17]

Another solution was aerial photography, which had the advantage
of a single photograph covering an entire site, even one that spread over sev-
eral acres. Southwestern aerial photography developed as a specialty in the
1930s. At Awatovi, Edward P. Beckwith, along with commercial operations
Fairfield Air Photos and Spence Air Photos, captured overviews of fieldwork

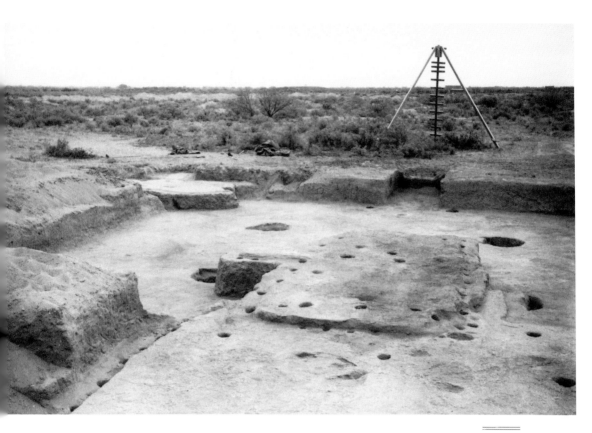

This site
photograph shows
Emil Haury's
photo ladder
for recording
excavations.

Emil Haury stands
on a perilous perch as
he photographs near
the Canyon Creek
ruin and Sierra Ancha
cliff dwellings.

sites. And those were not the only aerial efforts at the Peabody Museum site; using a practice that dated from the late nineteenth century, Alden Stevens launched a photographic box kite for the same purpose (see below). The attraction of the removed perspective appealed to the young Tad Nichols, who snapped aerial photographs of Kinishba Ruins in 1936.[18] Though Nichols, a University of Arizona student at the time, had yet to develop his skills in aerial photography, taking photographs from on high was becoming part of the archaeological vision. The distant view revealed broad patterns, as it concealed the messy details and debris below. It offered a sense of mastery over the landscape, providing a perspective unavailable from the ground. One could photograph a site being excavated in relation to other sites, trails, rivers, groves of trees, and other critical landscape features. One could even see sites that were all but invisible from the ground as well as changes in vegetation zones, buried canals, walls, and ditches.[19]

One problem with aerial photography was that it was expensive. Connections helped. Archaeologist Neil M. Judd parlayed his World War I experience into the involvement of the U.S. Army Air Corps for aerial surveys in the Gila River and Salt River watersheds. Joined by Odd Halseth, Judd and the Air Corps lieutenants focused their attention on disappearing Hohokam sites and canals. With Lt. Edwin Bobzien piloting the Douglas O2-H observation plane, photographer Sgt. R. A. Stockwell manipulated the bulky forty-two-pound Fairchild camera from the open rear cockpit. For Judd, the

Alden Stevens launched his photographic box kite at Awatovi.

This 1930 Army
Air Corps aerial
photograph
depicts a section
of the Park of
Four Waters, near
Phoenix.
R. A. Stockwell.

Pilot Lt. Edwin Bobzien
and photographer
Sgt. R. A. Stockwell,
here safely on the
ground, demonstrate
their positions for
"'Shooting' Oblique
Pictures," as part of the
1930 aerial surveys.

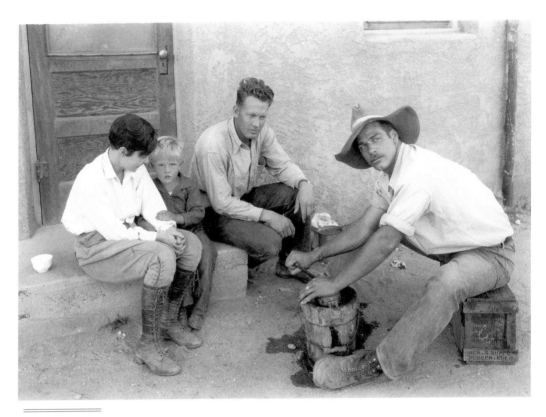

An informal shot of pal Julian Hayden, churning ice cream in Coolidge, Arizona. Milton Snow.

resulting aerial photographs provided "trustworthy data" that enabled the creation of a "permanent record" before the Gila River watershed's transformation, soon to be set in motion by the completion of the Coolidge Dam.[20]

Whatever the angle of vision—aerial, ethnographic, scientific, artistic, romantic—archaeological photographers presented a distinct perspective on 1930s Arizona. Though most frequently published in scientific papers, some of these photographs entered the mainstream media through newspaper reports, *Arizona Highways,* and museum displays. These photographs translated and interpreted the scientific information obtained from survey and excavation to the public, directing their view of the ancient past. In the chaos engendered by the Depression and drought, perhaps the contemporary explanations and evidence of earlier Anasazi, Hohokam, and Mogollon peoples who had confronted similar crises offered some comfort.

Being an archaeological photographer involved many skills—having a good eye, an understanding of light and perspective, a mastery of photographic developing and printing techniques, and disciplinary knowledge. Though they recognized that "cameras lie," archaeologists also relied on the instrument to control and shape a particular version of the past. As Frank Hole and Robert Heizer have argued, "in the hands of a skilled operator the camera can be made to do what the archaeologist wishes."[21] Most photographs taken by archaeologists were not "professional quality," but they still

accomplished a wealth of purposes. The camerawork that had helped shape a field of knowledge was shaped in turn by cultural ideas and values.[22]

Today the majority of the images fill boxes and binders in museums and repositories, largely hidden from view. Brought to light, the photographs reveal considerable overlap between their roles as scientific documents and artistic images—a tension sometimes recognized by their 1930s creators.

Although Snow pursued a career as a photographer and Hayden became a distinguished archaeologist, Julian, like other field workers, learned to wield a camera as well. In his early 1940s field reports from Ventana Canyon, he included photographs taken with a new Leica camera. But he made a distinction between his scientific photography and his artistic efforts. He sent along some of the images, yet, as he explained in a note, "most of the activity shots were angle shots, in which I was trying for dramatic lighting, etc. and I'm keeping those for a while."[23]

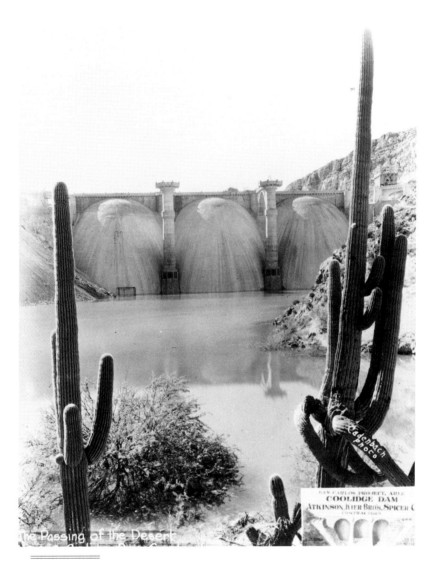

SAN CARLOS PROJECT, ARIZ
COOLIDGE DAM
ATKINSON, KIER BROS, SPICER C
CONTRACTORS

The Passing of the Desert

Coolidge Dam.
Joseph Cadenbach,
"Passing of the
Desert."

KATHERINE G. MORRISSEY

Dams and Erosion

INTERPRETATIONS AND REPRESENTATIONS OF ARIZONA'S ENVIRONMENT

There's an image that has haunted me for several years. Ever since viewing it in the National Archives' Still Pictures Collection, it has lingered in my mind and teased my imagination. And it is not just the image itself that has intrigued me, but the combination of pictures and texts represented in the photograph. Titled "Passing of the Desert," the photograph depicts the final construction stages of the Coolidge Dam, in Arizona. Visually striking and carefully composed, it is, in many ways, a distinctive Arizona image: the water control project is both located within and characteristic of the state; the saguaro cacti define its ecological location in the Sonoran Desert. The photograph, taken by Joseph Cadenbach, celebrates the transformation of arid lands into an implied agricultural paradise made possible by the dam.

More recently, I've been intrigued with another photograph, this one by Milton "Jack" Snow, taken on the Navajo reservation in 1939. Titled "Erosion in Granunoa," the photograph depicts the gullying process in a grass rangeland. Like the Coolidge Dam photograph taken some ten years earlier, Snow's image is visually striking and carefully composed. It, too, marks a transformation. In this case, however, the photograph emphasizes the destruction of productive land.

As an environmental and cultural historian, I'm interested in the various visions of the environment portrayed by 1930s Arizona photographers.[1] These two evocative images, shaped by the artistic talents of their photographers, reflect cultural ideals held by Depression-era Americans. Both images depict human interventions in nature. They identify environmental problems—water control and soil erosion—that absorbed local, regional, and national attention. Less visibly to a twenty-first-century audience, perhaps, are the ways these photographs participated in 1930s debates over competing

interpretations of the Arizona landscape, especially concerning the role of dams and the causes of soil erosion. To learn the story of those debates, let's return to the opening image.

The Coolidge Dam picture was shot by a commercial photographer in the employ of the Los Angeles–based Atkinson, Kier Bros, Spicer Company, the construction partnership responsible for building the dam.[2] It shows off the dam's unique design; the double-curved dome structure,

Milton Snow, "Erosion in Granunoa."

with two buttresses supporting three inclined egg-shaped domes, is the only example of a multiple-dome dam built in the United States.[3] Taken one year after the beginning of construction, the photograph portrays the dam essentially complete. Although work continued on gates and valves, water has just begun to fill up the reservoir behind the dam. By framing the dam with the two foreground saguaro cacti, the photographer contrasts symbolic representations of desert and water. The next photograph in the sequence, reproduced on page 173, makes the point even more tellingly. In this image, taken sometime later by the same commercial photographer, the rising water has half submerged the cacti, now placed in the middle ground. In both images, the dam's reflection in the water reinforces the dominance of the built environment. There's not much of the desert shown here. The mirrored image in this second photograph, eerily enlarging and uniting elements of nature and human construction, also calls attention to a stylized pose, likely familiar to its viewers. Nineteenth-century landscape photographers often arranged their views in such a manner, with bodies of water reflecting grand scenes of forests, mountains, or cliffs. Following this photographic tradition that celebrated the scale and power of the western natural environment, the Coolidge Dam images celebrate the scale and power of the western built environment.[4]

Although the photograph's power derives in part from its apparent transparency of meaning, the written text associated with this image also guides the viewer's interpretation. Most notably, of course, it does so through the caption that situates the image in its historical and cultural moment. The Coolidge Dam, as the attached label indicates, was part of the larger San Carlos Project. This irrigation and flood control project on the Gila River, long under discussion, consideration, and debate in Arizona and in Washington, D.C., had been authorized in 1924. But the controversy over the water shortages that plagued farmers along the Gila dated from the late nineteenth century. Complaints from Apache Indians on the San Carlos reservation and from Pima and Maricopa Indians on the Gila Indian reservation about the appropriation of increasing amounts of water by non-Indian settlers upstream from their respective reservations, as well as periodic floods, drew attention to reclamation needs. The drawn-out political struggle also pitted Gila River settlers against Salt River Valley residents as they clamored for federal funds authorized under the Newlands Reclamation Act. Portions of the eventual project received appropriations as early as 1916, but the San Carlos Project bill failed numerous times in Congress, frustrating Arizonans eager for agricultural development. Its final approval placed the project under the control of the U.S. Indian Service, not the Bureau of Reclamation. The project provided water control systems for both Gila Indian reservation lands and non-Indian lands in the

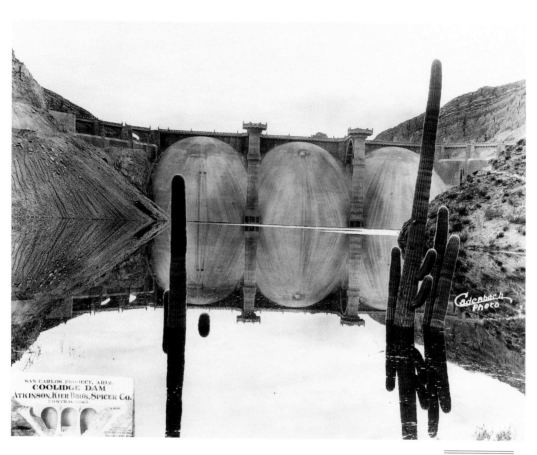

Coolidge Dam.
Joseph Cadenbach.

A rigger balances on
a cableway headtower
during the construction
of Boulder [Hoover]
Dam. Ben Glaha, 1934.

Florence–Casa Grande Valley. The keystone of the system of diversion dams and canals was Coolidge Dam.[5]

Dedicated with great local fanfare and excitement in 1930, the Coolidge Dam would soon be overshadowed by another dam that was under construction in the northwest corner of the state between 1931 and 1935.[6] The Coolidge Dam was dwarfed not only by the monumental size of the Boulder (Hoover) Dam, but also by the length of its construction phase, the number of photographs taken of the process, the public interest in the project, and the symbolic resonances of the dam's representations. Local photographers, such as Norman Wallace, along with federal photographers, such as the Bureau of Reclamation's Ben Glaha, and commercial photographers, such as the McCulloch brothers, took thousands of images of the Hoover Dam project.[7]

Dams, especially during their construction phases, were a popular subject for photographers—professional and amateur, official and unofficial. The first issue of *Life* magazine, in 1936, featured the striking series of images shot by Margaret Bourke-White to document the construction of Montana's Fort Peck Dam. There is a common appearance to 1930s dam pictures; different photographers replicated the similar views, subjects, and angles as they took their shots, repeating rhythms of massive concrete buttresses, juxtaposing workers against the geometry of machines and nature.[8] The photo files of construction at Arizona's dams—Coolidge, Parker, and Hoover dams, for example—look remarkably similar. Partly the shared vision was a result of shared limitations—of access to the site and of photographic equipment, for example. But the perspective was also shaped by cultural expectations of what dams represented.[9] When Secretary of Interior Harold Ickes celebrated Hoover Dam's "conquest of nature," he expressed a widely shared sentiment. The images, like the dams themselves, celebrated human mastery over the power of nature. The encapsulated message, as articulated in the dam photographs, revealed the successful application of technology to control nature. And the use of the technology of photography to control the representation of that process underlined that ethos.[10]

The concerns of the Depression decade added to the power of the dam photographs. Documentary photography in the 1930s, as David Peeler argues, was about "rendering order from chaos."[11] Discovering patterns within the uncertainty of the Depression, government-sponsored photographs projected optimistic perspectives of economic opportunity and growth. And they linked federal government activities with economic recovery. The control and symmetry characteristic of the dam photographs contributed to their value as national metaphors. Hoover Dam, celebrated as an engineering and technological marvel, became a national symbol of economic recovery; the size and scale of the project echoed that of the national

Norman Wallace,
an Arizona
State Highway
Department
employee, found
this row of pipes
camera-worthy
when he visited the
Boulder [Hoover]
Dam site on
January 28, 1934.

New Deal agenda. The Coolidge Dam, with its symbolic meanings tied to Arizona deserts and to agricultural productivity, paled next to the broader associations connected to Hoover Dam.

Arizonans, however, found Coolidge Dam more appealing than Hoover Dam. Although the Colorado River dam may have symbolized economic recovery at the national level, locally it held less positive connotations. It was, an editorial in the *Arizona Daily Star* proclaimed in 1935, "a monument to greed and the despoiling of the weak by the strong." Referring to the longstanding struggle between California and Arizona over Colorado River water, the editorial described the dam "as a monument to how the vast power of the federal government has overreached itself, and deliberately taken a great natural resource of one state, and given it over for the benefit of another state without any kind of compensation."[12]

Both dams attracted the attention of local amateur photographers and camera clubs. Although access was limited during construction, especially to Hoover Dam, various Arizona residents journeyed to the dam sites and carried away photographic mementos. Their artistic quality may not match that of their commercial and professional counterparts, but these snapshots, saved in private photo collections and scrapbooks, testify to the

Attending the Coolidge
Dam dedication, an
unknown photographer
snapped this keepsake
photograph.

Pima Indians at
Coolidge Dam
dedication.

additional personal meanings accorded the dams. From the nearby mining town of Miami, Katherine Bario Kellner snapped images of Coolidge Dam, marking her excursion to the local landmark. A series of photographs by Norman Wallace reveal his fascination with the phases of construction and the unique structural qualities of the double-curved dome dam, an interest borne out in his paid employment as an Arizona state highways engineer.[13]

In addition to its local rather than national connotations, the Coolidge Dam became tainted by problems that plagued the San Carlos Project during the Depression years. Overestimating the Gila River's average water flow, engineers had designed the San Carlos Reservoir to provide 1.2 million acre feet and San Carlos Project plans had divided the estimated available water based on these optimistic projections. The reservoir never filled even close to capacity during the 1930s. At the dam's dedication, the water level was so low that vegetation was still visible, prompting speaker Will Rogers to quip, "If this was my lake, I'd mow it." Ten years after the dam's completion, the reservoir held only fifty-five thousand acre feet during the wettest season. The original provisions of the 1924 San Carlos Project legislation gave priority to the Pima and Maricopa Indians, but the upstream non-Indian farmers received far more of the limited water supply than the Gila Indian reservation lands. A large portion of the Indian lands turned out to be nonirrigable due to excessive alkali and other unfavorable soil conditions. And all project farmers, especially during drought years, were unable to meet agreed-upon repayment schedules to the federal government for the construction costs.[14]

For the Western Apache living on the San Carlos reservation, the Coolidge Dam brought different problems. The project provided some temporary work to Apache laborers but left behind significant economic and environmental consequences. Rising waters behind the dam flooded the town of San Carlos and acres of irrigated farmlands along the river. Anthropologist Grenville Goodwin, talking with San Carlos reservation residents in the 1930s, heard reports of farms that were "all washed away now," and considerable resentment against those tribal members "who made it possible to build Coolidge Dam." One older woman later recalled, "lots of people used to have farms at Old San Carlos. . . . Then they took our farms to build the dam, and people never have farms anymore. They just don't care now."[15] The meager financial compensation, allocated by Congress, quickly ran out, and attempts to locate new water sources for irrigation farming by drilling wells proved largely unsuccessful. As Commissioner of Indian Affairs Charles Rhoads summarized the situation in 1930, "their giving up of the Coolidge Reservoir and subsequent payment . . . has availed them nothing." Lutheran missionary Francis J. Uplegger, who spent fifty years on the San Carlos reservation, illustrated these changes in his personal photograph albums—but his photographic perspective was rarely visible anywhere else.[16]

Instead, nineteenth-century stereotypical representations of the Apache shaped outsiders' perspectives on San Carlos reservation issues. Senator Carl Hayden in his political struggle for congressional appropriations, for example, contrasted the deserving "peaceful Pima" with the "warlike Apache." Playing the "Indian card," as historian Jack August has characterized Hayden's astute political maneuverings, was not without its difficulties. At least one congressman was confused by the various references to Indians. Seeking to clarify, Representative Charles Carter asked the assistant commissioner of Indian affairs as he testified in front of the Subcommittee of House Committee on Appropriations, "Let the committee understand that . . . this reservoir is not providing irrigation for the San Carlos Indians?" It was not.[17]

As this chronicle of the San Carlos Project limitations and problems suggests, the differently characterized environmental and economic difficulties associated with the Central Arizona water project can be attributed to many factors. But in the broader cultural imagination, they became increasingly consumed under one category: erosion. The link between the water project and erosion had been made before the 1930s. In arguing for the San Carlos Act, for example, Senator Hayden tied water shortage problems not to aridity, but to erosion caused by overgrazing. "The Gila River has been so changed," he asserted, "by overgrazing that, without reservoirs to store its flood waters, that stream is no longer dependable for irrigation." In the Depression, as the Dust Bowl garnered public attention, the evils of soil erosion juxtaposed against the promise of water control became a popular narrative of the Arizona environment.

The United States Geological Survey had sounded the alarm in the previous decade, noting that the silt and sediment carried by southwestern desert streams and rivers threatened the dams under construction. A newly established federal government program, the Soil Erosion Service (SES), under Hugh Hammond Bennett, echoed those concerns in June 1933.[18] On southwestern tours, Bennett, who inspected the Navajo reservation, and his assistant director, Walter Lowdermilk, who surveyed the Gila River watershed, found severe soil erosion in these Arizona locations. According to their understanding of the physical and geological processes at work, they feared that overgrazing and erosion would contribute to a detrimental buildup of silt in key reservoirs, especially behind the just-completed Coolidge Dam and the still-under-construction Hoover Dam. The accumulation would not only limit the storage capacity of the reservoirs, but it could also exert excessive pressure on the dams themselves. Bennett quickly established vast demonstration projects—the Navajo Project and the Gila River Watershed Project—to deal with the erosion problems.

In the midst of a drought, many Arizonans appreciated the federal

relief efforts addressing the visible manifestations of their economic and environmental problems. State officials and politicians, including Governor Benjamin Moeur, Senator Carl Hayden, and Representative Isabella Greenway, supported the Gila River Watershed Project, which covered 8.2 million acres in Graham and Greenlee counties, and stretched into neighboring New Mexico. More than twenty-five hundred men worked on the Gila River Watershed Project during its first two years of operation, reseeding rangelands and building check dams, among other activities. Initially funded under the Federal Emergency Relief Administration and the Civil Works Administration, two other New Deal agencies, the Civilian Conservation Corps and the Soil Conservation Service, took over the work in 1934.[19]

Photographs by Glenn L. Fuller of the Soil Conservation Service recorded the agency's operations alongside the overgrazed plains and wind erosion near the Coolidge Dam, making the government equation of erosion and limited reservoir water storage clear. Not all central Arizona residents, however, agreed with the federal government assessment of local human responsibility for the environmental and economic ills. Their interpretations turned to larger natural and economic forces. Roy Kenworthy, president of the San Carlos (Indian) irrigation and drainage district, understood the related Coolidge Dam and San Carlos Project problems to be temporary and circumstantial; "We built our project in the depression and a dry spell

Placing an Anglo girl in the foreground, Milton Snow presents the evils of erosion as a problem for all Arizonans. Milton Snow, 1939.

was on us, and those two things don't go together. . . . All we need is to straighten out our water problems and build up our land, and we will have one of the best little valleys anywhere."[20]

In northern Arizona, the Bureau of Indian Affairs (BIA), already concerned about erosion, welcomed SES funds to establish the Navajo Project.[21] As Commissioner of Indian Affairs John Collier explained the situation to the Navajo Council in Tuba City, "the Boulder Dam will be filled up with your fine agricultural soil in no great number of years if we do not stop erosion on the Navajo reservation."[22] BIA and SES officials concurred in their assessments of the soil erosion problem: it was caused primarily by overgrazing. The Navajo herds of sheep, goats, cows, and horses, they concluded, were three times larger than the range could sustain. Their proposed solutions were to reduce the number of stock, to improve the damaged grazing lands, and to develop water supplies. After setting up an experimental station at Mexican Springs, they turned their attention to mandatory stock reduction.[23]

Most Navajos interpreted the environmental situation differently. From their perspective, lack of rainfall and limits to available grazing lands caused the current difficulties. They echoed the sentiments of the San Carlos Project farmers: the problem was drought, not erosion. "My land is not washed away. My land is all right," asserted Chischilly Yazzie, in 1936.[24] Natural cycles, they argued, would restore the damaged range. To slaughter sheep, the mainstay of the Navajo economy and culture, was not the solution. Anger and resistance to the BIA reduction program, which targeted first sheep, then sheep and goats, then horses, were widespread.[25] By reducing the reservation herds by more than 50 percent, the program destroyed the livelihoods of many Navajo, especially small owners. The BIA stock reduction had a devastating effect on the Navajo and failed to remedy the environmental problems. Current scientific understandings of the gullying and erosion cycle in the Southwest point out that although overgrazing certainly exacerbated the conditions, it was not the primary cause.[26]

The federal government campaign against overgrazing was also waged photographically. The erosion picture by Snow, mentioned at the beginning of this essay, was taken as part of a BIA photographic project to illustrate the historical impact of overgrazing. The reservation images were published in 1939 as part of a didactic pamphlet, *Along the Beale Trail: A Photographic Account of Wasted Range Land, Based on the Diary of Lieutenant Edward F. Beale, 1857.* As H. C. Lockett explained the project in the introduction, "With cameras to record the contrast, Navajo Service photographers recently followed the route of the trail-blazer, photographing identical areas which his diary describes as lush with vegetation, where clear narrow streams abound with fish and 'grass is belly high to mule.'"[27] The fifty-six-page pamphlet juxtaposes quotes from

FIVE MILES NORTH OF WINSLOW

AS BEALE SAW IT IN 1857:
"We left camp at noon, and following a stretch of country as level as a billiard table, crossed, after coming five miles, a slight elevation, from which we came into a broad, level and beautiful valley, stretching as far as the eye could reach to the westward and southward. In this valley, we found a small stream of running water, but very narrow, scarcely over a foot in width."

81 YEARS LATER—THE PLACE BEALE DESCRIBED ➤
Beale's "small stream of running water" is today a dry wash. Only dead grass roots remain in the torn soil.

38

An erosion photograph by Milton Snow, "Five Miles North of Winslow," as published in a Bureau of Indian Affairs didactic pamphlet. Milton Snow, 1939.

Beale's diary on one page with Snow's contemporary photos on the other. Each two-page layout also includes added text in bold print to direct the interpretation of the contrasts. In brief, "the pictures tell a story of a wasted rangeland, crumbling walls of mud, and nature thrown out of balance by man's wanton misuse of his resources." The repeated message comes across bluntly and clearly: "Had man not selfishly squandered the bounties provided by Nature—had he merely used them with normal care and foresight—he might have preserved the grass and water, retained the precious top soil and prevented the destructive erosion. This is not THEORY—it is FACT. . . . NO CYCLE OF DROUTH MADE THE BEALE TRAIL WHAT IT IS TODAY. IT WAS BROUGHT ABOUT BY MAN'S STUPID MISUSE OF NATURE'S RESOURCES."[28]

Jack Snow had been an official photographer on the Navajo reservation since the early 1930s. Hired originally by the Soil Conservation Service, he was familiar with the reservation, and with the SCS message. As "Erosion in Granunoa" suggests, his photographs demonstrate considerable artistic and technical skills.[29] But this particular picture, although taken as part of the Beale Trail project, was not included in the published booklet. The images of destroyed range that were selected are visually uniform, depicting drab stretches of canyon lands. They stand in sharp contrast to the final six photographs in the booklet, chosen to illustrate the benefits of government control and wise use of resources, depicting "perfect range . . . verdant, productive, a symbol of the basic economy of the West."[30]

The exclusion of "Erosion in Granunoa" reminds us that the federal government–sponsored photographs of Depression-era Arizona were "official images," selected and used as part of public relations efforts. Similar decisions affected the Snow SCS photographs published during the 1930s in *Indians at Work*, an Indian Service publication. Although I introduced and discussed the images individually, many of these photographs were part of

Photographer
Milton Snow
posing with the
tools of his trade.

distinct series, compiled for political and publicity purposes. The Coolidge Dam series, for example, distributed by the construction company to political officials, businessmen, and government agencies, tells a narrative of the successful completion of an agricultural project. The set in the National Archives had been given to Representative Louis C. Crampton, chair of the House Subcommittee on Appropriations. These Arizona images also made their way into the photo files maintained by different agencies of the federal government. The distinct agendas of the federal agencies at work in Arizona— including the Bureau of Reclamation, Farm Security Administration, and Bureau of Indian Affairs—guided the formulation of their photographic collections. For such national interests, Arizona-specific images generally held less value than generic images. When presented to mass audiences, the selected prints publicized public needs and documented the efficacy of each agency's efforts to ameliorate those problems.

Images of drought and overgrazing fit readily into 1930s political agendas, and into the narratives linking economic and environmental disasters. But such photographs were not always convincing to members of their audiences, especially those who might hold other points of view. One infamous 1936 controversy swirled around an image by FSA photographer Arthur Rothstein that depicted a cow skull casting a lifelike shadow on

parched South Dakota soil. Republicans, tipped off by a local newspaper, learned that Rothstein had created this haunting image by moving the skull and carefully framing the shot to emphasize the shadow. They seized upon the opportunity to make a political point and to challenge President Roosevelt's assertions about the dire need to address such environmental conditions. The "faked" photograph became, for them, a symbol of the false premises on which the Resettlement Administration and other New Deal programs were based. In Arizona, when the beneficiaries of those programs challenged the government's portrayal of environmental ills, however, they disputed the explanations, not the existence, of the problems.[31]

The regional historical and cultural contexts of the photographs emerge from examining the "official" photographs in conjunction with those of other photographers at work in the state. Arizona residents used photographs for somewhat different personal and promotional ends. Downstream from the Coolidge Dam, in the towns of the San Carlos Project, for example, photographs of the dam adorned letterheads, promotional pamphlets, and newspapers. Although Russell Lee and Dorothea Lange snapped shots of the project farms, livestock, machinery, and workers for national agency purposes, for local residents it was the dam that symbolized their story. The official stationery of the Florence chamber of commerce celebrated the connection with a photograph and a caption—"Coolidge Dam Makes Our Desert Bloom"—a sentiment with which its photographer, Joseph Cadenbach, would agree.[32] The Arizona photographs of Coolidge Dam and Navajo reservation erosion may not be as familiar to audiences today as the images taken by government-sponsored photographers Lange and Lee, but they are artistically powerful, culturally resonant, and historically revealing. As participants in 1930s debates over competing interpretations of the Arizona landscape, they tell a regional story that reveals the conflicts and controversies of the decade.

Appendix

WHERE TO FIND 1930S PHOTOGRAPHS IN ARIZONA

*W*ant to see more 1930s photographs? Conduct research on 1930s Arizona through photographs? This volume includes only a small fraction of the available photographs created in 1930s Arizona. The works of the federal government photographers represented here are available on-line through the National Archives and the Library of Congress. Check out the Library of Congress, American Memory Web site, "America from the Great Depression to World War II: Photographs from the FSA-OWI, 1935–1945," http://memory.loc.gov/ammem/fsowhome.html.

We encourage Arizona residents, and visitors, to seek out other photographs that interpret and reflect the concerns of Depression-era Arizona. Home is the first place to look. Family albums, photographs, and keepsakes are wonderful resources for visual records of the decade. You can also visit collections in archives, libraries, and museums around the state, and through some of their Web sites. Listed below is a good representative sampling of such Arizona repositories, organized by location. Each listing includes a brief description of the types of 1930s photographs in the collection, the repository's address and phone number, and, as available, the estimated size of the overall photograph collection and a Web site address.

Bagdad
Bagdad Museum
N. Lindahl Rd.
Bagdad, AZ 86321
928-633-2930
Located in an old jailhouse and maintained by retired miners, the collection focuses on the history of this Yavapai County mining town and the local mines. (The town itself was relocated in 1953 as the open mining pit expanded.) More than a hundred 1930s photographs of mining, people, and landscapes are organized into binders and albums.

Bisbee
Bisbee Mining and Historical Museum
No. 5 Copper Queen Plaza
Bisbee, AZ
520-432-4232
www.bisbeemuseum.org
Photographs: 25,000
The Mining Museum in Bisbee, a well-photographed town, maintains a collection that extends from the last decades of the nineteenth century to the 1970s. The collection is primarily made up of works from amateurs but also features the photography of professional photographers.

Buckeye
Buckeye Valley Museum
116 E. Hwy 85
P.O. Box 292
Buckeye, AZ 85326-0024
623-386-4333
The museum's photograph collection, focused on Buckeye Valley and surrounding communities, includes some 1930s snapshots, images produced by the chamber of commerce, and school photographs.

Camp Verde
Camp Verde Historical Society
435 S. Main St.
Room 201
Camp Verde, AZ 86322
928-567-9560
Although many of the photographs in the Society's four large files are undated, the collection includes those of identified local residents and their activities, as well as unidentified cowboys and American Indians.

Casa Grande

Casa Grande Valley Historical Society

110 W. Florence Blvd.

Casa Grande, AZ 85222-4033

520-836-2223http://www.cgvhs.org

Photographs: 23,000

The photograph collection, like the Historical Society's other collections, focuses on Casa Grande Valley, including all of Pinal County and Arizona where local ties exist. It includes school photographs, especially from the renovated Southside Colored Grammar School established in the 1930s, which once served the children of local cotton workers. The photo collection is currently undergoing digitization; in 2002, some 4,000 photographs were digitized and available for research.

Chandler

Chandler Historical Museum

178 E. Commonwealth Ave.

P.O. Box 926

Chandler, AZ 85244

480-782-2717

Open to the public by appointment.

Most of the Chandler Museum's photo collection was gathered from private donations. The images, typically by unknown photographers, are contained in twelve large books and primarily deal with the activities and city scenes (sheep runs, parades, ostriches, and buildings) of Chandler.

Cottonwood

Clemenceau Heritage Museum/Verde Historical Society

1 N. Heritage St.

P.O. Box 511

Cottonwood, AZ 86326

928-634-2868

http://www.sharlot.org/roundup/archives/CHM.shtml

Researchers are encouraged to make appointments.

With a focus on local communities in and around the Verde Valley, the Museum's principal subjects include mining, logging, and railroad development. Some of the photographic collections include 1930s images, such as Verde Valley scenes; school children, listed by grade; and local residents.

Douglas
Douglas Historical Society and Museum
Cochise County Historical Society
1001 D Ave.
Douglas, AZ 85607
520-364-7370 or 520-364-5226
http://www.mycochise.com/history.php
Photographs: 40,000
These two historical societies are in the same building—the historic Williams house. They collect, preserve, and exhibit educational, cultural, and industrial items related to the history of the county, especially the Douglas, Arizona, and Agua Prieta, Sonora, communities. Cochise County Historical Society is in charge of the archives; a number of its wide variety of twentieth-century images come from the 1930s.

Dragoon
Amerind Foundation, Inc.
2100 N. Amerind Rd.
P.O. Box 400
Dragoon, AZ 85609
520-586-3666
http://www.amerind.org/
Photographs: 7,000
Archives closed. Call for more information.
Although the photograph collections, undergoing organization and conservation, are not currently available to scholars, they include photographs of 1930s archaeological work at Painted Cave, Navajo reservation, and in the Gleason area.

Flagstaff

Arizona Historical Society/Northern Arizona Division

2340 N. Fort Valley Rd.

Flagstaff, AZ 86001

928-774-6272

http://aao.lib.asu.edu/RepositoryList.jsp

Photographs: 30,000

You'll find the Arizona Historical Society/Northern Arizona Division housed separately at Special Collections, Cline Library, Northern Arizona University. Check the Arizona Archives Online Web site above to see an online inventory of its collections.

Harold S. Colton Memorial Research Library
Museum of Northern Arizona

3101 N. Fort Valley Rd.

Flagstaff, AZ 86001

928-774-5211 x212

http://www.musnaz.org

Photographs: 250,000 (various formats)

Research is by appointment only.

Focused on the Colorado Plateau, Southwest Indians, and prehistoric and historic Southwestern archaeology, the photo archives include 1930s photographs from the Rainbow Bridge–Monument Valley expeditions and Wupatki National Monument projects, as well as Navajo reservation and personal photography by Milton "Jack" Snow.

Lowell Observatory

1400 W. Mars Hill Rd.

Flagstaff, AZ 86001

928-774-3358 or 928-774-2096

http://www.lowell.edu/

At this first observatory in Arizona, the archives include historic photographs that focus on astronomer Clyde Tombaugh, who discovered the planet Pluto, in 1930.

Riordan House
Arizona State Parks

409 Riordan Rd.

Flagstaff, AZ 86001

520-779-4395

http://www.azparks.gov/Parks/parkhtml/riordan.html

The park's small collection of 1930s photographs includes scrapbooks.

Special Collections and Archives Department
Cline Library
Northern Arizona University
P.O. Box 6022
Flagstaff, AZ 86011-6022
928-523-6502
http://www.nau.edu/library/speccoll/
Photographs: 800,000
Photographs from the 1930s can be found in more than sixty of the extensive photograph collections at NAU's Special Collections and Archives. Many of them can be accessed on-line through an imaging database—the Colorado Plateau Digital Archives—located at http://www.nau.edu/library/speccoll/index.html

Florence
McFarland State Historic Park
Arizona State Parks
P.O. Box 109
Florence, AZ 85232
520-868-5216
http://www.azparks.gov/parks/parkhtml/mcfarland.html
The McFarland library and archives include photographs, among other materials, relating to Ernest W. McFarland's career as a U.S. senator, Arizona governor, and Arizona Supreme Court justice, as well as those related to the Florence area. You can see some of the photographs through the Web site above; they are in the process of digitizing the collection.

Pinal County Historical Society Museum
715 S. Main
P.O. Box 851
Florence, AZ 85232
520-868-4382
Photographs: 3,000
Limited hours. Call for information.
Photograph collections at this local history society include 1930s snapshots as well as Arizona State Prison photographs from the 1930s to 1960s. Also included is the work of Al Gressinger, a local photographer who documented the people and places of Florence beginning in 1930.

Fort Huachuca
Fort Huachuca Museum
Fort Huachuca, AZ 85613-6000
520-533-5736
http://huachuca-www.army.mil/HISTORY/museum.htm
Research is by appointment only.
Located in the Museum Annex, the archives and photograph collection include a range of 1930s photographs related to the Fort and military personnel. You can see a portion of its collection at the Fort Huachuca History Program Web site, http://cms.portal.hua.army.mil/channels/content/history/html/index.html, where you can download digital images.

Glendale
Glendale Arizona Historical Society
9802 N. 59th Ave.
P.O. Box 5606
Glendale, AZ 85312
623-435-0072
Photographs: 1,200
You'll find family photographs and works documenting old Glendale in this local history society collection.

Globe
Gila County Historical Museum
1330 N. Broad St.
P.O. Box 2891
Globe, AZ 85501
928-425-7385
Photographs: 3,000
The photographs, including some from the 1930s, document the mining, ranching, and business interests of the area.

Jerome

Jerome Historical Society

Archives—Jerome History Center

407 Clark St.

Jerome, AZ 86331

928-634-7349

http://www.jeromehistoricalsociety.org

Photographs: 11,000

Appointments for research are recommended.

Using the Society's photo database, one can search for photos by the subject's name. Among the 1930s photographs are those of the 1936–37 landslides in downtown Jerome.

Mesa

Mesa Historical Museum

2345 N. Horne St.

P.O. Box 582

Mesa, AZ 85211

480-835-7358

http://mesaaz.org/

Photographs: 7,500

This local collection, largely uncataloged, features many photographs that record the growth of Mesa, including 1930s images from the old Mesa School District.

Nogales

Pimeria Alta Historical Society

136 N. Grand Ave.

Nogales, AZ 85621-3211

520-287-4621

Photographs: 5,000

Although the Pimeria Alta Historical Society features photographs from the early 1900s to the 1990s, most of its collection dates from the first half of the twentieth century. The collection, organized according to subject and event (not by date), documents the events and growth of the cities of Nogales, Arizona, and Nogales, Sonora.

Parker

Colorado River Indian Tribes Library/Archives

Second Ave. and Mohave Rd.

Rte. 1, P.O. Box 23B

Parker, AZ 85344-9704

928-669-9211

http://www.critlibrary.com

This tribal archive is accessible to tribal members. Application is required by nontribal members for use of archival materials, and they must agree to abide by the rules governing the use of manuscripts and photographs.

Peridot

San Carlos Apache Cultural Center

P.O. Box 70

Peridot, AZ 85542

928-475-2894

You can see some 1930s photographs, copies from photographs in Tucson's Arizona State Museum collections, as part of exhibit displays on the history of Apache people.

Phoenix

Heard Museum

2301 N. Central Ave.

Phoenix, AZ 85004

602-252-8840

http://www.heard.org

Photographs: 300,000

Research is by appointment only.

The Heard, a private museum, focuses its collection on the indigenous populations of the American Southwest. Included in the collection are the works of John Brown McKinley, an artist who documented the Gallup Intertribal gatherings from the 1930s until his death in the 1980s, and the Fred Harvey Photograph Collection. The museum is currently in the process of digitizing its collection.

History and Archives Division
Arizona State Library, Archives and Public Records
State Capitol Suite 342
1700 W. Washington
Phoenix, AZ 85007
602-542-4159
http://www.lib.az.us/archives/
Photographs: 90,000
The Archives' historic photograph collection focuses on Arizona and governmental history and includes photographs, slides, negatives, postcards, and others. About 9,000 images are currently digitized and available through http://photos.lib.az.us/; try a date search or subject search with a New Deal agency name (such as Civil Works Administration or Emergency Relief Administration) for 1930s photographs. The Salsbury Collection of missionary life on the Navajo reservation from 1930 to the 1940s is also of note. A more complete database of nondigitized photographs is available in the Reading Room at the Archives.

Phoenix Museum of History
Heritage and Science Park
105 N. Fifth St.
Phoenix, AZ 85004-4404
602-253-2734
http://www.pmoh.org/
Through personal donations, the Phoenix Museum of History has collected many items, including works from the 1930s. This collection is organized according to subject and is still "hit and miss" on finding specific images.

Pueblo Grande Museum
Library and Archives
4619 E. Washington St.
Phoenix, AZ 85034-1909
602-495-0901
http://www.ci.phoenix.az.us/PARKS/pueblo.html
Photographs: 20,000
Research is by appointment only.
About a third of the photographs, focused on the archaeological projects at this prehistoric Hohokam site, were taken during the 1930s; they include the activities of Public Works Administration, Civilian Conservation Corps, and Work Projects Administration workers. The photographs, taken by Julian Hayden and Odd Halseth, among others, are organized by project.

Pima

Eastern Arizona Museum and Historical Society of Graham County

2 N. Main St.

P.O. Box 274

Pima, AZ 85543

928-485-9400

The photograph collection, built through donations, focuses primarily on the original settlers of the town. Most of the works are stored in large albums compiled during Heritage Days over the past ten years.

Prescott

Sharlot Hall Museum

415 W. Gurley

Prescott, AZ 86301-3615

928-445-3122

http://www.sharlot.org/

Photographs: 100,000

The collections focus on the central mountain region of Arizona, with emphasis on Yavapai County and the Prescott area; subjects include ranching, military, commerce, women's literature, and cowboy folk traditions. Photographs of individuals, organizations, events, and places are indexed at http://info.lib.asu.edu/BRS/gate.exe?f=search&state=puburk.1.1

At the Museum library you can search through binders, organized by subject, that include photocopies of the collection's photographs.

Scottsdale

House of Broadcasting Museum

7150 E. 5th Ave.

Scottsdale, AZ 85251-3208

602-944-1997

http://www.houseofbroadcasting.com

The Museum's collections include some 1930s materials related to the history of Arizona broadcasting.

Scottsdale Historical Museum

7333 E. Scottsdale Mall

P.O. Box 143

Scottsdale, AZ 85251-4414

480-945-4499

http://www.scottsdalemuseum.com/

Photographs: 3,000

Located in the 1910 "Little Red Schoolhouse," the Museum's archives include five large cabinet drawers filled with photographs related to the history of Scottsdale and the Southwest.

Tempe

Arizona Historical Foundation

Hayden Library

Arizona State University

P.O. Box 871006

Tempe, AZ 85287-1006

480-965-3283

http://www.ahfweb.org

Photographs: 60,000

Photograph collections relate to Barry Goldwater, the state of Arizona, and the Southwest. To perform a full search of all photographs held by the Arizona Historical Foundation that are currently on-line, go to http://info.lib.asu.edu/ and search the Arizona and Southwestern index.

Arizona Historical Society–Central Arizona Division

Papago Park

1300 N. College Ave

Tempe, AZ 85251

480-929-0292 ext. 174

http://www.arizonahistoricalsociety.org

Photographs: 170,000

Only 70,000 images of the Division's photograph collections, focused on the central portion of the state, are currently processed and listed in the library database. About 7,000 of those relate to the 1930s, including family scrapbooks, ranching photographs, and city street scenes.

Arizona State University

Architecture and Environmental Design Library

Archives and Special Collections

Architecture Building

University Dr. (between Myrtle and Forest)

P.O. Box 871006

Tempe, AZ 85287-1006

480-965-6370

http://www.asu.edu/caed/AEDlibrary/

Although much of the collection includes archival drawings, it also features many architectural photographs from the period.

Department of Archives and Manuscripts

Hayden Library

Arizona State University

P.O. Box 871006

Tempe, AZ 85287-1006

480-965-3145

http://www.asu.edu/lib/archives/

Photographs: 970,217

The Department of Archives and Manuscripts encompasses several discrete collections. You can access the Arizona Collection, Chicano Research Collection, and University Archives at the Hayden Library, Luhrs Reading Room, and search their specialized database—Arizona and the Southwest Index. The Arizona Collection's historic images include 1930s photographs in a number of collections–Carl T. Hayden, W. Ryder Ridgway, Lisle Updike, McLaughlin, and McCulloch.

Map Collection

Noble Science and Engineering Library

Arizona State University Libraries

Tempe, AZ 85287-1006

480-965-3582

http://www.asu.edu/lib/hayden/govdocs/maps/airphoto.htm

The Map Collection houses the Fairchild Aerial Photos—photo mosaics created from aerial photos taken between 1935 and 1940 to assist with the Soil Conservation Service's work in Arizona.

Tempe Historical Museum

809 E. Southern Ave.

Tempe, AZ 85282

480-350-5130

http://www.tempe.gov/museum/

Photographs: 20,000

Research is by appointment only.

This local history museum includes photographic and archival collections related to the city of Tempe; you can read descriptions of the major collections through their on-line index, http://www.tempe.gov/museum/rgindex. htm

Tombstone

Tombstone Courthouse State Park

Arizona State Parks

219 Toughnut St.

P.O. Box 216

Tombstone, AZ 85638

520-457-3311

http://www.pr.state.az.us/parks/parkhtml/tombstone.html

Photographs: 1,600

The Courthouse collection, focused on Tombstone and southwestern Arizona, covers the period from the 1860s through the 1940s, but only a small proportion of images date from the 1930s.

Tucson

Arizona Historical Society–Southern Arizona Division

949 E. Second St.

Tucson, AZ 85719-4898

520-617-1152

http://www.arizonahistoricalsociety.org

Photographs: 750,000

Focused primarily on southern Arizona, the photographic collections include albums and personal and commercial collections, as well as files of unattributed photographs. Of special note for 1930s images are the Buehman Studio, E. D. Newcomer, Norman Wallace, Oliver Ambrose Risdon, and A. E. Magee aerial photographic collections. You can search for specific collections through the Society's on-line database, http://lista.azhist.arizona.edu/

Arizona State Museum
Photographic Collections
University of Arizona
1013 E. University Blvd.
P.O. Box 210026
Tucson, AZ 85721-0026
520-621-6281
http://www.statemuseum.arizona.edu/
Photographs: 250,000
Research is by appointment only.
The Arizona State Museum is the photographic archive for many of the major archaeological excavations in Arizona. Its 1930s holdings include the complete photographic records of the Gila Pueblo Archaeological Foundation, as well as the Tad Nichols, Grenville Goodwin, Forman Hanna, Neil Judd, and Emil Haury collections.

Center for Creative Photography
University of Arizona
P.O. Box 210103
Tucson, AZ 85721-0103
520-621-7968
http://dizzy.library.arizona.edu/branches/ccp/
Photographs: 60,000
The Center maintains significant collections of nineteenth- and twentieth-century photography from around the world. Its holdings of photographers Ansel Adams, Edward Weston, Russell Lee, Fritz Henle, and Laura Gilpin include relevant Arizona images. You can set up a print viewing appointment to see original works of art of your choice from the collection.

Western Archaeological and Conservation Center
National Park Service
255 N. Commerce Park Loop
Tucson, AZ 85745
520-670-6501
Photographs: 20,000
Research is by appointment only.
The Center maintains materials related to southwestern U.S. parks and monuments. The major photograph collections related to the 1930s, totaling 6,000 images, include the Southwestern National Monuments Collection and the George Grant Collection; Grant was the Park Service photographer during the decade.

Vail

Colossal Cave Mountain Park

16711 E. Colossal Cave Rd.

P.O. Box 70

Vail, AZ 85641

520-647-7121

http://www.colossalcave.com/

Photographs: 2,700

This Pima County park includes several buildings built by the Civilian Conservation Corps. In the research library you'll find Ezra Whitney's photographs of the local Civilian Conservation Corps (Camp # SP-10-8 Camp 8) of particular interest.

Wickenburg

Desert Caballeros Western Museum

21 N. Frontier St.

Wickenburg, AZ 85390

928-684-2272

http://www.westernmuseum.org/

Photographs: 5,000

The Museum houses many historical photographs from the end of the nineteenth century to the present day. The collection centers on the history of Wickenburg, including numerous photographs of the town's mining, railroad, and ranching industries.

Willcox

Chiricahua Regional Museum

127 E. Maley St.

Willcox, AZ 85643

520-384-3971 or 520-384-4882

Photographs: 200

Formerly the Museum of the Southwest, this regional museum also has a small photo collection; the Amalong family photographs, for example, include some from the 1930s.

Window Rock
Navajo Nation Museum
27002 Highway 264
(at the intersection of Post Office Loop Rd.)
P.O. Box 1840
Window Rock, AZ 86515
928-871-6673
Research is by appointment only.
The extensive photograph archives include some 16,000 items in the Milton "Jack" Snow collection, many of which focus on Navajo reservation Soil Conservation Service (SCS) work. Other SCS photographs in the collection include nearly 15,000 photographs by Stan Bartos.

Yuma
Yuma Crossing State Historic Park
Arizona State Parks
201 N. Fourth Ave. (at I-8)
Yuma, AZ 85364
928-329-0471
http://www.azparks.gov/parks/parkhtml/yumacross.html
Since the park interprets the region and those who settled there from the 1850s to the 1930s, only a small portion of the collection dates from the 1930s.

Notes

Introduction: Picturing Arizona

1. Entries for Charles Augustus Brinley and Rudolph D'Heureuse in Peter E. Palmquist and Thomas R. Kailbourn, *Pioneer Photographers of the Far West: A Biographical Dictionary, 1840–1865* (Stanford: Stanford University Press, 2000).

2. War Department, Corps of Engineers, U.S. Army, *Photographs Showing Landscapes, Geological and Other Features, of Portions of the Western Territory of the United States. Obtained in Conjunction with Geographical and Geological Explorations and Surveys West of the 100th Meridian, Seasons of 1871, 1872, 1873, and 1874.* First Lieutenant George M. Wheeler, Corps of Engineers, U.S. Army in Charge (n.p., ca. 1874).

Chapter 1. Constructing an Image of the Depression

1. For an overview of the art history of Arizona, see James K. Ballinger and Andrea D. Rubinstein, *Visitors to Arizona, 1846–1980* (Phoenix: Phoenix Art Museum, 1980). Lee, Lange, and Delano are included.

2. Studies of the visual arts in Depression-era Arizona are meager, and photography has been almost completely ignored. Daniel Hall's pioneering 1974 master's thesis, "Federal Patronage of Art in Arizona, 1933–43" (Arizona State University, Tempe), does not include photography. The two historians who have considered the photographic history of the state focus solely on pre-statehood work. See Evelyn S. Cooper, "Etched without Light: A Survey History of Photography in the Territory of Arizona," Ph.D. diss., Arizona State University, Tempe, 1993; and Jeremy Rowe,

Photographers in Arizona, 1850–1920: A History and Directory (Nevada City, Calif.: Carl Mautz Publishing, 1997). Even Barbara Vilander's excellent book *Hoover Dam: The Photographs of Ben Glaha* (Tucson: University of Arizona Press, 1999) scarcely mentions Arizona. Peter Bermingham's 1980 show, *The New Deal in the Southwest: Arizona and New Mexico* (Tucson: University of Arizona Museum of Art) was accompanied only by a slim catalogue. *The New Deal in Arizona* (Phoenix: Arizona State Parks Board, 1999), by historian William S. Collins cites only two sources on the visual arts in his bibliography, and the FSA is not mentioned. Geta LeSeur, *Not All Okies Are White: The Lives of Black Cotton Pickers in Arizona* (Columbia: University of Missouri Press, 2000) utilizes Lange's photographs only as adjuncts to the contemporary oral histories she has compiled. Thirties photographs provide illustrative counterpoints in a fine autumn 1991 issue of *The Journal of Arizona History* (vol. 32, no. 3); see Marsha L. Weisiger, "Mythic Fields of Plenty: The Plight of Depression-Era Oklahoma Migrants in Arizona," 241–66; Melissa Keane, "Cotton and Figs: The Great Depression in the Casa Grande Valley," 267–90; and Peter MacMillan Booth, "Cactizonians: The Civilian Conservation Corps in Pima County, 1933–1942," 291–332.

3. May Noble, "Arizona Artists," *Arizona Teacher and Home Journal,* 11 (February 1923): 10.

4. John Steinbeck, *The Grapes of Wrath* (New York: Viking Press, 1939), 274.

5. Many New Deal agencies also hired photographers, though the majority did not define themselves as artists, either before or after their federal employment. Other photographers included Jack Delano, Fritz Henle, Arthur Rothstein, Milton "Jack" Snow, and Ben Glaha.

6. For the best concise historical account of the state during this period, see "The Depression and the New Deal," in Thomas E. Sheridan, *Arizona: A History* (Tucson: University of Arizona Press, 1995), 251–67, 393–94. For other accounts of this period in the state, see also "Hard Times in Tucson," in Charles Leland Sonnichsen, *Tucson: The Life and Times of an American City* (Norman: University of Oklahoma Press, 1982), 230–58, 335–37; "La Crisis," in Thomas E. Sheridan, *Los Tucsonenses: The Mexican Community in Tucson, 1854–1941* (Tucson: University of Arizona Press, 1986), 207–16, 298–99; "Decline and Recovery, 1929–1940," in Bradford Luckingham, *Phoenix: The History of a Southwestern Metropolis* (Tucson: University of Arizona Press, 1989), 101–35; C. Wesley Johnson Jr., *Phoenix in the Twentieth Century: Essays in Community History* (Norman: University of Oklahoma Press, 1993); and Marsha L. Weisiger, *Land of Plenty: Oklahomans in the Cotton Fields of Arizona, 1933–1942* (Norman: University of Oklahoma Press, 1995).

7. Not only is the photographic material connected with these agencies considerable, but the contested historical and political complexities inherent in their analysis are deserving of separate study. There are only a few photographs of Native Americans in the FSA/OWI file, as the Bureau of Indian Affairs maintained strict bureaucratic control over how the reservations were imaged. When Native Americans worked off reservation, as did Yaqui cotton pickers or Navajos employed by the railroad, they could be recorded by the FSA/OWI photographers. See Donald Lee Parman, *The Navajos and the New Deal* (New Haven: Yale University Press, 1976); and James C. Faris, *Navajo and Photography: A Critical History of the Representation of an American People* (Albuquerque: University of New Mexico Press, 1996).

8. See Nicholas Natanson, *The Black Image in the New Deal: The Politics of FSA Photography* (Knoxville: University of Tennessee Press, 1992).

9. Stryker, who headed the FSA, was from Colorado. Lange, born in Hoboken, New Jersey, moved to California in 1918 and remained there for the rest of her career.

10. Other WPA projects were also located in the state. The Index of American Design, not permitted to record Native American work, focused on artifacts of the Spanish-Colonial era (mainly branding irons). The Historic American Buildings Survey recorded notable structures throughout the state (some had also been photographed by FSA artists) and paralleled an initiative dedicated to the Restoration of Historic Shrines. The state was home to few professional actors, and therefore there was no Federal Theatre Project in the state, though there was an active Federal Music Project. Its productions were local in character, providing an interesting counterpoint to Ferde Grofé's *Grand Canyon Suite,* first performed in 1933. Its modernism echoes the *Grand Canyon Trilogy* (1927), by New Mexico painter Raymond Jonson.

11. Thomas Wardell, interview by Sylvia Loomis, Archives of American Art, Smithsonian Institution, Washington, D.C.; Monty Noam Penkower, *The Federal Writers' Project: A Study in Government Patronage of the Arts* (Urbana: University of Illinois Press, 1977); Jerre Mangione, *The Dream and the Deal: The Federal Writers' Project, 1935–1943* (Boston: Little, Brown, and Company, 1972); Petra Schindler-Carter, *Vintage Snapshots: The Fabrication of a Nation in the W.P.A. American Guide Series* (New York: Peter Lang Publishing, 1999).

12. The highly pictorial magazine *Arizona Highways* was sponsored by the Highway Department and began publication four years before the beginning of the Depression. Its emphasis soon shifted from roads to the promotion of places visitors could see by traveling on them. See Tom C. Cooper, "Arizona Highways: From Engineering Pamphlet to Prestige Magazine," master's thesis, University of Arizona, Tucson, 1973. The role of tourism, including the Fred Harvey Company and the Santa Fe Railway, in marketing the state's national image, is a significant part of the story. A fascinating tension exists between the inside and outside view of the state, especially when the work of these photographers is positioned within a larger revisionist history of the West. For an excellent account of the history of tourism in Arizona, including the Santa Fe Railway and the Fred Harvey Company, see Arnold Berke, *Mary Colter: Architect of the Southwest* (New York: Princeton Architectural Press, 2002). See also Sandra d'Emilio and Suzan Campbell, *Visions and Visionaries: The Art and Artists of the Santa Fe Railway* (Salt Lake City: Gibbs-Smith, 1991); Kathleen Howard and Diana F. Pardue, *Inventing the Southwest: The Fred Harvey Company and Native American Art* (Flagstaff, Ariz.: Northland Publishing Company, 1996); and Marta Weigle and Barbara Babcock, *The Great Southwest of the Fred Harvey Company and the Santa Fe Railway* (Phoenix: Heard Museum, 1996).

13. In 1937, Oscar Berninghaus and Laverne Nelson Black won a competition to decorate the new Phoenix post office. Berninghaus chose *Communication during Period of Exploration, Pioneer Communication,* and *Early Spanish Discover Pueblo Indian,* and Black portrayed *Historical Development* and *The Progress of the Pioneer.* Sculptor Robert Kittredge produced reliefs for the Springerville (1939) and Flagstaff (1940) post offices (*Arizona Logging* and *Apache Chiefs Geronimo and Vittorio*). For more on these competitions, see "Surviving the Depression," in my

book *The Cowboy's Dream: The Mythic Life and Art of Lon Megargee* (Wickenburg, Ariz.: Desert Caballeros Western Museum, 2002), 80–89.

14. Nationwide, the 48 States Competition attracted nearly fifteen hundred entries by more than nine hundred artists for a mural in a rural post office in each state. Fifty-seven entries were received from all over the United States for Arizona, including one from Adolph Gottlieb, who is better known for his later abstractions. He lived in Tucson between 1937 and 1939. Several Arizona entries were recycled in post offices in other states. Philip von Saltza's image of wild horses was selected for Schuyler, Nebraska, though he had to change the cacti to poplars. Lew Davis revised his Arizona Indians to Spanish caballeros to make the figures more suitable for Los Banos, California. A cowboy mural by Edward Buk Ulreich found a home in New Rockford, North Dakota. Boris Deutsch's sketch involving a visual pun of an Indian chief set against the backdrop of the Santa Fe Railway's Super Chief locomotive was ultimately installed in Hot Springs (now Truth or Consequences), New Mexico. On the Safford controversy, see Jared Fogel and Bob Stevens, "The Safford Arizona Murals of Seymour Fogel: A Study in Artistic Controversy," *Social Education* 60 (September 1996): 287–91.

15. Although the popular image of the Depression is indelibly in black and white, about seven hundred of the nearly one hundred thousand images in the FSA file were shot in color. Kodak had first marketed Kodachrome in 1936, and had improved it enough by 1939 that Stryker decided to experiment with it. But cost, the efficiencies of centralized printing, unreliability of the color, and the fact that most publication venues remained black and white meant its use by the FSA was soon discontinued. In October 1940, Lee recorded the distribution of commodities in St. Johns in color. See Sally Stein, "FSA Color: The Forgotten Document," *Modern Photography* 43, no. 1 (January 1979): 90–98, 162–64, 166; Andy Grundberg, "FSA Color Photography: A Forgotten Experiment," *Portfolio* (July/August 1983): 52–57; and Ellen Handy, "Farm Security Administration Color Photographs," *Arts Magazine* 58 (January 1984): 18.

16. Lange's first husband had been painter Maynard Dixon, with whom she first visited Arizona. Dixon's *Legend of Earth and Sun* was executed in 1928 for the Biltmore Hotel. For more on Lange's work in this state, see Betsy Fahlman, "Cotton Culture: Dorothea Lange in Arizona," *Southeastern College Art Conference Review* 13, no. 1 (1996): 304–11.

17. Phillips Sanderson, interview by Sylvia Loomis, 1965, Archives of American Art, Smithsonian Institution, Washington, D.C.

18. Other artists who pursued mining themes included Lew Davis, who returned to Arizona in 1936 and painted scenes inspired by mining life in his native Jerome and the Miami/Globe area; printmaker Edgar Dorsey Taylor; and painters Henry Strater and Phil Curtis.

19. See Peter Wright and John Armor, *The Mural Project* (Santa Barbara, Calif.: Reverie Press, 1989).

20. During the 1930s, Laura Gilpin began her study of Native American culture, and Barry Goldwater began his extensive camera travels throughout the state. In 1937, Edward Weston received the first Guggenheim awarded to a photographer, to make a series of epic pictures of the American West. He photographed the Coolidge Dam and the San Carlos Lake in back of it, traveling also through

Globe, Phoenix, Jerome, and Yuma. In Prescott, he stopped to visit fellow photographer Frederick Sommer.

21. I am referring to it by the name by which it is best known. First called the Boulder Dam, it was named Hoover Dam in 1930, but was changed back to Boulder Dam in 1933. Finally in 1947, the name was restored to Hoover Dam. Dams were prominent symbols of government efforts in the West. For the FSA, Lee photographed the Roosevelt Dam.

22. There was occasional agency overlap. On this same trip Lee recorded Cairns General Hospital at Eleven Mile Corner. There, girls were taught how to care for babies, under a program funded by the National Youth Administration.

23. Fritz Henle and Jack Delano both worked in Arizona for the OWI. In June 1942, Delano began a two-year study of the nation's railroads for the OWI, a project that brought him to Arizona in March 1943. His subject was the Atchison, Topeka, and Santa Fe Railway Company. One of the preferred means of tourist transportation had been temporarily taken over for military purposes. Traveling west from Chicago, he journeyed across Texas, New Mexico, and Arizona to Los Angeles. En route, he documented the full range of the company's operations, structures, and employees.

Chapter 2. Migrant Labor Children in Depression-Era Arizona

1. Contemporary studies of children in the Depression include James H. Bossard, *Children in a Depression Decade* (Philadelphia: American Academy of Political and Social Science, 1940); Thomas Mineham, *Boy and Girl Tramps of America* (New York: Farrar and Rinehart, 1934); Maxine Davis, *The Lost Generation: A Portrait of American Youth Today* (New York: Macmillan, 1937). Particularly interesting are the longitudinal sociological studies on the Depression's impact on children; see Glen H. Elder Jr., *Children of the Great Depression* (Chicago: University of Chicago Press, 1974); John A. Clausen, *American Lives: Looking Back at the Children of the Great Depression* (Berkeley: University of California Press, 1995).

2. N. Ray Hiner, "Seen but Not Heard: Children in American Photographs," in *Small Worlds: Children and Adolescents in America, 1850–1950,* ed. Elliott West and Paula Petrik (Lawrence: University Press of Kansas, 1992), 165–202; Jennifer Pricola, "Age of Lost Innocence: Photographs of Childhood Realities and Adult Fears during the Depression," master's thesis, University of Virginia, 2003; Kathleen Thompson and Hilary Austin's *Children of the Depression* (Bloomington: Indiana University Press, 2001), which brings together a selection of photographs from the FSA/OWI file; and Anne Higonnet, *Pictures of Innocence: The History and Crisis of Ideal Childhood* (New York: Thames and Hudson, 1998).

3. Editor Robert Cohen's *Dear Mrs. Roosevelt: Letters of Children of the Great Depression* (Chapel Hill: University of North Carolina Press, 2002) primarily focuses on children's written words and offers a useful introduction to Depression-era children and the federal government. See also Richard A. Reiman, *The New Deal and American Youth: Ideas and Ideals in a Depression Decade* (Athens: University of Georgia Press, 1993); Betty Grimes Lindley and Ernest K. Lindley, *A New Deal for Youth: The Story of the National Youth Administration* (New York: Viking Press, 1938); Kriste Lindemeyer, *A Right to Childhood: The U.S. Children's Bureau and Child Welfare, 1912–46* (Urbana: University of Illinois Press, 1997).

4. Florence May Warner, *Report of Activities of the Children's Health Camps in Arizona*

under the Emergency Relief Administration of Arizona (Phoenix: Emergency Relief Administration of Arizona, 1934); Florence May Warner, "Juvenile Detention in the United States," Ph.D. diss., University of Chicago, 1933; Mary Melcher, "Tending Children, Chickens, and Cattle: Southern Arizona Ranch and Farm Women, 1910-1940," Ph.D. diss., Arizona State University, Tempe, 1994. Warner's Arizona State Board of Public Welfare ran the federal relief programs until 1935, when the newly established Works Progress Administration took over the administration and, in Arizona, set up its own state office. In thinking about the Arizona ERA, I have benefited from conversations with Lisa Felix.

5. Warner, *Report of Activities,* 1–2. Warner's education at the University of Chicago's School of Social Service Administration strongly shaped her social work ideas. The School, which advocated social sciences research as well as practical training, was involved closely with federal child welfare legislation, especially through Grace Abbott, chief of the U.S. Children's Bureau, who was Dean Edith Abbott's sister.

6. Ibid., 31.

7. Ibid., 35, 37, 39.

8. Ibid., 50.

9. Ibid., 60; Katharine Lenroot speech to American Association of University Women, 1939, Speeches and Articles of the Chief of the Children's Bureau 1924-67, General Records, Records of the Children's Bureau, RG102, National Archives II, College Park, Md.

10. See Kirsten Jensen essay. The literature on Dorothea Lange and her work is too extensive to cite fully here. See, for example, Keith F. Davis, *The Photographs of Dorothea Lange* (New York: Abrams, 1995); Elizabeth Patridge, ed., *Dorothea Lange: A Visual Life* (Washington, D.C.: Smithsonian Institution Press, 1994); Milton Meltzer, *Dorothea Lange: A Photographer's Life* (New York: McGraw-Hill, 1978); Therese Thau Heyman, Sandra S. Phillips, and John Szarkowski, *Dorothea Lange: American Photographs* (San Francisco: San Francisco Museum of Modern Art/Chronicle Books, 1994).

11. Eleanor Roosevelt, "Children of the Future," in *Proceedings of the White House Conference on Children in a Democracy, January 18–20, 1940* (Washington, D.C.: GPO, 1940), 20–23. See also *White House Conference on Children in a Democracy, Washington, D.C., January 18–20, 1940: Final Report,* Children's Bureau Publication no. 272 (Washington, D.C.: GPO, 1942). The White House conference was the fourth in a decennial series examining children's issues. A 1934 letter from "a Mexican girl" in Marinette, Arizona, to Eleanor Roosevelt also highlights the value of education. See Cohen, *Dear Mrs. Roosevelt,* 216.

12. House Select Committee to Investigate the Interstate Migration of Destitute Citizens, *Hearings . . . to Investigate the Interstate Migration of Destitute Citizens,* 76th Cong., 3rd sess., 1940, part 1, 316 (hereafter cited as *Hearings*).

13. *Hearings,* part 8, 3258–59; Paul Schuster Taylor, *California Social Scientist;* interview by Suzanne B. Riess, 1970, Regional Oral History Office, The Bancroft Library, University of California, Berkeley, 1973, courtesy The Bancroft Library; Dorothea Lange and Paul Schuster Taylor, *An American Exodus: A Record of Human Erosion* (New York: Reynal and Hitchcock, 1939).

14. *Hearings,* part 8, 3245, 3267.

Chapter 3. Refusing to Be "Undocumented"

1. I would like to thank Katherine Morrissey, Karen Anderson, and Yolanda Chávez Leyva for their advice and guidance in writing this chapter. Additional thanks to Sarah Deutsch and the members of the University of Arizona's History Department's Women's History dissertator group for their comments. Last, I wish to thank Martha Sandweiss for suggesting that I cease my fruitless search for photographs that featured Mexican American participation in relief and work programs and instead concentrate on family and personal photographs.

2. My mother's given name was Maria de la Cruz Robles, but she preferred to use only Cruz. Friends and family called her Chita. She passed away on April 21, 2002 while I was writing the initial drafts of this article.

3. I use *Chicana/os* as an inclusionary term that incorporates all Mexican-origin people, including Mexican immigrants living in the United States.

4. See Arizona State Parks Board, *Historic Resource Survey of Concho, Arizona,* for more background on Concho. Photographers associated with the Farm Security Administration also focused their energies on Chicana/os in rural settings and migrant camps.

5. Ricardo Romo, "The Urbanization of Southwestern Chicanos in the Early Twentieth Century" in *En Aquel Entonces: Readings in Mexican-American History,* ed. Manuel G. Gonzales and Cynthia M. Gonzales (Bloomington: Indiana University Press, 2000), 132. Scattered among the photographs produced to document Arizona Works Progress Administration programs are some images of Mexican Americans.

6. Both of the following works provide a more comprehensive treatment of this period and its impact on Chicana/os: Francisco E. Balderrama and Raymond Rodriguez, *Decade of Betrayal: Mexican Repatriation in the 1930s* (Albuquerque: University of New Mexico Press, 1995); and Abraham Hoffman, *Unwanted Mexican Americans in the Great Depression: Repatriation Pressures, 1929–1939* (Tucson: University of Arizona Press, 1979).

7. Most of the photographs featured in this chapter, with the exception of family photographs, are from the Mexican American Heritage Project, located at the Arizona Historical Society (AHS), in Tucson. The photographs of Carmelo Corbellá, the priest of Holy Family Church during the early part of this century, are also included as part of the Mexican American Heritage Project. This collection offers another source of Chicana/o celebrations, outings, theatrical performances, and religious activities. Most of the individuals in Corbellá's collection, unfortunately, are not identified, and most of the photographs are not dated, a crucial factor that persuaded me not to include them in this chapter. Additionally, I did not include photographs of older adults because I could not find them. Even with the help of my cousin, Rita Lockas, the family archivist, we could not locate a single photograph of my grandfather or grandmother in the 1930s. Overall, families may have wished to express their optimism about the future and pride in their ability to provide their children with contemporary clothing and accessories during this difficult period, resulting in a predominance of photographs of youths.

8. Balderrama and Rodriguez, *Decade of Betrayal,* 121–22.

9. Charles Leland Sonnichsen, *Tucson: The Life and Times of an American City* (Norman: University of Oklahoma Press, 1982), 238.

10. George C. Kiser and Martha Kiser, *Mexican Workers in the United States: Historical and Political Perspectives* (Albuquerque: University of New Mexico Press, 1979), 36–37.

11. "Charities Plan to Aid Mexican," *Arizona Daily Star,* April 10, 1932; Pima County Welfare Board to Isabella Greenway, February 8, 1936, Isabella Greenway Papers, MS 311, box 118, Political Activity, folder 1619, AHS.

12. "Lorena Hickok Reports on the Great Depression's Ravages in Texas and the Southwest, 1934," in J'Nell L. Pate, *Document Sets for Texas and the Southwest in U.S. History* (Lexington, Mass.: D. C. Heath and Company, 1991), 144.

13. Vicki L. Ruiz, *From Out of the Shadows: Mexican Women in the Twentieth-Century America* (New York: Oxford University Press, 1998), 50; Vicki L. Ruiz, "Star Struck: Acculturation, Adolescence, and the Mexican American Woman, 1920–1950," in *Building with Our Hands: New Directions in Chicana Studies,* ed. Adela de la Torre and Beatríz M. Pesquera (Berkeley: University of California Press, 1993), 109–29.

14. Bryant Simon discusses the rural and gendered imaginary that underpinned New Deal programs in "'New Men in Body and Soul': The Civilian Conservation Corps and the Transformation of Male Bodies and the Body Politic" in *Gender and the Southern Body Politic,* ed. Nancy Bercaw (Jackson: University Press of Mississippi, 2000), 132–60.

15. Workers of the Writers' Program of the Work Projects Administration in the State of Arizona, *Arizona: A State Guide* (New York: Hastings House, 1940), 253.

16. This type of image appeared frequently in promotional material such as *Tucson: A Magazine of the Activities of the Local People and Interesting Things for Visitors and Newcomers,* 11, no. 3 (May 1938).

17. Workers of the Writers' Program, *The WPA Guide to 1930s Arizona* (Tucson: University of Arizona Press, 1989). Page 252 states 36,818 as the population of Tucson in 1940. Thomas E. Sheridan, in his *Los Tucsonenses: The Mexican Community in Tucson, 1854–1941* (Tucson: University of Arizona Press, 1986), also uses this population figure for 1940 but does not provide a population estimate for Tucson in the 1930s. I estimated the Chicana/o community to comprise 33 percent of the total population in 1930 by averaging the "Hispanic Percentage" of both 1920 (54.7) and 1940 (29.9) in Sheridan's table 1, page 3. Granted that this percentage may be overinflated because of deportations and repatriations.

18. Numerous photographs of Chicana/os posing next to and on their automobiles during the 1930s are part of the Mexican American Heritage Project, AHS. For more on the cultural meanings of automobiles, see Virginia Scharff, *Taking the Wheel: Women and the Coming of the Motor Age* (New York: Maxwell Macmillan International, 1991).

19. Minutes of meeting for the Pima County Advisory Board, January 17, 1933, Isabella Greenway Papers, MS 311, box 118, Political Activity, folder 1619, AHS; Suzanne Metter, in her *Dividing Citizens: Gender and Federalism in New Deal Public Policy* (Ithaca, N.Y.: Cornell University Press, 1998), contends that two oppositional forms of citizenship evolved in the welfare state. This system conferred more material and societal rewards on European American males characterized as hardworking and "deserving" citizens.

20. Rodolfo Acuña, *Occupied America: A History of Chicanos* (New York: Longman, 2000), 264.

21. For further discussions of Chicana/o appropriation of popular culture, see

Ruiz, *From Out of the Shadows,* 67–68; Ruiz, "Star Struck"; and George J. Sanchez, *Becoming Mexican American: Ethnicity, Culture, and Identity in Chicano Los Angeles, 1900–1945* (New York: Oxford University Press, 1993), 171–87. See also Laura Lee Cummings, "*Que siga el corridor:* Tucson Pachuchos and Their Times," Ph.D. diss., University of Arizona, Tucson, 1994, 13. Cummings argues that the attire associated with *pachuchos* was evident in Tucson as early as 1935.

22. *Congressional Record,* 71st Cong., 2nd sess., 1930, part 7, 7226, quoted in Kiser and Kiser, *Mexican Workers,* 50.

23. Hod carriers physically moved heavy loads associated with construction projects, such as bricks and mortar, usually on their backs; Albert Camarillo, *Chicanos in a Changing Society: From Mexican Pueblos to American Barrios in Santa Barbara and Southern California, 1848–1930* (Cambridge, Mass.: Harvard University Press, 1979), 91.

24. *Tucson City Directory* (Tucson: Arizona Directory Company, 1932); Ruth Milkman, "Women's Work and the Economic Crisis: Some Lessons from the Great Depression," in *A Heritage of Her Own: Toward a New Social History of American Women,* ed. Nancy F. Cott and Elizabeth H. Pleck (New York: Simon and Schuster, 1979), 507–41. Milkman studied employment patterns during the Depression and found that women were able to find work and keep working because they worked at lower-paying jobs in service industries. In addition, adherence to gendered stereotypes dictated which jobs men and women could perform. The opportunity to earn more money persuaded my mother to work at the Rialto Apartments after the Depression; she later moved to the Holiday Inn. She worked as a domestic until 1965.

25. Most trains were destined for El Paso, Texas, making their way to Ciudad Juárez, in Chihuahua, Mexico, but some repatriates were separated in Tucson and shipped to Nogales, Sonora. See Hoffman, *Unwanted Mexican Americans,* 118; and "Hardship Told by Emigrants: Starving Hordes Are Sent Back into Mexico," *Arizona Daily Star,* March 5, 1931.

26. As quoted in Charles Leland Sonnichsen, *Tucson: The Life and Times of an American City* (Norman: University of Oklahoma Press, 1982), 148; "Births Top Deaths Here during 1933," *Tucson Daily Citizen,* January 6, 1934, p. 6. In 1933, tuberculosis accounted for 331 deaths, or 42 percent of all deaths for persons over five years old, in Tucson. Fred P. Perkins, *Health Problems of Arizona* (Arizona State Board of Health, Press Release, 2, no. 16), Ephemera-Tuberculosis, AHS. WPA project no. 2-10-128 intended to turn an abandoned Civilian Conservation Camp in the Tucson Mountains into a "Children's Preventorium" for "undernourished and incipient tubercular children." Peter Riley to Isabella Greenway, December 17, 1935, Isabella Greenway Papers, MS 311, box 118, Political Activity, folder 1619, AHS.

27. This information was handwritten on the side of the photograph by the family member who submitted it to the archives.

Chapter 4. Casa Grande Valley Farms

1. Studies of the New Deal's rural resettlement program include Paul K. Conkin, *Tomorrow a New World: The New Deal Community Program* (Ithaca, N.Y.: Cornell University Press, 1959); Sidney Baldwin, *Poverty and Politics: The Rise and Decline of the Farm Security Administration* (Chapel Hill: University of North Carolina

Press, 1968); and Brian Q. Cannon, *Remaking the Agrarian Dream: New Deal Rural Resettlement in the Mountain West* (Albuquerque: University of New Mexico Press, 1996). A stimulating history of Casa Grande from the perspective of a former FSA official is Edward C. Banfield's *Government Project* (Glencoe, Ill.: Free Press, 1951). Two other resettlement projects in Arizona, Chandler Farms (310 acres) and Camelback Farms (242 acres), provided low-cost housing to families, full-time work for a handful of their residents, and part-time work in slack seasons for other residents. Casa Grande Valley Farms, however, was the only rural resettlement project in the state that was designed to furnish full-time, permanent employment for the head of every household.

2. Jonathan Garst to Will Alexander, June 3, 1937, box 37, folder 4; C. W. Menard, "Casa Grande Valley Project Final Inspection Report," mimeograph, October 6, 1937, box 38; C. B. Baldwin to John Robert Murdock, March 15, 1943, box 35, entry 8, Record Group (RG) 96, National Archives, College Park, Md.; *Arizona Blade-Tribune*, February 18, 1938.

3. Banfield, *Government Project*, 40; James S. Heizer to C. B. Baldwin, n.d. [ca. June 1942], box 35, folder 1, entry 8, RG 96; *Arizona Blade-Tribune*, February 18, 1938.

4. Banfield, *Government Project*, 59–60; *Arizona Blade-Tribune*, February 18, 1938; George Hussey, interview by Brian Q. Cannon, January 12, 1990, Phoenix, transcript in author's possession; B. F. Thum to Resettlement Administration, September 11, 1936; B. F. Thum to Walter Packard, November 13, 1936; Jonathan Garst to John O. Walker, October 25, 1938, box 39, folder 11, entry 8, RG 96.

5. *New York World-Telegram*, January 3, 1939; Lester Rosner to W. W. Alexander, January 3, 1939, box 36; Jonathan Garst to W. W. Alexander, January 13, 1939, box 36, entry 8, RG 96.

6. *Arizona Daily Star*, January 3, 1939; *Arizona Daily Star*, August 22, 1938; James N. Gregory, *American Exodus: The Dust Bowl Migration and Okie Culture in California* (New York: Oxford University Press, 1989), 163–64.

7. Mildred Frederick, interview by Brian Q. Cannon, February 12, 1990, Phoenix, transcript in author's possession; *Arizona Daily Star*, January 4, 1939.

8. Hussey interview.

9. Ibid.; Ewell Bennett, interview by Marsha Weisiger, May 29, 1992, Oklahoma-Arizona Migration Project, Arizona Historical Society, Tempe; F. N. Mortenson, "Casa Grande Valley Cooperative Farms—Problems and Progress of the Members," in *Proceedings of the Utah Academy of Sciences, Arts and Letters* 18 (1941): 21.

10. Hussey interview; Banfield, *Government Project*, 129. The FSA originally planned to divide each year's surplus among the members. See Jonathan Garst to W. W. Alexander, June 3, 1937, box 37, folder 4, entry 8, RG 96.

11. Banfield, *Government Project*, 75.

12. Banfield, *Government Project*, 89, 176, 191.

13. Mark W. Johnson, "Appraiser's Report: Casa Grande Valley Farms, Inc.," March 17, 1943, box 42; James S. Heizer to C. B. Baldwin, n.d. [ca. June 1942], box 35, folder 1, entry 8, RG 96.

14. R. W. Hollenberg to H. P. Dechant, November 25, 1943, box 35, entry 8, RG 96.

15. *J. F. Aldridge et al. vs. Casa Grande Valley Farms, Inc.,* Amended Complaint, November 13, 1943, box 35, entry 8, RG 96; Johnson, "Appraiser's Report"; Fred Campbell to R. W. Hollenberg, March 19, 1943, box 42, entry 8, RG 96; Banfield, *Government Project*, 207.

16. Casa Grande Valley Farms, minutes of special membership meeting, August 16, 1943, box 36, entry 8, RG 96.

17. Casa Grande Valley Farms, minutes of meeting of the board of directors, August 3, 1943, box 36, entry 8, RG 96; Aldridge et al., Amended Complaint.

18. F. Preston Sult to Ernest W. McFarland, October 1, 1943, box 35, entry 8, RG 96.

19. R. W. Hollenberg to R. W. Hudgens, December 8, 1943, box 35, entry 8, RG 96; Robert G. Craig to Laurence I. Hewes Jr., December 1, 1943, box 35, entry 8, RG 96; *Coolidge Examiner,* January 21, 1944; *Coolidge Examiner,* February 11, 1944; Banfield, *Government Project,* 217.

20. R. W. Hollenberg to Frank Hancock, February 15, 1944, box 35, entry 8, RG 96; Millard S. Cox et al. to Farmers Home Administration, December 27, 1946, box 35, entry 8, RG 96; Ernie Bias to Carl Hayden, January 2, 1945, box 35, entry 8, RG 96; Deed Register no. 83, pp. 520, 566, 571, 578, 582, 584, 594; Deed Register no. 84, pp. 130, 141, 176, 178, 191, 199, 321, 413; Docket no. 1, pp. 14, 43, 56, 67, 110, 121, 132, 155, 175, 186, Pinal County Courthouse, Florence, Ariz.

21. *Arizona Daily Star,* November 17, 1943.

22. F. Preston Sult to Ernest W. McFarland, October 1, 1943, box 35, entry 8, RG 96; transcript of telephone conversation between R. W. Hudgens and Laurence I. Hewes Jr., November 10, 1943, box 35, entry 8, RG 96; Banfield, *Government Project,* 191, 217, 231–33, 255–56.

23. Charles J. Shindo, *Dust Bowl Migrants in the American Imagination* (Lawrence: University Press of Kansas, 1997), 4, 7.

24. Shindo, *Dust Bowl Migrants,* 2.

Chapter 5. Dorothea Lange and Russell Lee

1. Dorothea Lange's "Migrant Mother" series was photographed in 1936, when Lange stopped at a pea workers' camp "by chance." See James Curtis, "Dorothea Lange, Migrant Mother, and the Culture of the Great Depression," *Winterthur Portfolio* 21 (Spring 1986): 4.

2. For histories of women during this period, see Susan Ware, *Holding Their Own: American Women in the 1930s* (Boston: Twayne Publishers, 1982); Susan Hartmann, *The Homefront and Beyond: American Women in the 1940s* (Boston: Twayne Publishers, 1982); William H. Chafe, *The American Woman: Her Changing Social, Economic, and Political Roles, 1920–1970* (New York: Oxford University Press, 1972); and Landon Jones, *Great Expectations: America and the Baby Boom Generation* (New York: Coward, McCann and Geoghegean, 1980).

3. See Karen Becker Ohrn, *Dorothea Lange and the Documentary Tradition* (Baton Rouge: Louisiana State University Press, 1980), 39–98. Ohrn's book, primarily an oral interview with Lange, contains a wealth of biographical information.

4. Roy Stryker to Russell Lee, September 6, 1939, quoted in James B. Colson, "The Art of the Human Document: Russell Lee in New Mexico," in Russell Lee, Jack Delano and James B. Colson, *Far from Main Street: Three Photographers in Depression-Era New Mexico* (Santa Fe: Museum of New Mexico Press, 1994), 4. These comments were made to Lee in regard to his documentation project at Pie Town, New Mexico. In April, Stryker instructed Lee that "the photographs, as far as possible, will have to indicate something of what you suggest in your letter, namely: an attempt to integrate their lives on this type of land in such a way as to stay off the highways and the relief rolls." Roy Stryker to

Russell Lee, April 22, 1940, quoted in Colson, "Art of the Human Document," 5.

5. Russell Lee to Roy Stryker, April 20, 1940, quoted in Joan Myers, *Pie Town Woman: The Hard Life and Good Times of a New Mexico Homesteader* (Albuquerque: University of New Mexico Press, 2000), 104.

6. See Curtis, "Dorothea Lange, Migrant Mother," generally, for a discussion of Lange's attempts to capture the dignity of her subjects.

7. William Henry Dethlef Koerner (1878–1938) worked as an illustrator under the tutelage of Howard Pyle, N. C. Wyeth, and Harvey Dunn, and in 1919 he was asked by the editors of the *Saturday Evening Post* to illustrate two series, "Traveling the Old Trails," and "The Covered Wagon." These assignments were a turning point for Koerner, who went to great lengths to research his Western subjects, including making several visits to the West with his family and spending time at an Indian reservation in Montana. Koerner imbued his paintings with romantic and mythological images of the West's people, events, and landscape. For more information on Koerner, see *W.H.D. Koerner: Illustrating the Western Myth* (Fort Worth, Tex.: Amon Carter Museum of Western Art, 1969) and *W.H.D. Koerner: Illustrator of the West* (Los Angeles: Los Angeles County Museum of Natural History, 1968). For more information on the western imagination as captured in American art, see Alan Axelrod, *Art of the Golden West* (New York: Abbeville Press, 1990); William H. Goetzmann, *West of the Imagination* (New York: Norton, 1986); and Ed Ainsworth, *The Cowboy in Art* (New York: World Publishing Co., 1968).

8. And, of course, the mythology of the West was as equally pervasive in films and popular novels of this time. See, for example, Jon Tuska, *The American West in Film: Critical Approaches to the Western* (Lincoln: University of Nebraska Press, 1999); Jenni Calder, *There Must Be a Lone Ranger: The American West in Film and in Reality* (New York: McGraw-Hill, 1977); and Scott Emmert, *Loaded Fictions: Social Critique in the Twentieth-Century Western* (Moscow: University of Idaho Press, 1997).

9. See Corlann Gee Bush, "The Way We Weren't: Images of Women and Men in Cowboy Art," in *The Women's West,* ed. Susan Armitage and Elizabeth Jameson (Norman: University of Oklahoma Press, 1987), 19–33. Bush examines closely images of women in the frontier and compares their representation with images of cowboys and homesteaders. She argues that "regardless of artist or era, cowboy art tells the same story of independent men and dependent women."

10. Lee had begun his professional career as a chemical engineer, but left his position as a manufacturing plant manager in 1929 to paint, eventually taking classes at the California School of Fine Arts and with John Sloan in New York. Interested in portrait painting but dissatisfied with his skills as a draftsman, Lee bought a thirty-five millimeter Contax camera to record images for his paintings. Before long, he was taking more photographs and painting fewer pictures. Prior to joining the FSA, Lee photographed people on the streets of New York and coal miners in Pennsylvania. In 1936, he approached Roy Stryker with his portfolio. Although at the time Stryker had no steady work for Lee with the FSA, he nonetheless was impressed by what he saw and hired the aspiring photographer for a freelance assignment in New Jersey. Mydans's subsequent move to *Life* afforded Stryker the opportunity to see what Lee could deliver for the FSA. Myers, *Pie Town Woman,* 106.

11. Lange had also visited these programs, but her photographs indicate she was

more interested in the projects' buildings—particularly the apartments at Chandler, which were considered rather modern in their design and appliances.

12. James Curtis, "The Last Frontier: Russell Lee and the Small-Town Ideal," in *Mind's Eye, Mind's Truth* (Philadelphia: Temple University Press, 1989), 97.

13. Russell Lee to Roy Stryker, April 22, 1940, Roy Stryker Papers, Special Collections, University of Louisville, Kentucky.

14. Curtis, "The Last Frontier," 97.

15. Russell Lee to Roy Stryker, April 20, 1940, Stryker Papers.

16. See Curtis, "Dorothea Lange, Migrant Mother," 4. In many ways, the anonymity was due to Stryker's insistence. Stryker placed enormous significance upon the captions for each photograph, which he insisted should be detailed. He was fond of saying that the photograph was "only the subsidiary, the little brother of the word," and he often wrote Lee with suggestions for crafting his captions. However, he directed his photographers, when writing captions for their images, to follow techniques employed by contemporary social scientists: subjects of photographs were treated in the same manner as interview subjects—as anonymous individuals. Stripped of their individual identities, the photograph's subjects became the "common men and women whose plight the Roosevelt administration was working to improve." Stryker to Lee, April 4, 1940, Stryker Papers. Yet even though Stryker wanted his photographers to maintain the anonymity of their subjects, the words that Lange and Lee used in their captions highlight the differences between their viewpoints, as well as the differences in the lives they captured.

17. This was, of course, a time when women spent more time doing housework—an average of ninety-nine hours per week. See Susan J. Douglas, *Where the Girls Are: Growing Up Female with the Mass Media* (New York: Random House, 1994), 54. Douglas provides an excellent overview of the role of the mass media in America's idealization of women from the Depression era to the 1970s. See also Ruth Schwartz Cowan's *More Work for Mother: The Ironies of Household Technology from the Open Hearth to the Microwave* (New York: Basic Books, 1983), a classic study of women and housework; and Sherrie A. Inness, ed., *Kitchen Culture in America: Popular Representations of Food, Gender, and Race* (Philadelphia: University of Pennsylvania Press, 200). Various feminist scholars have studied aspects of the mass media and women. See Janice Radway, *Reading the Romance* (Chapel Hill: University of North Carolina Press, 1984); Christine Gledhill, ed., *Home Is Where the Heart Is* (London: British Film Institute, 1987); Mary Jane Doane et al., eds., *Re-Vision: Essays in Feminist Film Criticism* (Frederick, Md.: University Publications of America, 1984).

18. Russell Lee to Roy Stryker, July 13, 1940, Roy Stryker Collection, Special Collections, University of Louisiana. See also Russell Lee to Roy Stryker, June 24, 1940. In these letters, Lee outlines to Stryker the lengths he went to in order to become acquainted with his subjects and to make them feel comfortable regarding his photography. In New Mexico, he and his wife, Jean, stayed with a local family and took their meals with them as well; Lee notes that he met "the priest, postmaster, majordomo, merchants and several of the farmers."

19. It is interesting to note that in the National Archives' on-line representation of this image, the caption reads "[African-American] cotton picker," changing and editorializing Lange's original caption.

20. Brown and Cassmore, "Migratory Cotton Pickers in Arizona" (1939): 5–6, cited by Lange in General Caption 8, Cortaro Farms, Pinal County, Ariz., Bureau of Agricultural Economics, National Archives and Records Administration.

21. Myers, *Pie Town Woman,* 119.

22. Robert L. Reid, *Picturing Texas: The FSA/OWI Photographers in the Lone Star State, 1935–1943* (Austin: Texas State Historical Association, 1994).

23. Ohrn, *Dorothea Lange,* 174. Lange continued: "I can't just now give an example, but it did happen more than once that we unearthed and discovered what had been either neglected, or not known, in various parts of the country, things that no one else seemed to have observed in particular, yet things that were too important not to make a point of."

24. Milton Meltzer, *Dorothea Lange: A Photographer's Life* (New York: McGraw-Hill, 1978), 131.

25. Jean Lee quoted in Myers, *Pie Town Woman,* 109.

Chapter 6. Pictures for Sale

1. Pete Daniel and Sally Stein, *Official Images: New Deal Photography,* viii.

2. Charles Leland Sonnichsen, *Tucson: The Life and Times of an American City* (Norman: University of Oklahoma Press, 1982), 177–229; Bradford Luckingham, *Phoenix: The History of a Southwestern Metropolis* (Tucson: University of Arizona Press, 1989), 69–100; Jackson Lears, *Fables of Abundance: A Cultural History of Advertising in America* (New York: Basic Books, 1994), 323–29.

3. Roland Marchand, *Advertising the American Dream: Making Way for Modernity, 1920–1940* (Berkeley: University of California Press, 1985); Stuart Ewen, *Captains of Consciousness: Advertising and the Social Roots of the Consumer Culture* (New York: McGraw-Hill, 1976).

4. John Morrison Clements to Evelyn S. Cooper, March 1995, Arizona Historical Foundation, Arizona State University Libraries, Tempe; Barry M. Goldwater, interview by Evelyn S. Cooper, June 1993, author's file.

5. Evelyn S. Cooper, *The Buehman Studio Tucson in Focus* (Tucson: Arizona Historical Society, 1995), 5–13.

6. Lisle Chandler Updike, interview by Bob Spude, September 4, 1975, Lisle Updike Collection, Department of Archives and Manuscripts, Arizona State University Libraries, Tempe, 13–23; Lisle Updike obituary, Lisle Updike Collection, Department of Archives and Manuscripts, Arizona State University Libraries, Tempe, 2–4; Tom C. Cooper, "*Arizona Highways:* From Engineering Pamphlet to Prestige Magazine," master's thesis, University of Arizona, Tucson, 1973.

7. Patricia Beatrice McCulloch Neathery, interview by Evelyn S. Cooper, February 6, 1985, tape recording, author's file; William Thompson and Bonnie McCulloch, interview by William Thompson "Tom" McCulloch Jr., November 23, 1984, tape recording, author's file; William Thompson "Tom" McCulloch Jr., interview by Evelyn S. Cooper, November 30, 1984, tape recording, author's file.

8. Thomas Henry Bate Jr., interview by Evelyn S. Cooper, December 4, 1992, tape recording, author's file; Claude Bate's photographs are housed at the Arizona Historical Foundation, Arizona State University Libraries, Tempe; examples of Bate's celebrity portraiture can be found in the Biltmore Hotel Collection, Department of Archives and Manuscripts, Arizona State University Libraries, Tempe.

9. Sarah Pedersen, *Emery Kolb: A Guide to the Kolb Collection in the NAU Cline Library,* Discovery Series 17 (Flagstaff, Ariz.: Cline Library, Northern Arizona University, 1980), 2; Lewis R. Freedman, *The Colorado River, Yesterday, Today, and To-morrow* (New York: Dodd, Mead and Co., 1923), 339; Kenneth Arline, "River Man Plans Another Journey," *Phoenix Gazette,* October 4, 1976, sec. A; "In Memoriam Emery Clifford Kolb, 15 February 1881–11 December 1976," *Grand Canyon SAMA* (January 2, 1977): 1; Ellsworth Kolb and Emery Kolb, "The Picture Story of a Great Adventure," *American Magazine* (July 1913): 59; Ellsworth Kolb, *Through the Grand Canyon from Wyoming to Mexico* (New York: Macmillan Co., 1914), x–xi; *Grand Canyon Motion Picture,* 1911, Motion Picture Collection, part 1, Kolb Collection, Cline Library, Northern Arizona University, Flagstaff; *National Geographic Magazine,* August 1914; undated manuscripts concerning the Grand Canyon and Colorado River, Manuscript Collection no. 197, series 2, box 1, part 4, Kolb Collection, Cline Library, Northern Arizona University, Flagstaff; *Coconino Sun,* May 12, 1966, 4; Howard R. Lamar, ed., *The Reader's Encyclopedia of the American West* (New York: Harper and Row, 1977), 457; Michael Pace, "Emery Kolb and the Fred Harvey Company," *Journal of Arizona History* 24 (Winter 1983): 339–40, 350–54, 361; the Kolb Photograph and Manuscript Collection is housed at the Cline Library, Northern Arizona University, Flagstaff.

10. *Forman Hanna: Pictorial Photographer of the Southwest* (Tucson: University of Arizona, 1985). An exhibition catalogue.

11. Roy P. Drachman, *This Is Not a Book: Just Memories* (Tucson: R. P. Drachman, 1979), chap. 2; Kathleen Walker, "Chasing the Perfect Picture," *Arizona Highways* 68 (April 1992): 4–12; Herbert McLaughlin, interview by Evelyn S. Cooper, 1984, author's file; Carlos Elmer, interview by Evelyn S. Cooper, March 1982, author's file; Esther Henderson, interview by Evelyn S. Cooper, 1985, author's file; and Josef Muench, interview by Evelyn S. Cooper, August 1985, author's file.

12. Evelyn S. Cooper, *E. D. Newcomer: Arizona's Premier Press Photographer and Aerialist,* History of Photography Monograph Series (Tempe: Arizona Board of Regents, 1986), 1–20; Brothers Joseph and John F. Kennedy worked at the Jay-Six Ranch outside Benson in 1936.

13. Old newspapers from the 1930s provide a treasure trove of historical insight into the types of images Arizona photographers captured, as well as the central role photographs played in local advertising. Arizona masters Herbert McLaughlin, Carlos Elmer, and Senator Barry Goldwater told me many colorful stories about the relationship between the public and photographers across time, including the favoritism initially shown to those with press badges.

Chapter 7. Paper Faces

1. Martha A. Sandweiss, *Laura Gilpin: An Enduring Grace* (Fort Worth, Tex.: Amon Carter Museum of Western Art, 1986), 51.

2. Laura Gilpin, *The Enduring Navaho* (Austin: University of Texas Press, 1968), v.

3. Ibid.

4. Gilpin, *Enduring Navaho,* 23–32; Sandweiss, *Laura Gilpin,* 52–55. See also Elizabeth W. Forster and Laura Gilpin, *Denizens of the Desert: A Tale in Word and Picture of Life among the Navaho Indians,* ed. Martha A. Sandweiss (Albuquerque: University of New Mexico Press, 1988).

5. See Gilpin, *Enduring Navaho,* throughout; Sandweiss, *Laura Gilpin,* 24, 32, 36, 40, 55–57, plates 62–76, 78–81.

6. Sandweiss, *Laura Gilpin,* 58; Jonathan Goldberg, "Photographic Relations: Laura Gilpin, Willa Cather," *American Literature* 70 (March 1998): 63–95.

7. Peter Iverson, *Diné: A History of the Navajos* (Albuquerque: University of New Mexico Press, 2002), 153; Thomas E. Sheridan, *Arizona: A History* (Tucson: University of Arizona Press, 1995), 296.

8. Sandweiss, *Laura Gilpin,* 57–58.

9. James C. Faris, *Navajo and Photography: A Critical History of the Representation of an American People* (Albuquerque: University of New Mexico Press, 1996), 240, 245; Gilpin, *Enduring Navaho,* 23.

10. Gilpin, *Enduring Navaho,* 31; Faris, *Navajo and Photography,* 246.

11. Faris, *Navajo and Photography,* 235–53, 248–49.

12. Monty Roessel, "Navajo Photography," *American Indian Culture and Research Journal* 20, no. 3 (1996): 90.

13. Quoted in Martha A. Sandweiss, *Print the Legend: Photography and the American West* (New Haven, Conn.: Yale University Press, 2002), 270.

14. Roessel, "Navajo Photography," 83.

15. Gilpin, *Enduring Navaho,* 32.

16. Sandweiss, *Laura Gilpin,* 51, plate 61; Margaret Regan, "The Life of Timothy O'Sullivan: The Story of the Irishman Who Helped Shape American—and Arizonan—Photography," *Tucson Weekly* 20, no. 2, March 13–19, 2003, 18–23.

17. Alfred L. Bush and Lee Clark Mitchell, *The Photograph and the American Indian* (Princeton, N.J.: Princeton University Press, 1994), xvi.

18. Erin Younger and Victor Masayesva Jr., *Hopi Photographers/Hopi Images,* Sun Tracks (Tucson: University of Arizona Press, 1983), 15; Iverson, *Diné,* 51–52; Faris, *Navajo and Photography,* 54.

19. Faris, *Navajo and Photography,* 68–69, 62–63.

20. Sandweiss, *Print the Legend,* 191–92; printed in George M. Wheeler, *Photographs . . . Obtained in Connection with Geographical and Geological Explorations and Survey West of the 100th Meridian* (1874); Regan, "Timothy O'Sullivan," 22.

21. Edward S. Curtis, *The North American Indian: Being a Series of Volumes Picturing and Describing the Indians of the United States and Alaska* (New York: Johnson Reprint Corp., 1976), originally published 1907–1930; Jeremy Rowe, *Photographers in Arizona, 1850–1920: A History and Directory* (Nevada City, Calif.: Carl Mautz Publishing, 1997), 82; Margaret Regan, "Edward S. Curtis: A Look at One Man's Quest to Record the American Indian's 'Vanishing' Traditions," *Tucson Guide Quarterly* 22, no. 1 Spring 2004), 130–34.

22. Ira Jacknis, preface to *American Indian Culture and Research Journal* 20, no. 3 (1996): 1.

23. Sandweiss, *Print the Legend,* 224, 220.

24. Younger and Masayesva, *Hopi Photographers,* 11–12; Sandweiss, *Print the Legend,* 221.

25. Sandweiss, *Print the Legend,* 221.

26. Younger and Masayesva, *Hopi Photographers,* 21; Sandweiss, *Print the Legend,* 225. For reprints of Monsen's *Craftsman Magazine* work, see Frederick I. Monsen, *Frederick Monsen at Hopi* (Santa Fe: Museum of New Mexico, 1979). For examples

of Monsen's photographs, see Karen Current, *Photography and the Old West* (New York: Abrams, 1978), 246–55.

27. In a supreme irony, Wittick, who photographed the Snake Dance "from the mid-1880s to his death in 1903," actually died from a fatal snakebite. He had intended to give the Hopi a gift of a rattlesnake for their ceremony, but it bit him. Luke Lyon, "History of Photography of Southwest Indian Ceremonies," in *Reflections: Papers on Southwestern Culture History in Honor of Charles H. Lange,* ed. Anne Van Arsdall Poore, Papers of the Archeological Society of New Mexico, 14 (Santa Fe: Ancient City Press, 1988), 238. Cited in Sandweiss, *Print the Legend,* 228. See also Patricia Janis Broder, *Shadows on Glass: The Indian World of Ben Wittick* (Savage, Md.: Rowman and Littlefield, 1990).

28. Sandweiss, *Print the Legend,* 227; T. C. McLuhan, *Dream Tracks: The Railroad and the American Indian, 1890–1930* (New York: Abrams, 1985), 35. See also Leah Dilworth, *Imagining Indians in the Southwest: Persistent Visions of a Primitive Past* (Washington, D.C.: Smithsonian Institution Press, 1996).

29. Theodore Roosevelt, "The Hopi Snake Dance," *Outlook* (October 1913): 365; also quoted in McLuhan, *Dream Tracks,* 117; Lyon, "Southwest Indian Ceremonies," 241.

30. Lyon, "Southwest Indian Ceremonies," 242; Rowe, *Photographers in Arizona,* 82.

31. Lyon, "Southwest Indian Ceremonies," 242; Crane, 251–55, also quoted in Lyon, "Southwest Indian Ceremonies," 242.

32. Younger and Masayesva, *Hopi Photographers,* 10, 24; Lyon, "Southwest Indian Ceremonies," 252, 245.

33. Iverson, *Diné,* 142, 177.

34. Younger and Masayesva, *Hopi Photographers,* 28; Philip Deloria, *Playing Indian* (New Haven, Conn.: Yale University Press, 1998), 136–37. On the history of *Arizona Highways,* see Tom C. Cooper, "*Arizona Highways*: From Engineering Pamphlet to Prestige Magazine," master's thesis, University of Arizona, Tucson, 1973; James C. Cook and Wesley Holden, *Arizona Landmarks* (Phoenix: Arizona Highways, 1985).

35. Younger and Masayesva, *Hopi Photographers,* 28, 31.

36. Younger and Masayesva, *Hopi Photographers,* 29. The painting *Mixed Kachina Dance,* by Hopi artist Riley Sunrise, is in the Avery Collection of American Indian Paintings at the Arizona State Museum, Tucson.

37. McLuhan, *Dream Tracks,* 41, 34; Marta Weigle and Barbara A. Babcock, *The Great Southwest of the Fred Harvey Company and the Santa Fe Railway* (Phoenix: Heard Museum/Tucson: University of Arizona Press, 1996).

38. McLuhan, *Dream Tracks,* 41, 43. Examples of the pamphlets include Atchison, Topeka, and Santa Fe Railway Company, *Indian Detour* (Chicago: Rand McNally and Company, 1926–41). For photographs, see also Fred Harvey Collection, Special Collections, University of Arizona Library, Tucson; Fred Harvey Photograph Collection, Billie Jane Baguley Library and Archives, Heard Museum, Phoenix.

39. McLuhan, *Dream Tracks,* 42, 41.

40. The architecture is another example of cultural syncretism: the white architect Mary Elizabeth Jane Colter hired a Hopi artist to paint traditional murals on its rounded interior walls; the painter might have been the famed Hopi painter, Fred Kabotie, who is credited for murals in another one of her Grand Canyon buildings, Desert Watchtower. On Mary Colter, see Arnold Berke, *Mary Colter:*

Architect of the Southwest (New York: Princeton Architectural Press, 2002); and Virginia L. Gratton, *Mary Colter: Builder upon the Red Earth* (Flagstaff, Ariz.: Northland Press, 1980).

41. Younger and Masayesva, *Hopi Photographers,* 25.

42. Younger and Masayesva, *Hopi Photographers,* 26, 27; Faris, *Navajo and Photography,* 240; Sandweiss, *Laura Gilpin,* 58. Elizabeth Hegemann lived at Shonto Trading Post; see Elizabeth Hegemann Photographs, Photographic Collections, Arizona State Museum, Tucson. For other examples of Arizonans who photographed on the Navajo and Hopi reservations in the 1930s, see Forman Hanna Photograph Collection, Arizona Historical Society/Tucson; Forman Hanna Collection, Photographic Collections, Arizona State Museum, Tucson; Gretchen Swinnerton Collection, Colton Research Center Library, Museum of Northern Arizona, Flagstaff.

43. Gilpin, *Enduring Navaho,* 20.

44. Jacknis, preface, 3; Roessel, "Navajo Photography," 91; Faris, *Navajo and Photography,* 292; Younger and Masayesva, *Hopi Photographers,* 42–47; Joanna C. Scherer, "The Photographic Document: Photographs as Primary Data in Anthropological Enquiry," in *Anthropology and Photography, 1860–1920,* ed. Elizabeth Edwards (New Haven, Conn.: Yale University Press, 1992), 32–41. Another approach is taken in editor Lucy R. Lippard's *Partial Recall: With Essays on Photographs of Native North Americans* (New York: New Press, 1992), through which Native American writers and authors "look inside" selected historical photographs of Native Americans.

45. Roessel, "Navajo Photography," 90.

Chapter 8. Scientific Photography?

1. Julian Hayden to Natalie Patterson, 1995, MS 315-19-2, Milton Snow Collection, Colton Research Center Library, Museum of Northern Arizona, Flagstaff. Hayden worked on these Gila Pueblo Archaeological Foundation projects located, respectively, near Globe and Phoenix. See Mark R. Hackbarth, "Irwin and Julian Hayden at the Grewe Site," *Kiva* 64, no. 2 (1998): 211–23. Keet Seel, in northern Arizona, is located on the Navajo reservation. The grand tour was considered an important part of archaeological training; archaeologists needed to see and experience the land as well as learn how to excavate sites.

2. For more detailed history of Southwest archaeology, see Don D. Fowler, *A Laboratory for Anthropology: Science and Romanticism in the American Southwest, 1846–1930* (Albuquerque: University of New Mexico Press, 2000); and J. Jefferson Reid and David E. Doyel, eds., *Emil W. Haury's Prehistory of the American Southwest* (Tucson: University of Arizona Press, 1986); Paul S. Martin and Fred Plog's *The Archaeology of Arizona: A Study of the Southwest Region* (Garden City, N.J.: Doubleday/Natural History Press, 1973), 16–19, includes a partial list of the major Southwestern expeditions by year. On specific excavations and archaeologists, see Melinda Elliott, *Great Excavations: Tales of Early Southwestern Archaeology, 1888–1939* (Santa Fe: School of American Research Press, 1995); Robert H. Lister and Florence C. Lister, *Those Who Came Before: Southwestern Archaeology in the National Park System* (Globe, Ariz.: Southwest Parks and Monuments Association, 1983); Bruce B. Huckell, Darrell C. Creel, and G. Michael Jacobs, "E. B. 'Ted' Sayles: Pioneer Southwestern Archaeologist," *Kiva* 63, no. 1 (1997): 69–85.

3. Gila Pueblo Foundation Papers, 1928–1950, MS 15, Archives, Arizona State Museum, Tucson; Emil W. Haury, "Gila Pueblo Archaeological Foundation: A History and Some Personal Notes," *Kiva* 54, no. 1 (1988). In New Mexico, the Laboratory of Anthropology, Albuquerque, engaged in similar work.

4. Christian E. Downum, "The Observer: Julian Hayden at Pueblo Grande," *Kiva* 64, no. 2 (1998): 245–74; Colton Collection, Rainbow Bridge–Monument Valley Expedition, and Lyons Papers, MS 295, Colton Research Center Library, Museum of Northern Arizona, Flagstaff.

5. Edward H. Spicer and Louis R. Caywood, *Two Pueblo Ruins in West Central Arizona,* University of Arizona Social Sciences Bulletin 10, University of Arizona Bulletin, vol. 7, no. 1 (1936).

6. Work Projects Administration, Statewide Archaeological Project Papers, 1938–40, MS 2, Archives, Arizona State Museum, Tucson.

7. On the history of archaeology's use of photography, see Melissa Banta and Curtis M. Hinsley, "Archaeology: Intermingling of Human Past and Present through the Camera's Eye," in *From Site to Sight: Anthropology, Photography, and the Power of Imagery* (Cambridge, Mass.: Peabody Museum Press, 1986), 73–100. See also Ann Thomas, ed., *Beauty of Another Order: Photography in Science* (New Haven, Conn.: Yale University Press, 1997).

8. Curtis M. Hinsley and David R. Wilcox, eds., *Frank Hamilton Cushing and the Hemenway Southwestern Archaeological Expedition, 1886–1889,* vol. 1: *The Southwest in the American Imagination: The Writings of Sylvester Baxter, 1881–1899,* The Southwest Center Series (Tucson: University of Arizona Press, 1996). The practice of romanticizing cliff dwellings through evocative photographs that play with light, and making them seem like dark, mysterious, and remote places, has carried through into the present. An excellent example is the work of William Current (1922–86), a California architect and landscape photographer who tried to show cliff ruins as quasi-natural forms that harmonized with their surroundings. Jeffrey Cook, *Anasazi Places: The Photographic Vision of William Current* (Austin: University of Texas Press, 1992).

9. Cleaning up of the artifacts was also an important step in preparing artifacts for photographing in the museum setting. Sherds, tools, and other cultural remains were cleaned of dirt and repaired before being placed on neutral-colored backgrounds, or more rarely, returned to the field for photographing in context.

10. Julian Hayden to Natalie Patterson, 1995, MS 315-19-2, Milton Snow Collection, Colton Research Center Library, Museum of Northern Arizona, Flagstaff.

11. For a history of changes in field methods and techniques, see Gordon R. Willey and Jeremy A. Sabloff, *A History of American Archaeology* (San Francisco: W. H. Freeman and Company, 1974).

12. The treatment of human remains has changed since the 1930s. The archaeologists at work in 1930s Arizona dealt with human remains primarily as objects of study, regularly photographed and disturbed grave sites, and removed remains for study. The Native American Graves Protection and Repatriation Act (NAGPRA), passed in 1990, provides for protection of Native American graves, requiring, among other things, federal permits and tribal consent for excavation and removal of Native American human remains and objects from federal or tribal lands. There is an extensive literature on NAGPRA and its impact on archaeology. See, for example, Devon A. Mihesuah, ed., *Repatriation Reader: Who*

Owns American Indian Remains? (Lincoln: University of Nebraska Press, 2000); Tamara L. Bray, ed., *The Future of the Past: Archaeologists, Native Americans, and Repatriation* (New York: Garland Publishing, 2001). Following ethical standards, we have not included any of the numerous photographs of human remains in this book. A related issue is the ongoing debate over whether or not photographs of Indians should be included under NAGPRA. For thoughtful discussion of these issues see the following, each of which includes reference to Arizona examples: Michael F. Brown, "Can Culture Be Copyrighted?" *Current Anthropology* 39 (April 1998): 193–222; Martha A. Sandweiss, *Print the Legend: Photography and the American West* (New Haven, Conn.: Yale University Press, 2002), 269–72; Laura Downey, "A Tourist Album and Its Implications for the Intellectual Property Rights of Indigenous Peoples," *WAAC Newsletter* 20 (May 1998).

13. In thinking about these photographs, we have found useful Elizabeth Edwards, "Photographing Objects," in *Raw Histories: Photographs, Anthropology and Museums* (New York: Berg, 2001), 51–79.

14. On Anna Osler Shepard, see Linda S. Cordell, "Women Archaeologists of the Southwest," in *Hidden Scholars: Women Anthropologists and the Native American Southwest,* ed. Nancy J. Parezo (Albuquerque: University of New Mexico Press, 1993), 208–10. Carlos Garcia-Robiou, a University of Havana professor, was responsible for the large-format photography from Awatovi.

15. Courtney Reeder Jones, *Letters from Wupatki,* ed. Lisa Rappoport (Tucson: University of Arizona Press, 1995).

16. Elizabeth Edwards, ed., *Anthropology and Photography, 1860–1920* (New Haven, Conn.: Yale University Press, 1992); Banta and Hinsley, *From Site to Sight.*

17. Emil W. Haury, *The Canyon Creek Ruin and the Cliff Dwellings of the Sierra Ancha,* Medallion Papers, vol. 14 (Globe, Ariz.: Gila Pueblo, 1934).

18. Edward P. Beckwith, "Hopi Mesas," 1938, Watson Smith Album, Photographic Collections, Arizona State Museum, Tucson; Tad Nichols Collection, Photographic Collections, Arizona State Museum, Tucson; Byron Cummings, *Kinishba: A Prehistoric Pueblo of the Gila Pueblo Period* (Tucson: University of Arizona/Hohokam Museums Association, 1940). The U.S. Weather Bureau used box kites for aerial photography until the early 1930s.

19. "Aerial survey is one of the most useful means of finding sites, especially where there is a minimum of vegetation and where large areas are to be surveyed. Photos taken at the proper altitude and time of day show things that are not visible to anyone on the ground. When used in conjunction with surface inspection, aerial photos give information that could otherwise be learned only by excavation." Frank Hole and Robert F. Heizer, *An Introduction to Prehistoric Archaeology* (New York: Holt, Rinehart and Winston, 1965), 132.

20. Neil M. Judd, "A Lost Civilization Traced by an Air Survey," *New York Times,* March 2, 1930; Neil M. Judd, *Men Met along the Trail: Adventures in Archaeology* (Norman: University of Oklahoma Press, 1968). See also Fairchild Aerial Photo Collection, Map Collection, Noble Science and Engineering Library, Arizona State University, Tempe. Charles and Anne Morrow Lindbergh made a reconnaissance over the Colorado Plateau in the late 1920s. Erik Berg, "The Eagle and the Anasazi: The Lindberghs 1929 Aerial Survey of Prehistoric Sites in Arizona and New Mexico," presented at 2003 Arizona Historical Convention, to be published in *Journal of Arizona History.*

21. Hole and Heizer, *Prehistoric Archaeology,* 174.

22. One way to map changes in archaeologists' perspectives on the value and use of photography is to compare the texts on the subject: M. B. Cookson, *Photography for Archaeologists* (London: Max Parrish, 1954); S. K. Matthews, *Photography in Archaeology and Art* (London: John Baker, 1968); Harold C. Simmons, *Archaeological Photography* (New York: New York University Press, 1969); Elmer Harp Jr., ed., *Photography in Archaeological Research* (Albuquerque: School for American Research/University of New Mexico Press, 1975); John Collier Jr. and Malcolm Collier, *Visual Anthropology: Photography as a Research Method* (Albuquerque: University of New Mexico Press, 1986). See also Sydel Silverman and Nancy J. Parezo, eds., *Preserving the Anthropological Record* (New York: Wenner-Gren Foundation for Anthropological Research, 1995).

23. Ventana Cave, Julian Hayden Notes, 1942, A148, Archives, Arizona State Museum, Tucson. On Julian Hayden's photographs, see Mary Bernard-Shaw and Chet Shaw, "Borderlands: Views of a Region by Julian Hayden," *Journal of the Southwest* 31, no. 4 (1989): 453–70.

Chapter 9. Dams and Erosion

1. This essay draws on research in manuscript and photography collections at the Arizona Historical Society/Tucson; Archives and Public Records, Arizona State Library, Phoenix; Department of Archives and Manuscripts, Arizona State University Libraries, Tempe; National Archives II, College Park, Md.; Museum of Northern Arizona, Flagstaff; Special Collections, Northern Arizona University Library, Flagstaff; Navajo Nation Museum, Window Rock, Ariz.; Sharlot Hall Museum Library and Archives, Prescott, Ariz.; Special Collections, University of Arizona Library, Tucson; and Center for Southwest Research, University of New Mexico, Albuquerque.

2. Two Los Angeles commercial photographers were responsible for the construction company's Coolidge Dam photographs—Joseph Cadenbach and V. S. Roy. According to his son, Warren, Joseph Cadenbach "was the most proud" of "Passing of the Desert" out of all his Coolidge Dam images. Phone conversation with Marilyn Cadenbach, December 18, 2001.

3. On multiple-arch and multiple-dome dam designs in the United States, see Donald Jackson, *Building the Ultimate Dam: John S. Eastwood and the Control of Water in the West* (Lawrence: University Press of Kansas, 1995).

4. Weston Naef, *Era of Exploration: The Rise of Landscape Photography in the American West* (Boston: Metropolitan Museum of Art, 1975). The most obvious comparison is to the many photographs of Yosemite's Mirror Lake. See, for example, Carleton Watkins, "Mirror Lake," 1864; and Charles Leander Weed, "Mirror Lake and Reflections, Yosemite Valley, Mariposa County, California," 1865.

5. The San Carlos Project has been referred to by a variety of names over the years, including the San Carlos Indian Irrigation Project, the San Carlos Federal Irrigation Project, and the San Carlos Irrigation Project; to avoid confusion, I will use "San Carlos Project" in this chapter. On the political struggle for the San Carlos Project, see Jack L. August Jr., *Vision in the Desert: Carl Hayden and Hydropolitics in the American Southwest* (Fort Worth: Texas Christian University Press, 1999). Other sources include David M. Introcaso, *Water Development on the Gila River: The Construction of the Coolidge Dam* (San Francisco: Historic American

Building Survey, National Park Service, Western Region, Department of the Interior, 1986); Christine Pfaff, *San Carlos Irrigation Project: Photographs, Written Historical and Descriptive Data* (San Francisco: Historic American Engineering Record, National Park Service, Western Region, Department of the Interior, 1996).

6. Andrew Dunbar and Dennis McBride, *Building Hoover Dam: An Oral History of the Great Depression* (New York: Twayne Publishers, 1993); Beverly Bowen Moeller, *Phil Swing and Boulder Dam* (Berkeley: University of California Press, 1971); Joseph Stevens, *Hoover Dam: An American Adventure* (Norman: University of Oklahoma Press, 1988); Donald Worster, "Hoover Dam: A Study in Domination," in *Under Western Skies: Nature and History in the American West,* ed. Donald Worster (New York: Oxford University Press, 1992), 64–78; Norris Hundley, *Water and the West: The Colorado River Compact and the Politics of Water in the American West* (Berkeley: University of California Press, 1975).

7. Barbara Vilander, *Hoover Dam: The Photographs of Ben Glaha* (Tucson: University of Arizona Press, 1999); Norman G. Wallace Photographs, PC180, AHS. As noted in chapter 1, note 21, the dam changed its name several times during this period. To avoid confusion, I will use its present name, Hoover Dam, in this chapter.

8. "Franklin Roosevelt's Wild West," *Life* (November 1936); Sean Callahan, *Margaret Bourke-White: Photographer* (Boston: Little, Brown, 1998).

9. Not all the photographers had access to wide-angle and telephoto lenses, for example. Among the 1930s photograph collections of Arizona dams are: Herbert and Dorothy McLaughlin Collection, McCulloch Bros. Photographs, CP MCLMB, Special Collections, Arizona State University Libraries, Tempe; Jennie Parks Ringgold Photo Collection, PC 161, AHS; Bill Belknap Photo Collection, Special Collections and Archives Department, Cline Library, Northern Arizona University, Flagstaff; James Gardiner Photo Album, Gardiner Family Manuscript Collection, MS 1115, AHS; Wallace Photographs, PC180, AHS; Milton Snow Collection, Colton Research Center Library, Museum of Northern Arizona, Flagstaff. Snow photographed Coolidge Dam in 1931 and Hoover Dam in 1933.

10. On the cultural power of the technological ideology, see Cecelia Tichi, *Shifting Gears: Technology, Literature, Culture in Modernist America* (Chapel Hill: University of North Carolina Press, 1987).

11. David M. Peeler, *Hope among Us Yet: Social Criticism and Social Solace in Depression America* (Athens: University of Georgia Press, 1987), 88, 57–109.

12. "Not a Holiday, but a Day of Mourning," *Arizona Daily Star,* September 21, 1935. My thanks to Lane Rogers for calling the editorial to my attention.

13. Katherine Bario Kellner Photographs, Special Collections, Arizona State University Libraries, Tempe; Norman G. Wallace Photographs Collection, 1933–1936, AHS; Norman G. Wallace oral history interview, 1975, AHS; Henrietta Wallace oral history interview, 1987, AHS. For other examples of amateur photographers' depictions of Coolidge Dam, see Forrest Doucette Photographs, Special Collections, Arizona State University Libraries, Tempe; Henry E. Heiger Photograph Album, Arizona Historical Foundation, Arizona State University, Tempe.

14. U.S. Department of the Interior, Repayment Commission, "Federal Reclamation and Indian Projects: Arizona," February 1938, 242; House Committee on

Indian Affairs, *Pima Indians and the San Carlos Irrigation Project*, 68th Cong. 1st sess., 1924, passim; on the problems of the San Carlos Project, see also Pfaff, *San Carlos Irrigation Project;* Gregory McNamee, *Gila: The Life and Death of an American River* (New York: Orion Books, 1994). The amount of acre feet to be provided by the San Carlos Project, as well as the amount of land projected to receive that water, ranged widely throughout the planning and politicking process.

15. D. B., interview by Grenville Goodwin, July 17, 1936; Neil Buck, interview by Grenville Goodwin, January 13, 1936, Grenville Goodwin Collection, MS17, box 4, folders 51, 52, Archives, Arizona State Museum, Tucson; Richard J. Perry, *Western Apache Heritage: People of the Mountain Corridor* (Austin: University of Texas Press, 1991), 188.

16. *Annual Report of the Commissioner of Indian Affairs, 1930* (Washington, D.C.: GPO, 1930); Donald Clyde Pace, interview by Kristina Miller, May 6, 1982, Arizona Oral History Project, Arizona Collection, Arizona State University Libraries, Tempe. The dismal story of the San Carlos Apache and the Coolidge Dam has been told by various scholars. See Introcaso, *Water Development on the Gila River,* 59–65; Perry, *Western Apache Heritage,* 186–88; Richard J. Perry, *Apache Reservation: Indigenous Peoples and the American State* (Austin: University of Texas Press, 1993), 148–51; Stephen Cornell and Marta Cecilia Gil-Swedberg, "Sociohistorical Factors in Institutional Efficacy: Economic Development in Three American Indian Cases," *Economic Development and Cultural Change,* 43, no. 2 (1995): 239–68; Francis J. Uplegger Collection, CP SPC 187, Special Collections, Arizona State University Libraries, Tempe.

17. *Extracts from Hearings before Subcommittee of House Committee on Appropriations,* 69th Cong., 1st sess., 1926, CE Ephemera Collection, Department of Archives and Manuscripts, Arizona State University Libraries, Tempe.; U.S. Congress, *Sen. Doc. 11,* 89th Cong., 1st sess. (repr., Washington, D.C.: GPO, 1965; first published as *A History of the Pima Indians and the San Carlos Irrigation Project,* compiled by Carl Hayden, 1924); Jack L. August Jr., "Carl Hayden's 'Indian Card': Environmental Politics and the San Carlos Reclamation Project," *Journal of Arizona History* 33 (Winter 1992): 397–422. The Western Apache living on the San Carlos reservation in the 1930s included Tonto, Chiricahua, Cibecue, and White Mountain.

18. The Soil Erosion Service, initially established under the Department of the Interior, was renamed the Soil Conservation Service (SCS) in 1935 when it was moved to the Department of Agriculture. Standard works on the SCS include D. Harper Simms, *The Soil Conservation Service* (New York: Praeger, 1970) and Wellington Brink, *Big Hugh: The Father of Soil Conservation* (New York: Macmillan, 1951).

19. William S. Collins, *The New Deal in Arizona* (Phoenix: Arizona State Parks Board, 1999), 222; Peter MacMillian Booth, "The Civilian Conservation Corps in Arizona, 1933–42," master's thesis, University of Arizona, Tucson, 1991, 83–85.

20. U.S. Department of the Interior, Repayment Commission, "Report of Hearing Held by the Reclamation Repayment Commission with Representatives of Various Arizona Reclamation Projects," Phoenix, January 5, 1938, 258; Soil Conservation Service Photographs, RG 114-FP, 261, Still Pictures Division, National Archives II, College Park, Md.

21. Governmental reports and studies of overgrazing and erosion on the Navajo Reservation include William Zeh, "General Report Covering the Grazing Situation on the Navajo Reservation" (1930); Donald Harrison, "Working Plan Report of the Grazing Resources and Activities of the Southern Navajo Indian Reservation, Arizona and New Mexico" (1930); U.S. Soil Conservation Service, "Reports and Statistics of a Land Management Survey on the Navaho Indian Reservation," AZ124, Special Collections, University of Arizona Library, Tucson; U.S. Soil Conservation Service Region Eight Papers, 1919–1953, MSS 289 BC, Center for Southwest Research, University of New Mexico, Albuquerque; see also U.S. Senate, Subcommittee of the Committee on Indian Affairs, *Survey of Conditions of Indians of the United States,* esp. part 18: *Navajos in Arizona and New Mexico,* 71st Cong., 3rd sess., 1931, and part 34: *Navajo Boundary and Pueblos in New Mexico,* 74th Cong., 2nd sess., 1936.

22. Collier's October 1933 speech is quoted in Richard White, *Roots of Dependency: Subsistence, Environment, and Social Change among the Choctaws, Pawnees, and Navajos* (Lincoln: University of Nebraska Press, 1983), 258. Collier is referring, of course, to the now-named Hoover Dam.

23. Scholarly works on the Navajo stock reduction controversy include Peter Iverson, *The Navajo Nation* (Albuquerque: University of New Mexico Press, 1981), 23–45; Leonard Schuyler Fonaroff, "The Navajo Sheep Industry: A Study in Cross-Cultural Administration," Ph.D. diss., Johns Hopkins University, 1961; Donald L. Parman, *The Navajos and the New Deal* (New Haven, Conn.: Yale University Press, 1976); White, *Roots of Dependency,* 212–323; Lawrence C. Kelly, *The Navajo Indians and Federal Indian Policy, 1900–1935* (Tucson: University of Arizona Press, 1968), esp. 104–31, 157–63.

24. Senate Committee on Indian Affairs, *Survey of Conditions of the Indians of the United States,* 75th Cong., 1st sess. 1936, part 34, 17,472. Also quoted in Iverson, *Navajo Nation,* 29. See also 1938 public correspondence between Chee Dodge and John Collier, reproduced in various places, including an Indian Service publication, *Indians at Work* (November 1938): 35–39.

25. For contemporary critiques of federal government stock reduction programs, see Thomas Jesse Jones et al., *The Navaho Indian Problem: An Inquiry Sponsored by the Phelps-Stokes Fund* (New York: Phelps-Stokes Fund, 1939); Maria Chabot and Margretta Stewart Dietrich, *Urgent Navajo Problems: Observations and Recommendations Based on a Recent Study by the New Mexico Association on Indian Affairs* (Santa Fe: New Mexico Association on Indian Affairs, 1940); Floyd Allen Pollock, "Navajo-Federal Relations as a Social-Cultural Problem," Ph.D. diss., University of Southern California, 1942. See also Ruth Roessel and Broderick H. Johnson, *Navajo Livestock Reduction: A National Disgrace* (Chinle, Ariz.: Navajo Community College Press, 1974).

26. See White, *Roots of Dependency,* 226–29; U.S. Soil Conservation Service, "Reports and Statistics of a Land Management Survey on the Navaho Indian Reservation," AZ124, Special Collections, University of Arizona Library, Tucson.

27. H. C. Lockett, *Along the Beale Trail: A Photographic Account of Wasted Range Land, Based on the Diary of Lieutenant Edward F. Beale, 1857,* with photographs by Milton Snow (Lawrence, Kans.: Haskell Institute Printing Department, 1939). The pamphlet was a publication of the Education Division of the U.S. Office of Indian Affairs, prepared primarily for use in federal Indian schools, but, as

indicated on the back cover, "suitable for use in all schools." A second edition was published within six months. The most comprehensive survey of photographers of and on the Navajo reservation is found in James C. Faris, *Navajo and Photography: A Critical History of the Representation of an American People* (Albuquerque: University of New Mexico Press, 1996).

28. Lockett, *Along the Beale Trail,* 2–3, 44–45. Capitalization as in original. For another example: "Concentration of livestock in the area above this canyon has greatly reduced the protective plant cover. Water falling on the land is rapidly carried off in flash floods which have cut this deep arroyo" (10).

29. Jack Snow trained Navajo and Hopi assistants in photographic work, some of whom became artists and photographers. As he explained, "I trained Navajo and Hopi Indian assistants to photographic techniques so that my time was free for camera operation and administrative duties," MS 315-08-5, Milton Snow Collection, Colton Research Center Library, Museum of Northern Arizona, Flagstaff. James Faris argues that Snow's photographic work represents a sensitive, respectful portrayal of Navajo people. Although employed by the government, Snow "transcended his assignment." Faris, *Navajo and Photography,* 208, 191–208.

30. Lockett, *Along the Beale Trail,* 54. Snow's SCS photographs are available in the Milton Snow Photograph Collection, Navajo Nation Museum, Window Rock, Ariz.

31. See, for example, *Indians at Work,* June 15, 1936, 16; *Indians at Work,* February 1, 1937, 35; Pete Daniel et al., *Official Images: New Deal Photography* (Washington, D.C.: Smithsonian Institution Press, 1987); and Maren Stange, *Symbols of Ideal Life: Social Documentary Photography in America, 1890–1950* (Cambridge: Cambridge University Press, 1989), 129–30. On the controversy over Arthur Rothstein's cow skull photograph, see Arthur Rothstein, "The Picture That Became a Campaign Issue," *Popular Photography* 49 (September 1961): 42–43, 79; F. Jack Hurley, *Portrait of a Decade: Roy Stryker and the Development of Documentary Photography in the Thirties* (Baton Rouge: Louisiana State University Press, 1972); John Mraz, "What's Documentary about Photography? From Directed to Digital Photojournalism," *Zone Zero Magazine* (2002), http://www.zonezero.com/magazine/indexen.html.

32. For an example of the Florence chamber of commerce letterhead, see B. F. Thum to Governor R. C. Stanford, May 17, 1937, Governor Stanford Papers, Arizona Department of Library, Archives and Public Records, History and Archives Division, Phoenix; *The Coolidge Dam Edition of the Arizona Blade-Tribune of Florence and the Casa Grande Dispatch and Bulletin of Casa Grande,* May 1928. On the Dorothea Lange and Russell Lee photographs, see essays by Brian Q. Cannon and Kirsten Jensen in this volume.

Contributors

Brian Q. Cannon, associate professor of history and director of the Charles Redd
Center at Brigham Young University, is a scholar of twentieth-century western
agrarian history. He specializes in New Deal rural policy. Among his publi-
cations are a book on the Farm Security Administration's rural resettlement
program in the Mountain West and an introductory essay for *Life and Land: The
Farm Security Administration Photographers in Utah,* a Utah State University Art
Museum catalog.

Evelyn S. Cooper surveyed the history of photography in territorial Arizona for her
Arizona State University dissertation. She is also the author of *The Eyes of His
Soul: The Visual Legacy of Barry M. Goldwater, Master Photographer* (2003), *Arizona's
Hal Empie: His Life, His Times and His Art* (2001), *The Buehman Studio: Tucson in
Focus* (1995), and numerous articles and essays centered upon Arts and Letters
in the trans-Mississippi West.

Betsy Fahlman is a professor of art history at Arizona State University. A specialist
in American art of the nineteenth and twentieth centuries, she also has a strong
interest in the art history of Arizona and has lectured widely throughout the
state for the Arizona Humanities Council. She is working on an exhibition of
Precisionist painter Charles Demuth for the Amon Carter Museum and a book
on Depression-era Arizona that will focus on New Deal photography and cul-
ture. She has published widely in the field; major works include *Guy Pène du*

Bois: Painter of Modern Life (2004), *The Cowboy's Dream: The Mythic Life and Art of Lon Megargee* (2002), and *John Ferguson Weir: The Labor of Art* (1997).

Kirsten M. Jensen is an independent curator and scholar living in Stamford, Connecticut. Jensen's expertise is in nineteenth- and twentieth-century art and culture. She is currently working on her doctorate in art history at the Graduate Center, City University of New York. Previously, Kirsten was an archivist for architecture and photography at Yale University and a fine arts archivist at the University of Arizona Library Special Collections.

Katherine G. Morrissey, associate professor of history at the University of Arizona, received her degrees in American Studies from Yale University. Her interdisciplinary research on the North American West focuses on the region's environmental, social, cultural, and intellectual history. Her publications include *Mental Territories: Mapping the Inland Empire* (1997) and, along with Carlos Schwantes, David Nicandri, and Susan Strasser, *Washington: Images of a State's Heritage* (1987).

Lydia R. Otero is an assistant professor at the Mexican American Studies and Research Center at the University of Arizona, where she teaches courses in Chicana/o culture, immigration, and history. Her research concentrates on the histories of diverse ethnic groups in the Southwest, with an emphasis on Chicana/os, gender and racial formations, and border, urban, cultural, and social history. She received her Ph.D. in history from the University of Arizona and is working on a manuscript that examines urban renewal, historical preservation, and the politics of saving a Mexican past.

Nancy J. Parezo is a professor of American Indian Studies and anthropology at the University of Arizona and curator of ethnology at the Arizona State Museum. A noted scholar of Southwest Indian societies, she has published extensively on Navajo art and religion. She has also focused on the history of anthropology and has publications on collecting activities, exhibits, the role of women in academic professions, and the interaction between Indians and anthropologists. Her current book, *Anthropology Goes to the Fair: The 1904 Louisiana Purchase Exposition,* documents the anthropology of exhibits and the lives of indigenous demonstrators at the world's fair.

Margaret Regan is an independent arts journalist living in Tucson who holds a bachelor's degree in French from the University of Pennsylvania. The winner of more than thirty journalism awards, she has written about the arts of the Southwest for more than a dozen years. She has had her work published in *Camera Austria, Make: A Journal of Women's Art, Photovision, Sunset Magazine, Newsday,* and in regional and local publications in Arizona. She is the coauthor of *Steven Meckler Photographs Tucson Artists* (1995).

Martha A. Sandweiss, professor of American Studies and history at Amherst College and coeditor of *The Oxford History of the American West,* has written extensively on Western photography. Former curator of photographs at the Amon Carter Museum, Sandweiss received her Ph.D. in history from Yale University. Her publications include *Print the Legend: Photography and the American West* (2002); *Photography in Nineteenth-Century America,* editor and contributor, (1991); *Eyewitness to War: Prints and Daguerreotypes of the Mexican War, 1846–1848,* with Rick Stewart (1988); *Laura Gilpin: An Enduring Grace* (1986); *Masterworks of American Photography: The Amon Carter Museum Collection* (1982).

Illustration Credits

Amon Carter Museum

Laura Gilpin, [Casa Blanca, Canyon De Chelly], September 1930, gelatin silver print, P1979.107.4, © 1979 Amon Carter Museum, Fort Worth, Texas, Bequest of the artist.

Laura Gilpin, "Navaho Woman, Child and Lambs," 1932, platinum print, P1979.95.90, © 1979 Amon Carter Museum, Fort Worth, Texas, Bequest of the artist.

Laura Gilpin, "Navaho Covered Wagon," 1934, gelatin silver print, P1979.95.98, © 1979 Amon Carter Museum, Fort Worth, Texas, Bequest of the artist.

Arizona Highways

Arizona Highways cover, February 1934.

Arizona Historical Foundation

Barney York Dude Ranch, Prescott, ca. 1934, Claude Bate, FP CB-21.

Arizona Historical Society/Flagstaff

Portrait of "Kit" Carson, owner of Carson Photographic Studio, Carson Studio, AHS.0032.00506.

Arizona Historical Society/Tucson

Carmen Gomez, 1930, Mexican Heritage Photograph Collection, Portrait: Noriega, Jose, 64353.

Adolfo Morales, 1933, Mexican Heritage Photograph Collection, Portrait: Morales, Adolfo, 66210.

Rosendo Perez, 1930, Mexican Heritage Photograph Collection, Portrait: Perez, Felipe, 64663.

Celebration at the Riverside Ballroom, Tucson, September 16, 1937, Mexican Heritage Photograph Collection, Portrait: Peyron, Araneta, 62637.

Alicia Morales Mendoza, Mexican Heritage Photograph Collection, Portrait: Flores, Edward R., 64806.

Advertisement for the Buehman Studio, BN94,336.

Advertisement distributed by Keystone Photo Services, 41854.

Dunn's Market, Buehman Studios, BN25,155.

Steinfeld's Department Store, Buehman Studios, BN21,674.

Hoover Dam dedication, E. D. Newcomer Photograph Collection, PC196, box 6, f. 126/10.

Boulder [Hoover] Dam site, Norman Wallace, January 28, 1934, Norman Wallace Photograph Collection, PC180, Box 26, f. 274, no. 2544.

Coolidge Dam dedication, unknown photographer, Coolidge Dam Dedication Album, PC192-D.

Arizona State Library, Archives and Public Records, Archives Division, Phoenix

Unidentified portrait, Thomas Henry Bate, 01-9371 PhD249.

Arizona State Museum, University of Arizona

"Folded Rocks," Forman Hanna, photographer; Forman Hanna Collection.

Tuzigoot, Edward Spicer Collection, Photographic Collections, Group IV, no. 5, After Excavation Pix no. 446-x-94.

Stratigraphy photograph, Gila Pueblo Foundation Collection, Photographic Collections, no. 71.901.

"Keyhole" photo at "White House" cliff dwellings, Canyon de Chelly, May 24, 1931, Gila Pueblo Foundation Collection, Photographic Collections, no. 72.112.

Man and surveying stick, Gila Pueblo Foundation Collection, no. 70.771.

Cameraman, tripod, and assistant, Gila Pueblo Foundation Collection, no. 70.002.

Gila Butte, man curled up in grave, Gila Pueblo Archaeological Foundation Collection, Photographic Collections, GPF no. 70.020.

Grouped artifacts, Gila Pueblo Foundation Collection, no. 71.888.

Anna O. Shepard with her father, Henry Warren Shepard, summer 1938, Watson Smith Album, Photographic Collections, B-810.

The five Dennis brothers at Keams Canyon dig, Watson Smith Album, p. 12, B-810.

Unidentified Anglo field worker, Tad Nichols Collection, folder 4.

Unidentified Apache field worker, 1936, Tad Nichols Collection, folder 3.

Emil Haury's photo ladder in the field, Gila Pueblo Foundation Collection, no. 70.432.

Emil Haury photographing from a cliff, Gila Pueblo Collection, no. 71184.

Alden Stevens with box kite, Watson Smith Album, p. 20, Photographic Collections, B-810.

Section of the Park of Four Waters, near Phoenix, R. A. Stockwell, photographer, 1930, Neil Judd Collection, Photographic Collections, Pix 6572.

"'Shooting' Oblique Pictures," Neil Judd Collection, Photographic Collections, Pix 6555.

Casa Grande Valley Historical Society

Sunset Court, 1998-037-010M.

Rider in the chute, 1937 Casa Grande Cowboy Days, Esther Henderson, 1971-106-065.

Amelia Earhart with Judge Overfield at the Casa Grande Rodeo Grounds, 1967-041-031.

Pima Indians at Coolidge Dam dedication, 1994-042-018.

Cline Library, Special Collections and Archives Department, Northern Arizona University

Flagstaff All Indian Pow Wow and Rodeo, Fronske Studio, 1939, NAU. PH.85.3.00.199.

Woman leaping the gap, Emery Kolb, Emery Kolb Collection, NAU-568-8404.

"Pow Wow," Bob Fronske, Fronske Studio, 1939, NAU.PH.85.3.00.186.

Department of Archives and Manuscripts, Arizona State University Libraries

Woman diving, CP SPC 108:1.153.154, courtesy Arizona Biltmore Hotel Photograph Collection, Arizona Collection, Arizona State University Libraries.

Rainbo Bread Company, 1935, CP SPC 158:118, courtesy Lisle Chandler Updike Photograph Collection, Arizona Collection, Arizona State University Libraries.

McCulloch Brothers' promotional photograph for Wickenburg's Wigwam Resort, CP MCLMB A767A, courtesy Herb and Dorothy McLaughlin Photograph Collection, Arizona Collection, Arizona State University Libraries.

Pueblo Grande Ruins excavation in the 1930s, CP SPC 156:361.2, courtesy Odd Halseth Photograph Collection, Arizona Collection, Arizona State University Libraries.

Library of Congress, Prints and Photographs Division

Grand Canyon, Russell Lee, October 1940, FSA/OWI Collection, LC-USF34-037856-D.

Family of nine from Fort Smith, Ark., Dorothea Lange, May 1937, FSA/OWI Collection, LC-USF34-016613-C.

Irrigated field of cotton, Dorothea Lange, May 1937, FSA/OWI Collection, LC-USF34-016587-C.

WPA work as visualized by Homer Tate, Russell Lee, May 1940, FSA/OWI Collection, LC-USF34-036417-D.

Tourist attraction, Russell Lee, April 1940, FSA/OWI Collection, LC-USF33-012670-M3.

Miners monument in Bisbee, Ariz., Russell Lee, May–June 1940, FSA/OWI Collection, LC-USF33-012697-M5.

Open-pit copper mine, Fritz Henle, December 1942, FSA/OWI Collection, LC-USW3-027813-E.

Daughter of Mexican field laborer, Dorothea Lange, May 1937, FSA/OWI Collection, LC-USF34-016792-C.

Children inspecting the photographer's camera, Russell Lee, FSA/OWI Collection, LC-USF-33-13242-M1.

Drought refugee families, Dorothea Lange, FSA/OWI Collection, LC-USF34-016797-C.

Farmstead, Concho, Ariz., Russell Lee, October 1940, FSA/OWI Collection, LC-USF34-037844-D.

Houses at the Casa Grande Valley Farms, Russell Lee, 1940, FSA/OWI Collection, LC-USF33-012684-M1.

Casa Grande project, Dorothea Lange, June 1938, FSA/OWI Collection, LC-USF34-018210-E.

Refugee agricultural laborer on the roadside, Dorothea Lange, June 1938, FSA/OWI Collection, LC-USF34-018209-E.

Wife of member of the Casa Grande Valley Farms, Russell Lee, May 1940, FSA/OWI Collection, LC-USF34-036284-D.

Singing at Sunday school, Casa Grande Valley Farms, Russell Lee, May 1940, FSA/OWI Collection, LC-USF34-036332-D.

Casa Grande Valley Farms' manager with a member of the cooperative, Russell Lee, May 1940, FSA/OWI Collection, LC-USF34-036361-D.

Dairy cattle, Casa Grande Valley Farms, Russell Lee, April 1940, FSA/OWI Collection, LC-USF33-012676-M1.

Hay picker-up and chopper, Casa Grande Valley Farms, Russell Lee, May 1940, FSA/OWI Collection, LC-USF34-036396-D.

Workers on the hay-gathering and chopping machine, Casa Grande Valley Farms, Russell Lee, May 1940, FSA/OWI Collection, LC-USF34-036388-D.

In the grocery store of the Casa Grande Valley Farms, Russell Lee, May 1940, FSA/OWI Collection, LC-USF34-036296-D.

Homeless mother and youngest child of seven walking the highway, Dorothea Lange, February 1939, FSA/OWI Collection, LC-USF34-019185-E.

Picking roses, Casa Grande Valley Farms, Russell Lee, May 1940, FSA/OWI Collection, LC-USF34-036291-D.

Cats know the refrigerators contain plenty of food, Casa Grande Farms, Russell Lee, May 1940, FSA/OWI Collection, LC-USF34-036288-D.

Member of the Arizona Part-Time Farms with his wife and child, Russell Lee, May 1940, FSA/OWI Collection, LC-USF34-036075-D.

Spanish farmer's wife and daughter picking chili peppers, Russell Lee, September 1940, FSA/OWI Collection, LC-USF33-012943-M3.

Woman putting up dried meat, Russell Lee, October 1940, FSA/OWI Collection, LC-USF34-037907-D.

Rigger during construction of Boulder [Hoover] Dam, Ben Glaha, 1934, Lot 7365, LC-USZ62-089651.

Lydia R. Otero Collection

Cruz Robles and her sister Maria Luis Robles, 1930.

Uncle Pedro Robles, ca. 1935.

Maria Cruz Robles, U.S. Citizen's Identification Card, 1936.

Museum of Northern Arizona

Albert Einstein and his wife dress up at the Grand Canyon's Hopi House, courtesy of the Museum Of Northern Arizona Photo Archives, 78.0071.

Julian Hayden preparing to climb up to the Keet Seel ruins, Milton Snow Collection, courtesy of the Museum Of Northern Arizona Photo Archives, MS315-106-37.

Julian Hayden, churning ice cream, Milton Snow Collection, courtesy of the Museum
 Of Northern Arizona Photo Archives, MS315-10-18.

Milton Snow posing with the tools of his trade, Milton Snow Collection, courtesy of
 the Museum Of Northern Arizona Photo Archives, MS315-73-57.

National Archives and Records Administration,
College Park, Maryland

Families picking their own cotton, Dorothea Lange, November 1940, Records of
 the Bureau of Agricultural Economics, Record Group (RG) 83, NWDNS-83-
 G-44042.

Close-up of a section of Hoover Dam, Ansel Adams, 1942, Department of the Interior,
 National Park Service, RG 79, NWDNS-79-AA-B04.

Grand Canyon, Ansel Adams, 1941, Department of the Interior, National Park
 Service, RG 79, NWDNS-79-AA-F24.

Children in cotton picker's camp, Dorothea Lange, Records of the Bureau of
 Agricultural Economics, RG 83, NWDNS-83-G-41812.

Young American family, Dorothea Lange, Records of the Bureau of Agricultural
 Economics, RG 83, NWDNS-83-G-41844.

Migratory cotton picker's children come out of tent, Dorothea Lange, Records of the
 Bureau of Agricultural Economics, RG 83, NWDNS-83-G-41826.

On Arizona Highway 87, children in a democracy, Dorothea Lange, Records of the
 Bureau of Agricultural Economics, RG 83, NWDNS-83-G-44360.

Cotton pickers, Mexican children in ditch bank, Dorothea Lange, Records of the
 Bureau of Agricultural Economics, RG 83, NWDNS-83-G-41842.

Bus carries migratory cotton pickers' children, Dorothea Lange, Records of the
 Bureau of Agricultural Economics, RG 83, NWDNS-83-G-41825.

Child in cotton picker's camp, Dorothea Lange, November 1940, Records of the
 Bureau of Agricultural Economics, RG 83, NWDNS-83-G-41811.

Migratory family living in a trailer, Dorothea Lange, Records of the Bureau of
 Agricultural Economics, RG 83, NWDNS-83-G-4435.

Mexican boy coming in from cotton field at noon, Dorothea Lange, Records of the
 Bureau of Agricultural Economics, RG 83, NWDNS-83-G-41839.

Man and wife, migrant cotton pickers, Dorothea Lange, November 1940, Records of
 the Bureau of Agricultural Economics, RG 83, NWDNS-83-G-44101.

Water supply for migratory cotton pickers, Dorothea Lange, November 1940, Records
 of the Bureau of Agricultural Economics, RG 83, NWDNS-83-G-41817.

Migrant colored cotton picker and her baby, Dorothea Lange, November 1940, Re-
 cords of the Bureau of Agricultural Economics, RG 83, NWDNS-83-G-44371.

Sister of cotton picker, Dorothea Lange, November 1940, Records of the Bureau of
 Agricultural Economics, RG 83, NWDNS-83-G-44372.

Saturday afternoon in Eloy, Dorothea Lange, Records of the Bureau of Agricultural
 Economics, RG 83, NWDNS-83-G-44113.

"Passing of the Desert," Joseph Cadenbach, Coolidge Dam Album, Construction
 and Economic Results of Irrigation Projects, 1927–29, Records of the Bureau of
 Reclamation, RG 115, NWDNS-115-DE-3-35.

"Erosion in Granunoa," Milton Snow, Photographs of Navajo Life in the
 Southwestern Region of the United States, 1936–1956, Records of the Bureau
 of Indian Affairs, RG 75, 75-NG-8-NP-1-7.

Coolidge Dam, Joseph Cadenbach, Coolidge Dam Album, Construction and Economic Results of Irrigation Projects, 1927–29, Records of the Bureau of Reclamation, RG 115, NWDNS-115-DE-3-44.

Navajo Nation Museum

Navajo workers on the reservation. Photograph by Milton Snow, courtesy of Navajo Nation Museum, Window Rock, Arizona, no. NG4-88.

Sharlot Hall Museum

Smoki Ceremonial Dance, Bate Studio, 1930, HP SHM S-117, Sharlot Hall Museum Photo, Prescott, Arizona.

Special Collections, University of Arizona Library

Campers peeling potatoes, neg. 600, in Florence May Warner, *Report of Activities of the Children's Health Camps in Arizona under the Emergency Relief Administration of Arizona* (Phoenix: Emergency Relief Administration of Arizona, 1934).

Outdoor nature study group, neg. 597, in Warner, *Report of Activities.*

A dose of cod liver oil, neg. 606, in Warner, *Report of Activities.*

Girl campers dressed in their uniform sun suits, neg. 269, in Warner, *Report of Activities.*

Singing class, neg. 575, in Warner, *Report of Activities.*

Integrated crowd following boxing match, neg. 590, in Warner, *Report of Activities.*

Boys keep their eyes on their carvings, neg. 589, in Warner, *Report of Activities.*

"Home of Child Attending Camp," neg. 706, in Warner, *Report of Activities.*

Tucson Chamber of Commerce promotional pamphlet cover.

The Tucson barrio in the 1930s, Tucson (Ariz.), Views 1930–1939, Arizona Southwestern Photograph Collection.

Timothy O'Sullivan, "Aboriginal Life among the Navajoe Indians," in George M. Wheeler, *Photographs . . . Obtained in Connection with Geographical and Geological Explorations and Surveys West of the 100th Meridian* (1874), Arizona Southwestern Photograph Collection.

Atchison, Topeka, and Santa Fe Railway Company, *Indian-Detours Off the Beaten Path in the Great Southwest,* December 1932

Milton Snow presents the evils of erosion, in H. C. Lockett, *Along the Beale Trail: A Photographic Account of Wasted Range Land, Based on the Diary of Lieutenant Edward F. Beale, 1857.* Photographs by Milton Snow. (Lawrence, Kans.: Haskell Institute Printing Department, 1939), 29.

"Five Miles North of Winslow," in H. C. Lockett, *Along the Beale Trail*, 39.

Index